MONTAGE IN INTERNATIONAL FILM AND VIDEO

Editing and Montage in International Film and Video presents a theoretical and practical approach to the art of editing. In this book, Luís Fernando Morales Morante explores the international history, technology, theory, practical techniques, psychology, and cognitive effects of editing across a range of media from around the world, featuring case studies from film, dramatic television, news media, music videos, commercials, and mobile-delivered formats, from the films of Sergei Eisenstein and James Cameron's *Avatar* to television series like *Game of Thrones*, from Michael Jackson's video for "Thriller" to coverage of the 2012 US presidential elections. The book includes self-study exercises throughout to help readers put theory into practice.

Luís Fernando Morales Morante is Professor at the Autonomous University of Barcelona, Spain. He is the author of several books, and has worked as an editor for *Panamericana Televisión* and *Frecuencia Latina*, as well as for the media postproduction company Advanced Video Systems in Lima, Peru.

EDITING AND MONTAGE IN INTERNATIONAL FILM AND VIDEO

Theory and Technique

Luís Fernando Morales Morante

Routledge
Taylor & Francis Group

NEW YORK AND LONDON

First published 2017
by Routledge
711 Third Avenue, New York, NY 10017

and by Routledge
2 Park Square, Milton Park, Abingdon, Oxon OX14 4RN

*Routledge is an imprint of the Taylor & Francis Group, an informa
business*

Library of Congress Cataloging in Publication Data
Names: Morales Morante, Luís Fernando.
Title: Editing and montage in international film and video : theory
 and technique / Luís Fernando Morales Morante.
Other titles: Montaje audiovisual. EnglishDescription: New York :
 Routledge, 2017. | Includes bibliographical references and index.
Identifiers: LCCN 2016047675 (print) | LCCN 2017007934 (ebook) |
 ISBN 9781138244078 (hardback) | ISBN 9781138244085 (pbk.) |
 ISBN 9781315277141 (e-book) Subjects: LCSH: Motion pictures--
 Editing.
Classification: LCC TR899 .M62513 2017 (print) | LCC TR899
 (ebook) | DDC 777/.55--dc23
LC record available at https://lccn.loc.gov/2016047675

ISBN: 978-1-138-24407-8 (hbk)
ISBN: 978-1-138-24408-5 (pbk)
ISBN: 978-1-315-27714-1 (ebk)

Typeset in Palatino and Helvetica by
Servis Filmsetting Ltd, Stockport, Cheshire

MIX
Paper from
responsible sources
FSC FSC™ C013985
www.fsc.org

Printed in the United Kingdom
by Henry Ling Limited

CONTENTS

FIGURES AND SEQUENCES

INTRODUCTION

It would require a Herculean effort to bring together the many sources and communicative applications that give meaning and action to montage or video editing. Montage is principally a technical-operational discipline that arises from the close relationship between an editor and his/her material—in this case, images and sound. Montage is the creative exercise of joining fragments and fashioning a sequence imbued with meaning. At the end of his/her work, an editor should be able to create a unique product full of personality and meaning. To achieve this, an editor should not only be able to master the necessary software but should also put into practice his/her creative knowledge and problem-solving skills in order to achieve a product that can be fully understood, is easy to watch and is capable of easily communicating ideas and information and conveying emotions. With these objectives in mind, montage provides the techniques and skills to make a success of any production. Access to the information, materials and tools necessary to edit films and videos has grown rapidly in recent years thanks to the development of computers and the Internet. Editing is no longer an activity of a privileged few, as was the case just 20 years ago, when the technology was bulky, complicated to handle and so expensive that only the big producers could afford it. Montage, together with the increase in the number of professionals who study it as part of their training, is a true indicator of the fact that over time it has changed, adapting itself to today's demands, and continues to seek out new audiences, especially among the young, through experimentation with new and increasingly inventive and creative languages and messages. The current phenomena of *transmedia* and *cross-media*, inextricably linked to the Internet through its function as a communication and audiovisual transmitter, serve to inspire creativity and the use of narrative solutions that often emerge from the editing room itself. Audiovisual products designed for *new media* can be widely different in form and esthetics from those we would define as conventional in cinema and television. In this regard, the rhetorical resources of today's special effects, the rhythm of shots, and stories shown in reverse order are nigh on impossible to

analyze with two traditional narrative codes. We therefore need to rethink and come up with new editing models that professionals are able to fully understand. Our position on this matter is that narrative, semantic and expressive skills should take precedence in any editor's training, who can develop them through the combination of audiovisual components, controlling decisions according to their specific communicative aims and the perceptual-cognitive capacities of the target audience. In fact, some of the great findings in film montage made by Bálasz and Eisenstein in the 1910s focused on these aspects and are, therefore, still relevant today, while others have fallen by the wayside, since, as we have already mentioned, language adapts to modern times, ways of watching audiovisual products and experimenting with images and sound through the technologies that allow viewers to enjoy them to the maximum.

One aspect we should not forget to mention is the fact that much of the literature relating to film montage is scattered widely in individual publications, with each author developing his/her own interpretations without necessarily comparing them with other works. These interpretations were also conceived in times in which other intellectual paradigms prevailed. Something similar can be said for video editing, except that work in this field focuses on technical, format and project-management issues, with matters relating to drama, the improvement of contents and creation of meaning being largely neglected. In reviewing the literature on these issues, we have uncovered an extensive territory that is often disjointed and plagued by serious omissions. This has spurred us to write this book, which aims to bring together all aspects relating to this profession under one title. We have, therefore, taken a practical approach, providing examples of films, series, documentaries, news programs and commercials, which we use to illustrate the various procedures and work methods involved. Only through the analysis of case studies can we understand how the theory works. We need to be aware of prevailing styles, specific decisions, procedures and ad hoc solutions in order to successfully address the various types of montage. We believe that a theoretical and practical approach offers the best combination both for young people wishing to venture into filmmaking as well as those who, although already experienced, may wish to strengthen or refresh their knowledge in order to improve their professional qualifications.

To achieve our objective, we have decided to organize this book into 10 chapters:

Chapter 1 introduces the reader to editing and montage through a comprehensive review of the theoretical and academic definitions of montage, including the denominations given to it in other countries. This chapter concludes with a section on the difference between the concepts of montage, editing and postproduction, along with a proposed definition.

Chapter 2 reviews the main findings of montage theory and the way in which the guiding rules and criteria of audiovisual film and television

rhetoric have developed over time. Contributions by German, Russian, French and North American theorists, among others, are also reviewed.

Chapter 3 discusses the classical concepts of film structure: scene, sequence and shot. We also take a look at the way montage, as creative process, affects these units to create meanings and emotions. We refer to this as the *aims of editing*.

Chapter 4 focuses on the use of joining techniques such as cuts and transitions and their functional value in creating expressive audiovisual grammar. This is followed by **Chapter 5**, in which a synergistic model of montage in three operating levels is formulated.

Chapter 6 describes the technological evolution of editing and how different systems have provided users with various options for working with video and film material. It also describes early linear and non-linear editing models together with digital interfaces, and the main advantages and differences between commercial manufacturers. A basic protocol to fully edit a video piece is provided, from the recording of material, its assembly, postproduction and rendering, through to its export. Two subsections are included that discuss the special considerations to be taken for high definition and small-screen formats. Finally, Chapter 6 describes the development of videotape and film formats from early to current forms.

Chapter 7 discusses the planning of a shoot and explores how the various techniques help in postproduction editing.

Chapter 8 reviews case studies. Relevant examples of montage, covering various genres including action, advertising, drama, news and video clips, are analyzed. Two additional categories are included, along with examples of current videos for personal devices and program presentations.

Having analyzed case studies, in **Chapter 9** we explore montage in greater depth from a theoretical perspective, focusing on the psychology and perception of moving images. This section allows us to look at new means of construction and narrative analysis, examining viewers' real and imaginative capacities and how, through measuring and testing certain indicators, we can determine how images and sounds are processed in the brain, thus improving the efficiency of audiovisual narratives.

Finally, **Chapter 10** reviews the various experimental methods used to measure emotional and cognitive responses to editing. This unit also includes a review of Media Psychology, Perceptual Media Cognition and other studies that specifically focus on measuring the functioning of the rules of continuity, 180° violations, the order of information and other specific editing procedures. This chapter also includes examples of research that measures emotions and arousal generated by audiovisual content in viewers. Each of the six subsections includes a brief outline of the experimental designs, stimulus and response variables, participating subjects and results.

We believe that by organizing the contents of this book in this way we can provide useful theoretical and practical answers to the questions and concerns of both those training in this artistic-creative discipline and those seeking to refine the techniques, criteria and decision-making processes used by editors in their daily work. We hope this book proves to be an invaluable reference for many theoretical and practical endeavors in the art of montage and postproduction editing.

A NOTE ON THE ENGLISH TRANSLATION

The translation of this book into English has been made possible thanks to the support of the Language Service of the Universitat Abat Oliba CEU.

A Spanish edition under the title *Montaje audiovisual: teoría, técnica y métodos de control* was published in 2013 by Editorial UOC.

EDITING AND MONTAGE

Definition and Scope of Practice

Since its inception, montage has been considered the principal tool for constructing audiovisual narratives and activating emotional responses in viewers. Film theorists such as Pudovkin and Eisenstein, who developed Münsterberg's earlier ideas, created a series of models to intensify and make more effective the filmic experience. A review of the literature on the early years of silent cinema (Eisenstein 1999c; Pudovkin 1988; Bálasz 1978) reveals the refined systematization of self-taught editing techniques used in early US silent films, such as Porter's *The Great Train Robbery* (1903) and Griffith's *Intolerance* (1915) and *Birth of a Nation* (1908). These empirical and intuitive findings of the visual connection between shots and scenes were used as the basis for the first theories and subsequent models of montage. As Eisenstein himself pointed out, cinema is founded on the expressive structures and bases of literature, theatre, painting and even music. All arts have influenced cinema in one way or another and have served to create what we know nowadays as film language. However, montage has also been the subject of study by other disciplines that are not strictly artistic. In recent decades, researchers in cognitive psychology and perception have become increasingly interested in analyzing the effectiveness of narrative methods in cinema. By using instruments to test intellectual and emotional processing, it is possible to observe in real time the sensorial and neurological activity and behavior of subjects when challenged with audiovisual stimuli, information which is essential to understanding how to create messages that are more persuasive and effective. This has without a doubt revived the proposals put forward by Jean Mitry in the 1960s that contradict many of the postulates of classical film theory. In this regard, we believe that montage, as a theoretical and practical discipline, should be approached from a dual perspective: through the analysis of its form and content, and also as a psychological processing of this message by the viewer within the framework of their cinematic experience.

THE DEFINITION OF MONTAGE

The term *montage* comes from engineering and theatre and means, in its literal sense, *the process of construction of machines and vessels* and *the preparation phase of a stage*. Later, this term was used to designate the last step in making a film. In the next few sections, we explore the various definitions found in general and specialized dictionaries and encyclopedias, as well as those proposed by academics working in the fields of film theory, film techniques and video.

ENCYCLOPEDIC DEFINITIONS

The *Larousse Film Dictionary* defines montage as: "The phase of creating a film in which images and sounds of the film are assembled and adjusted." The *Focal Encyclopaedia of Film and Television Techniques* defines montage as:

> a rapidly cut film sequence containing many dissolves and overlays to produce a generalized visual effect. In a more specific sense, the word montage refers to a way of cutting film that originated in the Russian school shortly after the Revolution and which is characterised by staccato transitions and violent sequence changes that are seemingly unrelated. However, this latter meaning is now obsolete.
>
> (Spottiswoode 1976, 703)

According to the *Diccionario del cine*, by Jean Mitry and Ángel Falquina, montage is

> the assembly of film shots after having been "synchronised" with the sound recordings (dialogues, sounds, special effects, etc.) and having decided which "take" to use. Each scene is cleaned of clapperboards and then placed in order in the "continuity." The film thus obtained is then thoroughly reviewed to give the appropriate pace to the succession of scenes. The rushes serve as a model in the laboratory to obtain the negative image.
>
> (Mitry 1970, 190)

In the *Diccionario espasa: cine y TV: terminología técnica*, it is defined as:

1. In the making of a film, the process of selecting and joining the footage.
2. In the finished film, the set of techniques that govern the relationships between the scenes.
3. In mechanical terms, it refers to the moment chosen to move from one shot to another, the form of change, the order

and duration of the scenes, and the continuity of image and sound.

(Páramo 2002, 458)

The *Enciclopedia Ilustrada del Cine* defines montage as:

the process by which the various shots of a film come together to form a continuity of scenes of certain duration. Montage generally designates both the technical and creative process of filmmaking, through which the temperament of an artist, in this case, the director, is expressed through a deliberate succession of scenes, the rate that determines them, and the rate at which the images occur.

(Clotas et al. 1969, 237)

Valentín Fernández-Tubau, in his book *El cine en definiciones*, defines montage as "the process of ordering, cutting and joining of recorded material to create the final version of a film" (Fernández-Tubau 1994, 107).

Wordreference[1] defines it as the "selection and ordering of filmed material to produce the final version of a film. The producer personally monitors the editing of the film."

THEORETICAL DEFINITIONS

For Rafael Carlos Sánchez, montage

is the term used to indicate the specific nature of cinematographic work, as the need or requirement of film to be divided into scenes or takes (shots). It is, thus, an esthetic term that, far from referring to the creative process only, involves all phases. Therefore, in filmmaking, montage refers to the whole process, from the moment a film is conceived in the mind of a cinematographer to the moment he creates the technical script detailing the separate scenes and shots.

(Sánchez 2003, 66)

For Antonio del Amo, it is the "syntax of a language that begins to pursue its development; it is the art of directing attention" (Amo 1972, 20).

For Manuel Carlos Fernández Sánchez, montage is a "creative process which gives definitive form to a film or programme's cinematographic narrative and content, ordering the shots and applying transitions between shots and sequences with a narrative and aesthetic meaning" (Fernández 1997, 38).

Pedro del Rey del Val understands it as the "ordering, linking, articulation and adjusting of images with others in time, movement and duration to achieve a uniform composition that reflects the scene described

by the scriptwriter and captured by the camera from various angles and frame sizes" (Rey del Val 2002, 21).

For Vincent Amiel, "film montage is not only an indispensable technical procedure for filmmaking. It is also a creative principle, a way of thinking, a way of conceiving films by associating images" (Amiel 2014, 7).

Marcel Martin suggests the following definition: "it is the organising of shots of certain order and length" (Martin 2015, 169).

Jacques Aumont proposes that

> montage in a film is primarily a technical job, a profession. It has, over the course of a few decades of its existence, established and progressively defined certain procedures and activities. ... it consists of three major operations: selecting, combining, and joining. These three operations aim to achieve, from separate inputs, a totality that is a film.
>
> (Aumont et al. 1996, 53)

Finally, Michael Chion states that "montage is an abstract task of assembly that involves specific operations: cutting and joining celluloid or plastic tapes" (Chion 1994, 324).

FILMMAKERS' DEFINITIONS

Lev Kuleshov describes montage as a "technique of composition by which the film material (shots, cuts, scenes) is assembled to obtain a harmonious and expressive whole" (Kuleshov 1987, 63).

On the other hand, Sergei Eisenstein states that "montage is the expression of an intra-scene conflict (or contradiction), primarily the conflict between two scenes that are next to each other" (Eisenstein 2001a).

For Albert Jurguenson, montage

> is the most specific element of film language. Its importance among the expressive media of the seventh art has changed throughout the course of film history, but its dominance cannot be doubted. It can be defined as the organisation of scenes of a certain order and length.
>
> (Jurguenson and Brunet 1992, 17)

Vincent Pinel defines montage as "the final step in the production of a film that guarantees the condensing of the elements gathered during filming" (Pinel 2004, 4).

According to Dominic Villain, montage "is used ... to denote certain specific operations, sequences of assembled effects within films. Transition sequences must demonstrate many things in a short time, and depend on the power of montage to condense time or space" (Villain 1994, 30).

PRACTICAL DEFINITIONS

For Carliza and Forchino, "montage is a process in which a set of filmed images is divided into sequences that are then selected and recomposed in the order established by the author" (Carlizia and Forchino 1992, 73).

Jaime Barroso García claims that montage "is the production stage in which, through combining shots (visual system) with other important systems of television, such as sound and written/visual systems, the whole television narrative is shaped" (Barroso García 1988, 425).

According to Kevin Brownlow, montage "involves directing a film for the second time. Finding the psychological moment—knowing exactly where to cut—requires the same intuitive skills that a director needs" (Brownlow 1989, 280).

THE DEFINITION IN DIFFERENT COUNTRIES

In other languages the term is similar and comes from the same root. In some cases it is influenced by the American meaning of editing or cutting. The following are just some examples: French: *montage* and *découpage*; German: *Mon'tage and Schnitt*; Italian: *montaggio*; Portuguese: *montagem*; Holland and Belgium: *montage*; Polish: *montaz*; and Russian: *montazh*.

DOES MONTAGE = EDITING?

To talk of montage and editing is to talk of the same thing because in both cases we are referring to a creative technical process involving a series of steps aimed at constructing an audiovisual message, regardless of whether it is carried out through manipulating pieces of film, checking a recorded tape or transferring digital fragments from a non-linear editing system.

From the beginning of cinema and throughout the time the seventh art was the only way of reproducing reality in movement, the term montage has been used to refer to the last stage in the process of filmmaking. Directors would shoot and the fragments of film would be mechanically joined in a cutting, gluing and synchronization machine referred to as a Moviola. When the video emerged in the 1950s, electronic material was handled on reels, tapes and files through a linear editing system, or editing suite. The industry refers to this work as "video editing." In the last two decades, as recording and audiovisual transfer technologies have evolved, operational functions and professional profiles have moved a lot closer to the point where it is practically impossible to distinguish them. With the development of computer technology, film and video have become digital and, as such, the same system and similar work procedures are used to handle the two formats: software with the same functions and

data storage servers with similar features. The end product is exported either in film or video format. The differences that existed previously are, these days, practically imperceptible and we can use the term montage or editing for both the cinema and video with absolute validity.

We can therefore conclude that both concepts reflect the same task or the same set of actions and decisions, whose only difference lies in the nature of the capture or export media—film, magnetic tape or digital image—in which the sequence is finally created.

POSTPRODUCTION

Since the 1990s, the editor's way of working and professional profile has undergone further change. The availability of new audiovisual systems has provided a greater range of options, combinations and more agile ways of handling images through the way diverse files, folders and EDL (editing decision list) tracks can be accessed. Thus, an editor's approach and how he/she interacts with various fragments has changed. All of which marks a milestone: the beginning of the end of analogue systems and the birth of a new way of editing, headed by an editor with a new profile and a wider knowledge of man–machine interactions. The once glitzy computerized editing that shocked many in the early 1980s was completely superseded by non-linear systems, thereby bringing about a wholesale transformation, both procedurally and in the way in which editors interact with their material. The work of an editor is now more versatile, faster, intuitive, and the recreational possibilities are almost limitless, allowing for the totally unfettered computerized manipulation of audiovisual material throughout the process, as well as the adjustments, retouches and substantial changes that can be made without having to rely on editing the tape itself—as used to happen in conventional systems, with all the associated risks and loss of valuable time that this delicate task called for. This increase in post-shooting capabilities has given rise to a new profession, *postproduction*, a term which covers procedures for both the polishing and final revision of the product prior to its broadcasting. It has also given rise to a new professional in video production: the post-producer, who is responsible for overseeing the three now distinct phases of editing, sound mixing and titling, which were previously carried out by the same individual following predefined style and visual appearance guidelines that were followed throughout the whole process.

The film industry has, these days, shifted almost wholly to digital and high definition (HD) formats, both in cameras and editing systems. Only the optic for camera calibration has survived this transformation, even though its control and display is carried out with built-in or external digital tools. This means that current film and video production processes are almost one and the same. While shooting still occurs in film format,

editing is carried out using similar systems based on capture and export, regardless of the level of quality that differentiates the two and which are governed by the standard chosen for recording and digitalization of information. Under this scenario, a rethink of the basic concepts and procedures is required in order to adapt them to the new circumstances in which directors, editors and technicians are inevitably going to have to work together.

Having looked at the different regional and linguistic terminology, and the specialization and subdivision of the editor's duties, it is time to have a look at the current situation with regard to editing. The following definitions confirm the relation between editing and the video and television environment.

In his 1991 book *Video Production Handbook*, Gerald Millerson opts for a less ambitious definition that nevertheless includes a key term that is curiously not taken into account by other authors: persuasion. "Through editing, a compelling and persuasive presentation can be created by properly mixing shots" (Millerson 1991a, 169).

Carlos Solarino, in his 1993 book *Cómo hacer televisión* (How to Make Television), defines editing as a process whose aim is to create a finished or definitive product: "[Editing] consists of a set of operations performed on recorded material in order to obtain a complete and final version of the program" (Solarino 1993, 381).

The review of all definitions of film montage and editing, its video equivalent, highlights the constant theme running throughout the definitions of various authors at different times and which, in our opinion, takes the form of three very different approaches:

1. *Empirical*: Formulations from an entirely personal and practical viewpoint based on an attempt to "systematize" their experience as filmmakers and video producers.
2. *Adapted*: Theoretical models and concepts adapted from other theoretical models that are already established in the literature, theatre, art or semiotics.
3. *Technical-technological*: Based on the management of operating systems and the mechanical action of splicing (joining) a series of images and sounds.

With such diverse descriptions, the concept of montage has not been satisfactorily defined so far. This is understandable for early filmmaking, when there was no theory capable of satisfying the various challenges posed by montage and when filmmaking was obviously a new art and, as such, was studied as part of the arts and philosophy. This separation from the formal disciplines remained in place for many decades and, as such, film theory in general, and montage in particular, were not considered genuine scientific concepts. This almost quasi-obsessive recurrence to the esthetics

of art is also evident in the concepts developed by Balázs and, indeed, Eisenstein himself (discussed later), on whose foundations the contemporary theory of montage has been built in an attempt to artistically explain a phenomenon that, we believe, is specifically cinematographic and perceptual. Contemporary film theorists, even when they have tried to distance themselves from such approaches, have ended up taking the same route taken by cognitive psychologists. The existence of multiple approaches only contributes to this conceptual diaspora, which is the result of widely divergent strategies being developed at various times throughout history and which only disorientate and confuse us. On the other hand, contemporary literature has focused more on explaining how systems work, demoting the creative and conceptual aspects of the film or video editor's work, especially in light of the changes that his/her philosophy has undergone with the arrival of digitization and HD. The problem, we believe, can be solved by proposing two definitions: one operational, and one that integrates the concept of montage within the process of production and communication.

PROPOSED DEFINITION

In view of the variety of definitions of both montage and editing, we have chosen to establish two: the first is based on their operative nature; and the second, which is more conceptual, serves as a mechanism of narrative articulation and meaning creation.

Operational definition: Montage/editing is the task of selecting, cutting and pasting fragments of image and sound to create the final version of a film or video.

Conceptual definition: Montage/editing is the set of spatio-temporal relations created by the combination and length of scenes. These relations allow an audiovisual message to be transmitted smoothly and coherently, with rhythm and self-expression according to the intentions of the creator and the capabilities and expectations of the viewer.

These definitions, however, are not definitive, since there is room for improvement. Filmic narrative, video, discourses and the formats and technologies used for audiovisual production are constantly evolving, particularly in editing processes. Thus, it is highly likely that new definitions will appear that will be more open to improvements and/or changes that make them enduring. This need for constant redefinition has its origins in the progressive loss of validity in relation to certain rules of montage, which only a few decades ago were essential to its philosophy and everyday practice. Eyeline match, the 180° rule, the differential limit of a shot's size, all of which were once considered the causes of "unwanted jumps" in a "correct" audiovisual construction, are now permanently violated; the viewer no longer considers them an error or a break in

the visual logic but, rather, as defining an authentic style and format, whose keys are continually updated and revalidated by the viewer as the techniques and narratives themselves evolve. Good examples of this are video clips, video art and certain advertisements, where editing adopts a highly effective creative strategy based precisely on the discontinuity of shots or actions. Creations made especially for the small screen is another emerging area to which special attention should be paid. The remarkable growth of productions for broadcast on mobiles, the Internet and other mobile devices such as iPads or Smartphones also necessitates a rethink of the processes involved not only in composition but also in editing and montage in terms of the format, the technical characteristics of the devices and reception conditions, among other variables. Finally, we also anticipate what may represent the definitive introduction of HD and 3D television, videogames, virtual reality (VR) and augmented reality (AR)—new large-screen technologies that are opening up new avenues and that imply considerable changes in the way we view, process and understand media messages. But what role does montage/editing play in all of this? Will it continue to make a significant contribution? Or does it remain relegated to its basic function of joining a series of images, while the audiovisual experience focuses on maximizing the sense of realism, demoting to second or third class the transitions, the logical ordering of information, the expressive creativity and the rhetorical function of the narrative and associative techniques traditional to it? In the following chapters we discuss all these issues, and the role of montage in different genres, formats and situations will be analyzed in order to provide readers with the necessary criteria to address them successfully, and, through them, be able to successfully handle a set of narratives and expressive variables that form part of their work, whether in the film industry, video production, or creation of products intended for multiple platforms and channels.

Nevertheless, we believe that the two proposed definitions encompass all the elements and steps involved in the process not only at the basic, operational level, but also at the higher level—the expressive narrative, which occupies the principle functions of montage/editing in its many areas of application.

NOTE

1. Wordreference, available at www.wordreference.com/definicion/montaje

2

DEVELOPMENT OF TECHNIQUES AND THEORIES

DISCOVERY AND FIRST EMPIRICAL TECHNIQUES

In its early years, the cinema simply adopted the theatrical conventions of the time in order to communicate. The long shot of the face-on fixed camera was the standard way to record and reproduce reality, and had no other aim than to portray reality, share it and entertain audiences through the projection of moving images of far-off places and spectacular novel events that they could not experience first-hand. Although they were to a great extent the inventors of cinematography, the Lumière brothers did not recognize its full potential and their films were made in the simplest of ways: they chose their subject of interest, placed their camera in front of it and turned the handle until everything had been recorded. It was Méliès, however, who unwittingly came up with the technique of montage: when making one of his recordings, he decided to reposition the camera—though in a static position—without realizing that the object had changed its location. To his great surprise he saw upon subsequent inspection that one object changed in the image while the others remained in exactly the same place. It seemed as if it had suddenly disappeared from the scene and thus the magic of montage was discovered.

PORTER: CONTINUITY

It should, however, be acknowledged that the most important step was recognizing the potential of montage and then developing it for specific communication purposes, which involved putting montage at the service of the narrative story and, especially, using it as a way of capturing the viewer's attention. Edwin S. Porter exploited this potential in his film *Life of an American Fireman* (1903) after deciding to include *parallel montage*. By alternating images of two distinct spaces, one indoors and the other outside, along with the insertion of a close-up in between, he managed to greatly increase the sense of dynamism and tension through the variation

of spaces and perspectives, which strengthened the plot's continuity. His earlier, though more sophisticated, film *The Great Train Robbery* (1902) boasts a more complex narrative of fourteen scenes in which Porter selects and arranges the distinct stages of the robbery and the escape, pursuit and capture of the outlaws, thus creating a dynamic series of fully articulated, substantial spatio-temporal changes (see Sequence 2.1).

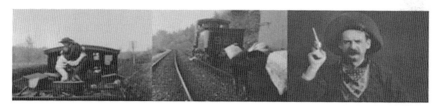

Sequence 2.1 A series of three scenes from *The Great Train Robbery* by Edwin S. Porter (1902). They show the combination of three scenes taken from three different angles. The last, a close-up of the outlaw.

(E. S. Porter © Edison Company)

Mastering the distinct options of contracting or expanding the action, which would require specifying the exact time of each scene in terms of its potential effect, would become the main preoccupation of filmmakers and editors. From now on, the work of montage would consist of the analysis and careful evaluation of the material, with thought being given to the overall strategy and to the whole sequence and not just the microscopic procedure of determining the ideal physical connection between one scene and the next.

GRIFFITH: DRAMATIC EMPHASIS

A more articulate development of the methods used by Porter can be seen in David Griffith's model of dramatic construction. In his two great works, *The Birth of a Nation* (1915) and *Intolerance* (1916) (Sequences 2.2 and 2.3), he pioneers the techniques of *parallel montage* and *alternate montage*, in which actions from different time periods are seen but taking into account strictly dramaturgical considerations. As Karel Reisz states:

> Porter and Griffith's reasons for fragmenting the action could not, however, be more different. When Porter passed from one scene to another, it was nearly always due to physical reasons, which prevented the action being accommodated within a single shot. In Griffith's continuity, the action rarely passes from one shot to another. The angle changes not because of physical reasons but dramatic, in

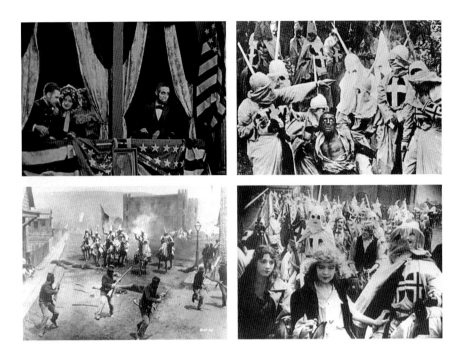

Sequence 2.2 In *The Birth of a Nation* (1915), montage is used to tell four parallel stories, interlinked by the figure of a woman rocking a cradle, symbolizing the plea against intolerance.

(D. W. Griffith © D. W. Griffith & Epoch)

order to show the viewer a new detail of the large scene, which raises the dramatic interest in a particular moment.

(Reisz and Millar 2003, 22)

Both examples represent a pioneering concept—"a form of montage"— designed to awaken mental associations in the viewer through the physical interconnection of a series of actions that take place in distinct times and locations but that are joined, since montage exploits and projects individual dramatic forces in a single sequence. In addition to careful planning, Griffith maximizes each scene and the effect resulting from the various combinations and angles brought about through montage. These films provide the first examples of how drip-feeding information can be used as a variable in the awakening of emotions: the deliberate variation in the length of each scene is meant to generate an increase in tension. Through parallel montage, the changes in scene have a direct impact on the narrative's evolution and montage is unleashed from its usual bounds to become the storyline's guiding force. This associative principle represents a procedure widely used these days to create relationships or contrasts between scenes and, as we shall see in the next section, formed the starting point of subsequent classifications by the great theorists.

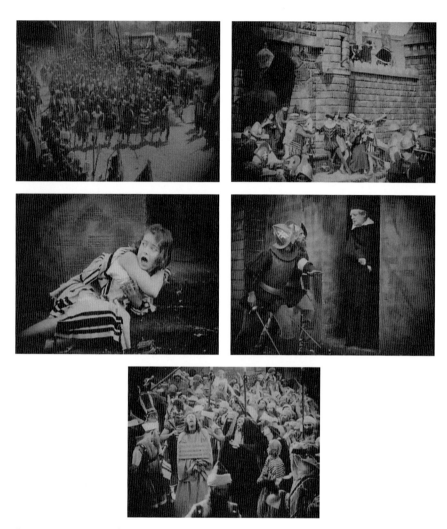

Sequence 2.3 In *Intolerance* (1916), one scene splits the rescuers' cavalcade and the terror of the persecuted. Each scene is given a duration opposite to that expected by the viewer, whose experience is more intense.

(D. W. Griffith © Triangle & Wark)

MODELS AND THEORETICAL CLASSIFICATIONS OF MONTAGE

The Soviet School (see Figure 2.1) developed two diametrically opposing lines. On the one hand, Eisenstein and Kuleshov attempted to justify film's narrative advance and its expression through dialectics, or *collision montage*. Pudovkin, on the other hand, breaks down the components

of *continuity*—or *Hollywood*—*editing*, which, unlike the "collision" theory proposed by Eisenstein, organizes the mechanisms of the cut's imperceptibility, or *raccord*, through the perfect physical assembly of the shots.

The French school of thought of the 1950s encompasses two very different trends. The first, led by Christian Metz and continued until the present day by Jacques Aumont, together with other semiologists at the Sorbonne, proposed a *visual grammar*, derived from montage and based on the fundamentals of linguistics, which can be applied not only to the analysis of the message but also to the rhetoric, or expression, of the filmic narrative (Metz 2002; Aumont et al. 1996).

Years later, and in response to the semiotic movement, Jean Mitry and Marcel Martin developed the concept of "filmness," which was based on the psychological nature of the cinematic experience and considered the biological and perceptual characteristics of the viewer and not concepts from other influential disciplines such as art, literature or theatre. This psychological trend explored in more depth the visionary idea proposed in 1909 by Ernest Lindgren, when he claimed that montage was capable of reproducing a mental process through which one image follows another according to whether our attention falls on one place or another (Lindgren 1954, 73).

Montage therefore directs the audience's attention by focusing on specific elements of the represented reality through combinations of varying perspective: changes in camera position with respect to either the subjects or objects—termed *horizontality*, the change in the angle of action—*verticality*, and the size of frame or portion of represented space—*distance*. Consequently, the events shown on the screen develop such that their linking together imitates the way in which we see the real world and the way our gaze moves from one object to another to take in specific details.

The product of all this reflection on montage put forward by film theorists can therefore be summarized in three main paradigms, which in turn make up the three classes of montage.

In his book *The Photoplay: A Psychological Study and Other Writings* (2013), Hugo Münsterberg presented an early psychological-cognitive schema of montage based on the processes that differed markedly from the other visual arts of the time. He claimed that the narrative mechanisms expressed through montage—flashbacks, close-ups and cuts—are exclusive to cinema and provide an answer to the formalization of a logic aimed at reproducing how we see and our ways of thinking, based on the basic principle of order and the orientation towards specific features in the scene. According to Münsterberg, a close-up reproduces what happens when we focus our attention on an object, a flashback symbolizes recalling an earlier event that occurred in our lives and a flashforward, a projection into the future of what we think or wish to see. In this way, cinema is able

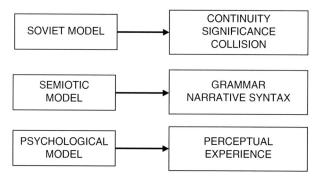

Figure 2.1 Montage models according to the Soviet, semiotic and psychological models

(Source: author)

to control our perception and, at the same time, requires us to engage our intellectual capacities in order to establish meaningful associations and connections between the various shots, thereby giving them meaning. Later, these ideas were taken up and developed further by theorists such as Jean Mitry and Marcel Martin, who proposed their own theoretical cinematic models of montage. In Figure 2.2., we can see, therefore, a basic intellectual connection that determines the approach and a range of audiovisual linking devices.

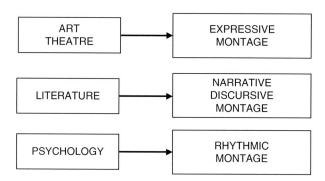

Figure 2.2 Relationships between artistic movements and montage techniques

(Source: author)

Lev Kuleshov: Experimental Model

An early approach of the effects of montage is provided by the experiments carried out by Lev Kuleshov in his psychology cinema laboratory, set up in 1922, in which his protégé, Vsévolod Pudovkin, and other collaborators participated. For the Russian filmmaker, the basic strength

of cinema comes from montage, as it allows material to be fragmented, reconstructed and, finally, refashioned.

Kuleshov's model is entirely based on systematic experiments carried out in the face of a shortage of original film footage, a situation that allowed him to perform a series of creative experiments to specifically test the efficacy of montage techniques. The first of these, and perhaps his most well known, is known as the *"Kuleshov effect."* The audience did not notice that it featured exactly the same close-up of the actor Ivan Mosjoukine (Sequence 2.4). Those who saw it enthused over the acting, believing that Mosjoukine acted differently in all three situations: expressing grief over a dead girl in a coffin, worry over a bowl of forgotten soup and desire for a seductive woman. Afterwards, they were told that it was the same shot and that in fact the meaning of each shot was formulated through the psychological relation that our minds automatically construct on seeing the subsequent image, i.e. the dead girl, the bowl of soup or the woman on the divan, respectively.

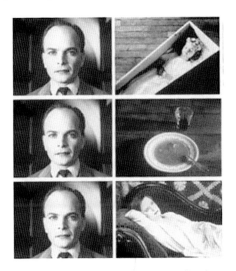

Sequence 2.4 The Kuleshov effect: The combination of a close-up of Ivan Mosjoukine with three different shots: a girl in a coffin, a bowl of soup and a seductive woman.

(Courtesy of Boxclever Films)

According to Kuleshov, this demonstrates that the various resulting interpretations are a result of montage. The capacity to condition the audience's emotional response lies in montage and not in the image's internal content. But what visual or mental mechanisms are able to explain, or at least play a part, in this type of response elicited by montage? The answer lies in a perceptual impact or a significance of correlations based on the viewer's previous knowledge—his/her background, an experience

that allows the individual to build meaningful connections between observed images. It is, as Mitry states, the coming together of the relationships between observed objects and recognized elements, since the audience "saw" something that, in reality, did not exist. In other words, by linking their successive perceptions and relating each detail to an organic "whole," they logically constructed the necessary relationships and assigned Mosjoukine the expression that should have normally been expressed (Mitry 2002, 333).

It is precisely at this point that Kuleshov's pivotal contribution to montage took shape through the empirical confirmation of the effectiveness of relational cut, whereby a meaning is produced only through montage. Along the same lines, we find other similar experiments that confirm this first theory of montage, but unfortunately cannot be verified as the original archives have been lost. One—*Creative Geography*—consisted of creating a non-existent scene of a couple meeting on the steps of the White House from real footage. Kuleshov himself described it thus:

> Khokhlova is walking along Petrov Street in Moscow near the "Mostorg" store. Oboíensky is walking along the embankment of the Moscow River—at a distance of about two miles away. They see each other, smile, and begin to walk toward one another. Their meeting is filmed on the Boulevard Prechistensk. This boulevard is in an entirely different section of the city. They clasp hands, with Gogol's monument as a background, and look at the White House!—for at this point, we cut in a segment from an American film, The White House in Washington. In the next shot they are once again on the Boulevard Prechistensk. Deciding to go farther, they leave and climb up the enormous staircase of The Cathedral of Christ the Savior.[1] We film them, edit the film, and the result is that they are seen walking up the steps of the White House. For this we used no trick, no double exposure: the effect was achieved solely by the organization of the material through its cinematic treatment.
>
> (Kuleshov 1987, 52)

Finally, a third experiment, *The Ideal Woman*, depicts the figure of the perfect female, although she does not exist in reality. This was achieved through the splicing of close-ups of different parts of the bodies of various women taken from distinct film footages.

> By montage alone we were able to depict the girl, just as in nature, but in actuality she did not exist, because we shot the lips of one woman, the legs of another, the back of a third, and the eyes of a fourth. We spliced the pieces together in a predetermined relationship and created a totally new person, still retaining the complete reality of the material.
>
> (Kuleshov 1987, 53)

This early evidence was the result of Kuleshov's interest in investigating the psychological bases of cinema and its effects. Although his work is of a practical nature and not backed up by the necessary theory, he has become an indispensable reference in the study of montage, even being adapted for reworking by other filmmakers and film theorists.

Arnheim: Classification by Categories

Rudolf Arnheim developed a cinematic theory based on Gestalt psychology and the German Psychology School, which has its origins in the twentieth century. In his book *Film as Art*, he proposes a classification based on the four main categories of montage: the cut as a basic tool and the possible relationships between space, time and subject. Arnheim's proposal takes into account the three main areas of montage. The first of these is *storyline adherence*, which is the capacity of montage to shape and build the guiding thread of the discourse and the message's narrative coherence. The second—*reproduction of reality*—concerns the way different processes and narratological techniques (the third area) make it possible to control and recreate the message's spatio-temporal dimensions (see Figure 2.3).

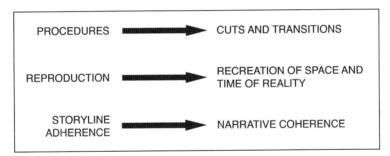

Figure 2.3 Montage categories according to Rudolf Arnheim

(Source: author)

In turn, in the area of *Procedures*, Arnheim makes a breakdown of the expressive function of the cut as a linking device, which is, in turn, applied to the construction of the relationships between space, time and the film's subject matter. This gives rise to the first classification, in which the uses of different montage techniques are divided, albeit generally, i.e. without considering the contents of the image, but simply as techniques to build a certain relational effect that can be recognized by the viewer.

As can be seen in the first column in Figure 2.4, cutting is regulated by the length of the shots, and is applied afterwards to the temporal and spatial articulation of the sequence. The second and third categories act as larger structuring devices that serve to build an impression of time

Principles of cutting	Time relations	Space relations	Relations of subject matter
Length of the cut units 1. Long strips. 2. Short strips. 3. Combination of short and long strips. 4. Irregular.	Synchronism 1. Of several whole scenes. 2. Of details of a setting of an action at the same moment of time.	The same place (though different time) 1. In whole scenes. 2. Within one scene.	Similarity 1. Of shape. 2. Of meaning.

Figure 2.4 Montage procedures proposed by Rudolf Arnheim

(Source: author, based on Arnheim 1986)

Montage of whole scenes	Before and after	Changed place	Contrast
1. Sequential. 2. Interlaced. 3. Insertion.	1. Whole scenes that succeed each other in time. 2. Succession within a scene.	1. Whole scenes 2. Within one scene. 3. Neutral.	1. Of shape. 2. Of meaning.
Montage within an individual scene 1. Combination of long shots and close-ups. 2. Concentration. 3. Proceeding from detail. 4. Long shots and close-ups in irregular succession. 5. Succession of detail shots.	Neutral 1. Complete actions that are connected in content but not time. 2. Single shots with no time connection. 3. Inclusion of single shots in a complete scene.		Combination of similarity and contrast 1. Similarity of shape and contrast of meaning. 2. Similarity of meaning and contrast of form.

Figure 2.5 Montage schema proposed by Rudolf Arnheim

(Source: author, based Arnheim's work)

and space. The final category consists of the relationships of the subject matter on two levels: shape and meaning. In the table (see Figure 2.5), Arnheim proposes a schema for the specific processing of scenes. In addition to the length of the shot acting as a general guide, variations in camera position to represent the change in location of the viewer within the scene are included. Time continuity is achieved through the joining of

scenes or within a particular scene. It is also possible to create a neutral impression by inserting single, decontextualized actions that are then inserted within a different scene with its own internal coherence. The last category—*Contrast*—includes the contrast of similarity and meaning, which are proposed as levels, or separate structures, though nowhere is it explained how these differences should be recognized.

In our opinion, this classification is the first systematic attempt to categorize the functioning of montage based on criteria of use and order. Arnheim, in theory, tries to produce an integrated model of montage by suggesting two independent but complementary areas, which he terms *areas of action* and *procedures*, connected throughout by the potential relations in space and time. This is perfectly understandable as the author takes the premise that film narrative is the sum of different parts with scenes shot in different times and places. They are always discontinuous shots whose appearance, or "true" impression, is achieved through montage. It is interesting how, in the section *montage within an individual scene*, Arnheim delineates the potential uses of close-ups as a narrative tool to concentrate the attention of the viewer on specific parts of the perceived visual space. Arnheim also analyzes montage from different areas of intervention and attempts to define the levels of interaction between them. The possible creative combinations are also modified in Arnheim's classification in the sense that the visual treatment of a sequence can suggest the simultaneous use of various montage techniques, thus giving rise to *bidirectional* schema, which may prove to be useful as it allows the associations and their effects to be linked with the different levels of the procedure. This system allows spatio-temporal relationships to be established that correspond to the narrative relationships, and also combinations based on relations between spatial dimensions, with the size of the space represented with a narrative clarity. Another valuable aspect of this proposal is the ability of its different levels to interact, which allows a strictly temporal dimension of montage to be incorporated within the classification in which ellipses, *flashbacks, flashforwards* and *retrospective scenes* fit perfectly in the construction of real time into a new, filmic time. Similarly, the direct connection established between the *cut* and the continuous action is an indicator to relate the cut with the linear continuity, while the dissolves and other transitions of the image's *progressive montage* are resources preferentially applied to discontinuous, or non-linear, visual forms that continuously incorporate breaks or jumps in the perception of the spatio-temporal fluidity.

Pudovkin and Continuity

Whilst Arnheim's model is a cinematic concept based on the narrative potential of montage, Vsévolod Pudovkin's proposed theory is based on the analogy between film and literature and theatre. He states that

for the poet or writer the individual words are the raw material. These words, in turn, acquire further meaning through their interaction with other words in a phrase. Thus, this meaning, along with its effect and value, is not fixed until the work is finished. And, in his opinion, the same thing happens in film: for the director, each individual scene represents what for the poet is a word, and with them can create a nearly limitless variety of "montage sentences" that then give rise to the product itself: the film.

> The entire script is divided into parts, which are divided into epi-
> sodes; episodes into scenes, which themselves are the product of a
> whole series of pieces shot from various angles. Such pieces are the
> primary elements of the film: the montage pieces.
>
> (Pudovkin 1957, 62)

Thus, the director or editor uses images to create a limitless number of possible combinations and meanings, which he/she needs to combine to fit in with the film narrative. Thus, Pudovkin sets out in four levels his *Methods for the Treatment of Material, or Structural Montage* (see Figure 2.6). These guarantee the viewer a smooth flow of the different events being shown on the screen.

Scene Assembly

Pudovkin states that the basic aim of montage is to direct the audience's attention to the distinct elements of the action, even though these may be spatially isolated by the camera during filming. Montage constructs the scene, reproducing the view of an 'ideal observer' by showing the events in detail through the series of shots and changes in angle so that they always mimic the logical and natural movements of the eye from a "perfect location." In this way the clarity, emphasis and realism, which awaken the viewer's emotional behavior, are assured. The close-ups, for example, direct the attention towards specific details and make the course of action clear. In the same way, by varying the point of view through alternating shots of different sizes and angle, the audience's attention focuses only on those elements the director wishes to emphasize. Conversely, long shots and dissolves evoke a sensation of calm and build what Pudovkin referred to as "slow montage."

Episode Assembly

The assembly of episodes operates at a second level of construction. For two scenes that occur in parallel, cutting and joining shots at the best moment has a far greater effect than if we see the two entire scenes consecutively. To better explain this, Pudovkin uses the following example:

> Two spies are creeping forward to blow up a powder magazine; on the way one of them loses a letter with instructions. Someone else finds the letter and warns the guard, who appears in time to arrest the spies and save the magazine. Here the editor has to deal with the simultaneity of various actions in several different places. While the spies are crawling towards the magazine, someone else finds the letter and hastens to warn the guard.
>
> (Pudovkin 1957, 43–44)

In this example, the combination of the scenes is a perfect analogy between camera and observer, since the attention of the viewer is shifted again and again between the spies and the guards. Through this procedure, the suspense increases dramatically, which translates into a progressive increase in the viewer's attention as the scenes develop. This is achieved by showing, through montage, the three key moments: the spies creeping along, the loss of the letter and finally the person finding it. Pudovkin claims that a film is not just a collection of several scenes with an independent theme, but a series of different scenes that are linked by montage to create an integrated sequence that is perfectly continuous and coherent in itself.

> One needs to learn that montage is real, an obligatory and deliberate directing of the viewer's thoughts and associations. If an uncontrolled combination of pieces is assembled, the viewer will not make anything of it. However, if the events are coordinated according to a definite chosen course or conceptual line, they will excite or calm the viewer depending on whether this conceptual line is frantic or serene.
>
> (Pudovkin 1957, 73)

Assembly of Acts

At this third level of construction, Pudovkin refers to the filmic units that equate to the acts in a theatre play. Acts are formed by a series of episodes that require a distinct montage procedure than the two previous categories. Rather than focusing on the visual variety of the scenes and the emotional guiding of the viewer through juxtapositions, the *assembly of acts* centers on the way the filmmaker articulates the series of episodes based on the structure of the film's script.

Script Assembly

Script assembly is the final montage process. The director already knows the length of the individual units—scenes, episodes and acts. The task now is to articulate all of these into the final product: the film. At this point a new factor is introduced: *dramatic continuity*. The continuity of the sequences, when reassembled, depends not just on directing the attention from one place or another, which would be obtained by joining the already

edited segments one after the other, but on the film's inherent dramatic structure. For this, it is important to bear in mind that a film always has its greatest moment of tension towards the end and, in order to prepare the viewer, it is especially important to make sure that they do not suffer from "dramatic burnout" beforehand.

The following table (Figure 2.6) shows the operational levels of Pudovkin's structural montage and the specific procedures employed in each one.

Structural assembly
Scene assembly Ideal observer Close-up shots Rhythm: duration of shots
Episode assembly Parallel montage Analogy: Observer-camera
Assembly of acts Partial dramatic articulation
Relational assembly Dramatic structure and continuity

Figure 2.6 Vsévolod Pudovkin's structural montage model

(Source: author, based on Pudovkin's work)

Pudovkin's proposal is formulated from the structural perspective of the four units according to which a film's discourse is organized. Each unit consists of one main procedure, although these can be applied indirectly to the others. Thus, Pudovkin expands on the notion of the *ideal observer*, proposed by Arnheim, and the camera-observer analogy, as elements to be used to monitor and manage the film's discursive coherence. Continuity and dramatic emphasis are the fundamental elements in the main units (acts and script) to strengthen an impression of reality powerful enough to convey emotional states. In this respect, Pudokvin's model is unique in the special importance he places on the concept of rhythm, not as a mere physical or metric question of the length of the shot, but as a factor in the fundamental dramatic and emotional control of the film's narrative.

Vertov and Correlations and Intervals

Dziga Vertov conceived the *Interval* or correlation—which Marcel Martin later retermed Relational Editing—as a set of mechanisms aimed at creating relationships, based on the movement of the image, between images and the transitions that link one visual impulse with another.

The progression between images (visual "intervals," visual correlation between images) is (for the cinema-eyes) a complex unity. It is made up of the sum of the different correlations, the main ones of which are:

1. Correlation of the shots (long, small, etc.),
2. Correlation of the shooting angle,
3. Correlation of the movements within the images,
4. Correlation of the light, shadows,
5. Correlation of shooting speeds.

<div align="right">(Vertov 1974b, 213)</div>

The correlations form the basis for establishing the order of the succession of the scenes and, subsequently, the length of each image taken separately (screen time and viewing time), taking into account each "interval" in addition to the movement between these two adjacent images. The underlying visual relationship of each image with the other images defines a correlation parameter as a stimulating component, since the unions of the scenes are fundamental and are selected by considering the contrast of their internal formal features, that is, the differences perceived by the observer. We believe that with the concept of Correlation, Vertov succeeds in getting to the raison d'être of montage, since the associative exercise of its different procedures is based on the principles of compatibility between what is shown on the screen and the viewer's associative and recognition capabilities, something that is corroborated by other researchers. We believe this new model of montage does not undermine previous models that focus on the message's narrative or dramatic attributes. Rather, it strengthens and enriches them with a protocol of fundamental relationships of construction.

Eisenstein

Eisenstein's theory of cinematography takes a multidisciplinary approach between cinema, theatre, psychology, art and other forms of expression. All of these concepts are unified with mathematical rigor, Hegelian dialectic fundamentals and Marx's materialism. Throughout its evolution, we can discern three milestones that mark the model and spirit of his dialectic concept of montage.

First Milestone: Proletkult Theatre—Attractions

The concept of *attraction* implies a breaking of the traditional schemas of theatrical staging. Throughout his time in *New Theatre*, Eisenstein carried out a series of experiments to test the parameters of space and time in the conventional theatrical scene through a hypernatural staging. These

included off-stage actions to allow the actors to interact with the audience and to bring them closer to the representation's sensorial reality (perceiving weak sounds, visual details, etc.) or even doing away with the word and communicating via gestures, mimicking and contortions (Eisenstein 1999a, 15). It was, thus, a form of scene montage, but one whose logic would inevitably lead to its application in cinema.

> Attraction (in our definition of theatre) is any aggressive moment in it, that is, any element that awakens in the audience those senses or that psychology that influences their sensations, any element that could be verified and mathematically calculated to produce certain emotional shocks in an appropriate order within the ensemble, which is the only means through which the final ideological conclusion is made perceptible.
>
> (Eisenstein 1974b, 169)

Second Milestone: Kabuki Theatre—Hegelian Dialectic

The second key moment for the development of the ideas regarding Eisenstein's theory of montage occurs in his encounter, through theatre, with Japanese culture. Eisenstein takes from Kabuki the concept of the ideogram and incorporates it into the cinematographic grammar. The meaning is the product of two elements, $a + b = c$, but not simply as a sum of both. In other words, we obtain a new, distinct meaning, which is the product of the union or juxtaposition of the parts. Thus, for example:

$$dog + mouth = barking$$
$$mouth + baby = crying$$
$$mouth + bird = singing$$

This concept is central to Eisenstein's theoretical concept of montage. While Kuleshov perceives montage as a construction of continuity and the scene as simply a "brick" in this construction, for Eisenstein, by contrast, montage is a vital mechanism for the production of meanings and relationships that arise as direct consequence of the effect of the encounter and opposition of the elements. From this perspective, montage only appropriates and combines, within the temporal physical parameters of the sequence, an organized series of sensorially relevant visual substances that selectively show a part of reality, expressing certain previously established ideas.

Third Milestone: Art, Literature and Philosophy

In his final phase, Eisenstein abandons his dialectic pretension and focuses on cinema's esthetic and rhetorical functions, understanding them in their

global dimension as a process of artistic creation. He uses various rhetorical procedures from literature, such as the concept of concordance of Tolstoy, which he applies to the treatment of image and light. He also makes use of Delacroix and Cézanne's structural concept of pictorial space, Descartes' rationalism and Kierkegaard's figurative generalizations. According to Eisenstein, cinema is still an *new art* and, therefore, it is necessary to turn to the knowledge of more consolidated and formalized disciplines. In his essay *Montage and Architecture* (2001b), he develops, for example, a structural dialectic theory of the visual scene based on the architectural models of Choisky and Witkoowsky. In this regard, the composition of the scene, its plastic richness and the movement of the scene are selected according the clashes and contrasts between the film's different levels. For Eisenstein, thus, a meticulous control of all the scene's important elements is accomplished, such that the new interactions through the juxtapositions of these scenes, at the level of montage, are able to project in the mind of the audience any construction of meanings, whether directly linked or not to the underlying expression of the film's storyline.

The birth of sound films and the arrival of color were two of the great developments that appeared at the height of Eisenstein's mature era and, therefore, prompted the beginning of new expressive explorations based on a new model of cinematographic construction: audiovisual. This new advance entailed the creation of a new concept of montage—*vertical montage*—which is based on "vertical" relationships between image and sound. According to this model, an image represents a mix of impulses that determine the sound and, conversely, a sound conditions the duration and meaning of an image. For Eisenstein, the link between image and sound is produced by using movement as a linking element, which constitutes the *lingua franca* of synchronization, generating a new typology termed *chromophonic montage*.

In *Alexander Nevsky* (1938), Eisenstein first constructed the visual strip and then, over the finished product, Sergei Prokofiev composed the music.

In this example (Figure 2.7), Eisenstein produces a detailed script in which he defines the key moments in the image and the way it should be accompanied by music in order to articulate a process of audiovisual combination. The image's dramatic effect is brought about by the increase in the intensity of the music. The four chords preceding the moment of synchronization mark a slow rise in tension. However, they coincide exactly with the viewer's sight falling on the points of interest in the image. In other words, in frame 3 the image shows an action that moves to the right and the music reproduces this sensation of movement in frame 4. At this moment, the image possesses a composition that is completely horizontal, as does the music. This fusion, according to Eisenstein, coincides with the emotional evolution of the sequence, generating a sensorial semantic area between image and sound.

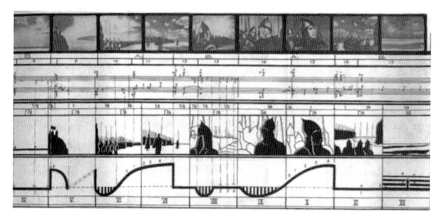

Figure 2.7 Audiovisual strip from the film *Alexander Nevsky* (1938), by Sergei Eisenstein

(S. Eisenstein © Mosfilm)

Methods

In his article *Methods of Montage* (Eisenstein 1999c, 72), Eisenstein defines five categories into which all the unifying procedures between shots can be classified.

1. *Metric montage*: Metric montage is based on the absolute length of the shots and follows a formula similar to the measure of music. The process consists of repeating these rhythms. Tension is produced by shortening the length of each shot. In this type of montage, the content of the shot takes second place to the shot's absolute length.

In the sequence from *October* (1927) (Sequence 2.5), corresponding to minute 15, Eisenstein follows a strictly metric schema in which he introduces a perceptive-sensorial process. The first three shots (1–3) are of exactly the same length and the meaning of the series is gained once the three have been shown. The length of the shot does not aim to arouse nor determine in any way an individual interpretation. Rather, it constitutes a serialized, metric filmic form. This way, any possible objective evaluation of any significant internal attribute or element is dispensed with. In the following scenes (4–9), the action accentuates a markedly accelerated rhythm: the shots progressively shorten and the images interconnect with one another, figuratively producing a single image and a single, definitive semantic meaning. The close-up of the canon followed by the sign in two different sizes symbolizes the Tsarist power. The camera in these two shots (4–5) brings about a slight change in perspective, generating, through the fusion of both images, an impression of subjective movement

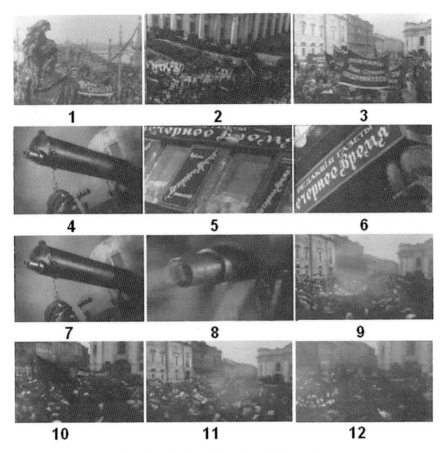

Sequence 2.5 Scene from *October* (1927), by Sergei Eisenstein
(S. Eisenstein © Sovkino)

from completely static elements. The last four frames (9–12), which possess the same metric rhythm, return to the initial action, thus bringing about a dialectic twist in the plot, inserting and linking it with the physical length of the scene's stimulus, but now causing a slight alteration in perspective. In this way, the image ends up incorporating the observer's vantage point in a perspective that assembles each of the symbolic elements of the representation of the popular uprising.

2. *Rhythmic montage*: The length of the shots is determined by the content and movement of the frame. In this case, there is an "effective length" that differs from the metric formula. This is derived from the characteristics of the scene and its length, the latter being determined by the overall structure.

In the fourth act of *The Battleship Potemkin* (1925) (Sequence 2.6.), "The Odessa Steps," at minute 50, which shows the clash of two groups, Eisenstein develops his strategy of rhythmic montage, focusing mainly on the meaning of the plastic elements and the action's direction. The sequence alternates differently sized shots. The interconnection of parallelism is brought about primarily by a child who, helpless and crying, appears in the middle frame, alone and desperate (1). However, this shot is an excuse to justify the plot's thematic idea, since it appears only to direct the viewer's attention. This can be seen in how the shots are precisely alternated: the terrified woman (2), the dead woman dressed in black on the stairs (3), another woman with a bleeding eye (4). In addition to producing an external force through its perfect combination, the value of this sequence is in maintaining an impeccable logical and chronological order of action. In the following shots we can see that the action focuses on the baby in the pram (5), the dead mother (6) and successive parallel intercuts (7–10). Finally, a sharp cut to close-ups of the attacking

Sequence 2.6 A battle scene from *The Battleship Potemkin* (1925), by Sergei Eisenstein

(S. Eisenstein © Sovkino)

soldier (11–12) leaves the battle's conclusion momentarily in suspense. We can see that the figurative meaning of the entire sequence comes from the conflict between the two main actions. The dramatic effect is intense and is heightened by the music and the rapidity of the shots.

The Battleship Potemkin is an emblematic example of the fusion of form and content in which the evolution of the image produces both an objective and subjective interpretation for the viewer. This capacity for emotional activation through montage is a central component in all of Eisenstein's film and undoubtedly had been underexplored by directors until then, even in the USA.

3. *Tonal montage*: Movement is perceived in a wider meaning, encompassing all the perceptible components of a shot—light, shadow, the position of objects and composition of the framing—producing the shot's *emotional sound* or a general *tone*. For example, in the steamship scenes from *The Battleship Potemkin* (1925) (Sequence 2.7), in minute 67, the montage treatment is exclusively based on the shots' emotional "tone." On top of this is a barely perceived *secondary dominant*, seen in the agitation of the water, the slight rocking of the buoys and anchored ships, the slowly rising steam and the seagulls that settle lightly on the sea.

Sequence 2.7 Steamship scenes from the *The Battleship Potemkin* (1925), by Sergei Eisenstein

(S. Eisenstein © Sovkino)

4. *Overtonal/Associational montage*: Overtonal montage constitutes the highest level for generating meaning and is the culmination of all the requirements of each scene. It is basically "a montage of physiological and overtonal sounds" in which the *tone* is understood as a rhythmic level and arises from the conflict between the scene's main tone (dominant) and the scene's visual harmony.

Along with the vibrations of the dominant basic tone, a whole series of similar vibrations, called high and low tones, come to us; they clash with each other and both, in turn, clash against the basic tone, which they envelop with a host of secondary vibrations.

(Eisenstein 1999c, 65).

5. *Intellectual montage*: This form of montage encompasses several levels of expression, from the most basic to the most complex and elaborate categories of meanings. The associative dynamic takes the "attack" to the real heart of matter. Thus, according to Eisenstein, cinema is "capable of building a synthesis of science, art and class militancy," as can be seen in the following sequence from *October* (1927).

The allegories set out by Eisenstein in this sequence (2.8), found at minute 31, lie in the exploitation of the intrinsic aggressive characteristics of the different forms of selected objects in order to assemble the

Sequence 2.8 Intellectual montage in *October* (1927), by Sergei Eisenstein

(S. Eisenstein © Sovkino)

montage. Different levels of analysis emerge as a result of the combinations of similarities and contrasts of figurative religious values that have negative connotations, and other symbols associated with power. We can see how, after the long shot of St. Petersburg's palace (1), the image of Christ appears in a low-angle shot (2), along with close-up shots that progressively transform through the deliberate blurring by the camera, but at a level perceptible through a few attributes of texture. Then the palace dome, also slightly out of focus, is shown but now from a tilted shot from two positions (3–4) in order to connote the political and social decline of the Tsarist regime. Shots 5 and 6 show a slight variation brought about by the arrangement of the light and shade on its surface and evoke a highly accomplished concept to highlight the slow progress of the conflict.

The differences between the two are very evident. While frame 5 is well-lit on the left-hand side, frame 6 shows clear contrasts in light and shade, since the lighting angle reinforces the sense of volume and the object's relief, clearly expressing a temporal degradation of forms and objects representative of Tsarist decadence. The following shots form part of the same semantic group, even though they appear to be different. A series of sculptures are seen in successive static shots, showing different details. Through montage, this process creates an illusion of external movement produced by the synchronous rhythm of sound and image, thus producing an aggressive ensemble through the short, atonal sound of the musical motif. It is worth remembering that there is no dialogue or melodious music here, only a series of metric gong beats, which serve to mark the change of shots. However, this is not an example of metric montage but of intellectual, as the timing of the music beats is determined by the evocative power of the image and the cuts between the shots, leaving a sufficiently prudent interval for their thorough interpretation. It can be seen how the foreground shots are composed by employing lighting that follows an expressionist pattern. After two unusual shots of the palace facade (always relating the actions' spatial axis so that the viewer does not lose sight of where the scene came from), frame 8 shows a close-up shot of the face of a statue of a Chinese emperor. Lighting from the front creates pronounced shading in the central part of the face and head, suggesting a fundamental breaking of him, his figure and what he represents. The definitive death of the regime, represented by a sickle dividing the highest icon of power, puts an end to the tyranny once and for all. The sequence of shots forms a giant mosaic. Frame 9 continues the impeccable photographic process by showing the body and legs of a statue seen in the previous shot. In a further religious jibe, the following three frames (10–12) depict the Buddha, suggesting the decline of the regime by resorting to an intentionally ironic image combined with a derisive mask. These last three frames emphasize the meaning in showing the deterioration and breakdown of the dictatorship.

In another memorable sequence from *The Battleship Potemkin* (1925), which comes immediately after "The Odessa Steps" in minute 55, Eisenstein presents three shots of the Odessa theatre lions (see Sequence 2.9).

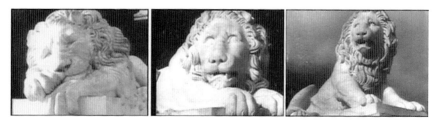

Sequence 2.9 The rising lion in *The Battleship Potemkin* (1925), by Sergei Eisenstein (S. Eisenstein © Sovkino)

The first shows a sleeping lion. The second shows a lion, but this time awake and head raised. The last shows a standing lion roaring. Seen in rapid succession, the three lions appear to be one and seem to confirm that inanimate objects quickly become real. This montage technique is an interesting gauge of Eisenstein's interest in controlling both the musical rhythm and the image's progress. The stone lions may be the most evident symbols in the film: they are used by Eisenstein to show the awakening and fury of the uprising to overthrow the Tsarist troops and start a new era in the country's history. This montage technique is a recurring theme in several scenes in his films. The use of close-ups of objects and static elements is intended to produce a visual sensation of subjective movement of the image. For Eisenstein, the movement is not just objective. We do not necessarily need to *see* the elements move on the screen but, rather, the impression of static forms evolving over time, generating in themselves an intrinsic subjective movement, which can be even more powerful for our imaginative projection, since, according to Eisenstein, the object's symbolism challenges our minds, provoking thought, generating rhetorical figures that are more intense than the purely denotative image, thus leaving the spectator totally free to develop his/her own subjective interpretative schema and to even discover new meanings through his/her individual intertextual analysis.

Eisenstein's visual and combinatorial concept (see Figure 2.8) is seminal in the development of film theories and montage throughout history. Whilst it is certain that the previous ideas and methods have their own antecedents, in other psychological theories and especially models based on theatre, Eisenstein manages to reach a much more precise level to define the set of expressive, esthetic and communicative functions and capacities. Eisenstein's methods were conceived to exploit to the maximum the totality of internal elements that produce a mobile, audiovisual image, which are carefully dissected to fully take advantage of them during the montage process. Obviously, however, it is not a random and unjustified

Figure 2.8 Sources of influence and effect for the creation of Eisenstein's Methods of Montage

(Source: author)

assignment; the value and meaning of each component of the filmic expression is carefully compared to and founded in the theoretical bases of other consolidated disciplines that, in this case, nourish cinema's expressive capacity. As we have seen, Eisenstein's innate ideological basis takes its sustenance from experimental theatre, Kabuki, Freud's psychoanalytical models, Pavlov's behavioral theories, Tolstoy's narrative techniques, Scriabin's musical structures and the impressionist chromophony based on Claude Debussy's ideas. The following diagram attempts to show the various esthetic influences that formed the basis of his Methods of Montage and the type of effect they aim to produce in the viewer.

Béla Balázs: Literary-Theatrical Models

The Hungarian dramatist and filmmaker Béla Balázs developed a categorization of montage as part of his *Theory of the Film*, published in 1949. From a clearly theatrical and literary perspective, he analyzed a selection of films made between 1923 and 1932 in which he devised nine categories of montage:

1. *Continuity of form and atmosphere montage:* This consists of the recreation of parallel actions between scenes, such that they alternate with each other. Such a technique is used to preserve the physical continuity of the events by avoiding interruptions for the viewer when passing from one image to another when these correspond to different spaces. This typology is the formalization of *parallel montage* established by David Griffith (discussed earlier in this chapter). In this method of montage, actions can be seen that occur in different spaces and times but that have an interconnection through the storyline, which makes the sequential and fluid harmony possible.

2. *Ideological montage:* This occurs when a succession of images creates relationships in a particular direction, evoking psychological associations between the images or representing those created in our minds.

3. *Metaphysical or metaphorical montage:* When an association between two images brings about a new concept or a meaning equivalent to a metaphor.

4. *Poetic montage:* At the most profound level, poetic montage establishes associations or literary effects through the union of images. To explain it, the author gives as an example a sequence from the film *Mother* (1926), by Pudovkin (see Sequence 2.10):

> The first revolutionary march by the workers in the street is accompanied by a series of images inserted between the revolutionaries: snow melting in the spring, water that converges, swells, crashes and froths up against the banks ... This relationship between the images is a process of psychological thought.

Sequence 2.10 The film *Mother* (1926), by Vsévolod Pudovkin

(V. I. Pudovkin © Mezhrabpom)

In the same way that sparks fly when two charged objects come close together, in this film the union of the images provokes this associative process, in which the images verify each other.

(Balázs 1978, 93)

5. *Allegorical montage:* This is obtained when isolated images alternate with the narration with the aim of accentuating the rhythmic and emotional effect of the scenes. The allegory is produced through a visual resource outside of the story.
6. *Intellectual montage:* This is the same typology proposed in Eisenstein's methods of montage. By systematically using a series of images, complex thoughts can be communicated or evoked through previously established, though publically known, conceptual symbols. These unions gain an ideological and political meaning through the specific artistic task of montage.
7. *Rhythmic montage:* This type of montage is not determined by the speed of the cuts but through a combination of the scenes' internal, dramatic rhythm and the external rhythm imposed through montage. In this case, Eisenstein's rhythmic method of montage is redefined. Balázs specifies that slow, majestic films exist with long scenes and peaceful landscapes and fast films with shots containing partial framings mounted in quick succession, but without forgetting that this internal content should be immediately identifiable for the viewer.

The prior condition for a rapid montage, in which images remain before our eyes for less than a second, is that the viewer is capable of recognising the images. This capacity is the result of a highly developed film culture and the consequence of quick perception through our senses.

(Balázs 1978, 95)

8. *Formal montage:* This is the result of the combination of the internal content of an image and the content of the other images that make up the visual sequence. Whilst a film is assembled on real content, in formal montage we must consider the expressive strength that arises from the combination of both structures. However logical the transition from one shot to another, this transition would not take place without obstacles such as a visual contradiction between the images.
9. *Subjective montage:* Similar to the concept of subjective framing, montage may opt for an analogous procedure. In other words, showing the actions from the perspective of each character, distancing him/herself from an ideal position as an author or director.

Balázs' proposal attempts to establish a more complete classification of montage, which in turn is able to clarify some of the imprecisions and weaknesses of the early models. Nevertheless, even when new categories are included, it can be seen that their contribution is not wholly natural, since several typologies try to define already existing types of montage. There are clear coincidences between Eisenstein and Pudovkin's classifications, especially in rhythmic, poetic and intellectual montage. However, the existence of new montage typologies, all of which are associated with generating symbolic meaning, could cause confusion in identification and practical application. They are sufficiently clear when they appear in a sequence produced and designed to build and validate a montage type. However, in other situations it would not be easy to assign a classification. Furthermore, when we compare them, the differences are not so clear-cut, to such an extent that a sequence could be placed in at least two categories. For example, the third, fourth and fifth categories are, in our opinion, the least precise. Balázs' efforts to establish classifications of montage by adapting literary figures led him to devise ambiguous formulas based on the same spirit and even employing the same mechanism of associative meaning in all of them. Balázs probably intended to create a classification according to levels of intensity for the generation of meaning in which he devised a scale from the simplest to the most complex, following a criterion similar to that used by Eisenstein in his "methods." Nevertheless, this principle and its corresponding nuances may not necessarily be followed, and even less processed by the viewer, since it establishes multiple levels of specificity and difference that do not possess clear criteria of separation and allocation. *Isn't an allegory a perfectly valid literary figure for a poetic construction? And is that same figure unable to reach an ideological dimension?* In our opinion, the only discriminating factor between them is the strength of that gradation: intensity, which Balázs seems to define by levels of depth of meaning creation. However, while his orientation is clear, the model also takes into account the importance of the spatio-temporal recreation when he refers to the *continuity of form and atmosphere* or to *subjective montage* as relational strategies, which is defined by the original characteristics of the material: shots, angles and camera movements, which are reformulated to produce a new meaning through montage.

Metz: Semiotics of Montage

The film semiotician Christian Metz also analyzed montage but in a broader context as part of a theory for the analysis of fiction film. In his work *Film Language: A Semiotics of the Cinema* (1974), in which he borrows linguistic terms, he formulates a set of units and syntagmas that define a film's structure and that are regulated by montage through their different articulating operations. The main unit, the Autonomous Shot, is the

unit that shows a part of the plot and cannot be subdivided. For Metz, there are various subtypes of autonomous shot. The first is the Single-Shot Sequence and the others are Inserts, which are introduced into other higher syntagmas according to the different mode of relationship. This is followed by the Scene, which is a more compact unit similar to a theatrical scene, since it possesses a meaning of clear and compact expression. Next are the syntagmas, which are true filmic units and reproduce a complex action that is developed in several places and deliberately suppresses portions that are not connected to the dramatic meaning. These can be divided into two other types of syntagmas: nonchronological and chronological syntagmas, which differ in their temporal relationship that they establish with other units, which may be consecutive or simultaneous, as occurs with alternate and parallel sequences. In the highest level of conceptualization, Metz proposed a final typology in his model, the Episodic Sequence, which he placed within a category he termed Sequences. The episodic sequence goes beyond the conventional filmic narrative and uses technical procedures, optical effects, an excessive compression of time and audiovisual synchrony.

In this way, Metz's model seems to be too broad and complex and constantly calls for subdivisions and derivative categories, which are increasingly less precise and which correspond to a definition of levels of filmic structure and not to autonomous actions and procedures that are specific to montage. While these methods are considered associative forms organized according to a progressive ordering of their internal units, from the simple to the complex, as is usually the case, in the end they are not very practical and even less applicable. Again we find ourselves with a classification whose level of abstraction is so high that the keys to the discursive problem of montage in everyday situations remain unresolved. There are two further problems associated with this classification. Firstly, the insistence on the terminology's linguistic adhesion, which tries to excessively tailor montage based on a global concept of syntagma. And secondly, its limited application to fictional discourse, which impedes, through its own complexity, any adaption to other audiovisual messages in which these structures are absent. Jacques Aumont, possibly aware of the disadvantages and impracticality of this classification, devised an improved version of the model based on the functions of montage.

Aumont: Semiotic-Expressive Model

Jacques Aumont derives a schema that, in theory, is less complex and, it seems, can be applied to various audiovisual genres. The author starts with a two-tiered model. The higher level contains two filmic syntagmas, or *montage objects*: one superior and the other inferior to the shot. The former is subdivided to two categories. The first includes the successive

large narrative units, which are easily separable (what Metz named *film segments*). The second contains the large narrative units, which are grouped according to what Eisenstein terms "complexes of shots," which alternate between two or more narrative sequences. The inferior level is also subdivided into two further categories. The first consists of *subordinate units*, which has two further subdivisions. The first is *duration*, in other words, the scene's length is determined by its internal morphological characteristics and its content. The second is based on the manipulation of the *visual parameters*, where the filmmaker resorts to other mechanisms to attract the viewer's attention, such as *collage effects*, black and white images, and composition designs within the frame itself, although this is in reality a procedure carried out prior to montage.

Forms of Montage Application

Aumont, thus, proposed forms of montage application (see Figure 2.9). These are the different areas in which montage can have a direct effect. The first corresponds to space and consists of the simultaneous occurrence of visual elements and distinct sounds that are ordered into units through montage techniques. Credit should be given to Aumont for incorporating sound directly as a component of significant character, in addition to other mixing, superposition and image fragmentation operations that entail "a fragmentation of the screen," none of which had been contemplated in previous models, which only focus on the visual system. For its part, *order* involves the relationships established between the distinct film units, such as shots, sequences, etc., and the transition mechanisms used to make the change or step from one image to the other flow in such a way that projection prevents *jumps* or significant variations between scenes being perceived. Finally, establishing the scene's *duration*, or its screen time, allows the creation of the so-called *montage effect*.

SPACE (JUXTAPOSITION)
ORDER (SUCCESSION AND LINKING)
TIME (DURATION)

Figure 2.9 Jacques Aumont's application of forms of montage

(Source: author)

In another phase of his formal schema (see Figure 2.10), which can explain all real cases, Aumont establishes a new category, the *functions of montage*, which is divided into three broad practical application fields.

Thus, the author devises a new method of approach to montage, which we could define as a process of *multi-stage organization*, in which *mounting* entails simultaneously attending to various issues and carrying out various functions.

Syntactic functions	Semantic functions	Rhythmic functions
Linking effects	Creation of denoted meaning	Temporal rhythms
Alternation effects	Creation of implied meaning	Plastic rhythms

Figure 2.10 Functions of montage according to Jacques Aumont

(Source: author)

Syntactic functions: These constitute the linking procedures to guarantee the flow and progress of the action. The Linking Effects are used to join scenes belonging to the same discursive unit, while the Alternation Effects are those that give coherence to the larger units, such as sequences, and to the restructured meaning of a sequence based on the parallelism of two actions separated in reality but joined in the film's narrative.

Semantic functions: These are those functions explicitly aimed at the creation of sense and meaning. They can be of two types: Denoted Sense, or directly inferred from what is seen or heard of the action or characters; and Implied Sense, which is inferred from the meaning produced by the linking procedures and the specific organization of the film.

Rhythmic functions: There are two types of rhythmic functions. Temporal rhythm is the recreation of filmic time through montage in which a structure conceived in the script is expressed in practice through montage when the individual parts are joined sequentially. Plastic rhythms are created through the objective differences that arise in content, chromatic values and light that exist between shots when joined.

Aumont preferred to distance himself from the formulation of methods, since categorization implied a more limited contribution due to the rigidity of defining procedures so strictly, which reduces their utility. A function-based approach is more appropriate and marks important differences with other contributions, since although he does not specify the areas of application nor make any comparisons or give examples of films, he does propose a set of functions that can be easily used in various situations in montage. In our view, the Syntactic Function is operational and involves ordering information, and subsequently forms the basis to impose meaning at the level of Semantic Function. Finally, the impression of rhythm is the product of the general organization: speed, shot length and, especially, the final impression brought about by the sequential observation of a series of edited shots. Similarly, the model can also be understood as a harmonious whole, in which the functions are achieved only if the previous functions have also been implemented correctly. If, for example, the syntactic function is not expressed adequately, the following semantic and rhythmic functions cannot be implemented correctly, and the final product will consequently be imperfect.

Mitry: Psychological Model

> If the effects of montage are based on perceptive phenomena, it is evident that montage, and montage itself, are facts that testify to a manifest intention.
>
> (Mitry 2002, 478)

Mitry developed his model based on the idea of montage as the reproduction of the mental processes that are activated by our senses the moment something is perceived. This is formalized through the work of montage, since it is the discursive articulation mechanisms that allow a credible spatio-temporal world to be built in which the observed objects are closely related to produce a single meaning. However, for Mitry, the truly useful thing is not montage itself, as a technique or operation to create a *credible reality* before the viewers' eyes, but the *effect of montage* that is obtained as a product of juxtaposition, and is truly creative when, through the use of the proportions and length of the image, it allows a new and distinct meaning to be obtained from that shown by the shots individually. Therefore, so that this *impression* is completely convincing, montage's main mission is to preserve above all else a narrative continuity, a coherent organization of the visual material whose correlation of shots gives a *single meaning* that it would not have done if it was organized any other way. The basis of this continuity is the transition from one shot to another in which detail is restored and the special unity re-established. This change immediately repairs the narrative thread by linking the elements in the same way that normal perception constructs them.

> The object of our perception is discontinuous although the act of perceiving is continuous: the frequent confusion, which comes from the continuity of perception, refers to the perceived things, whose relationships, then held by "objectives," are, nevertheless (not only in the memory but also in the immediate) reconstructed and constantly differentiated.
>
> (Mitry 2002, 474)

For Mitry, montage uniquely creates relationships and establishes differences, and only defines ideas in the parameters of an *imaginary representation*. However, although the human being, through his/her nature, establishes relationships and meanings in a visual sequence, the level of meaning that these images acquire through montage is determined necessarily through their relation to the observed story, which is a context in which our mental associations move, allowing the viewer to understand at the same time the plot he/she observes. In this regard, Mitry establishes three levels of understanding of the filmic image (see Figure 2.11), from the most simple to the most complex. The first regards perception, which

Figure 2.11 Jean Mitry's perceptive model of montage
(Source: author)

establishes a physiological contact between the image and its inevitable connection with reality. At the second level, we find the storyline and sequence of images, in which the viewers explore their desires, intentions and emotions, developing analogies between what they see and the undeniable need of their senses. Finally, at the third level, we find what certain artistic films offer, which is the construction of an abstract meaning by exploring new imaginative faculties that are disconnected from a merely perceptive link and even dispensing with plot development.

Screen Time and Perceived Scene Duration

In an attempt to establish values that allow shot length to be established, Mitry states that it is determined by the natural dynamic of space and time, where the unperceived and imperceptible relationships are invalid values and are, as such, useless. We cannot refer to long or short shots (metric length or screen time, in Eisenstein's strict sense) but to an image's *implied time*, which is the scene's physical, dramatic or psychological intensity associated with the image's internal complexity and which determines its exact screen time. It should last long enough to clearly express its content to the viewer. A scene is perceived as "long" when it is too long, that is, when it persists beyond the time required to understand what is being conveyed, or from the moment in which our interest starts to wane or even ceases, or becomes a negative value in maintaining the viewers' attention. Conversely, a scene is perceived as "short" when its brevity prevents viewers from reading its content, its meaning or it fails to convey what it intends to communicate, thus becoming an insufficient image. "Only this interest can and should determine the relationship between scenes, which should be calculated in function of the impression of the duration produced by each of them and not due to metric length" (Mitry 2002, 420).

If this impression cannot be anticipated absolutely due to the multiple conditions and variables that determine it, it can only be judged precisely afterwards, that is, during the montage stage before the image's

projection. It is, thus, a structure strongly determined by a value, an interval in which the viewer takes time to assimilate these projected visual contents.

Montage Models of Jean Mitry

Mitry also proposed a more concise classification consisting of four typologies of montage:

1. *Narrative montage*: The only function of narrative montage is to guarantee the action's continuity through the cut's invisibility. This typology represents a formalization of Griffith's method of montage, which is used as the basis for the design of Noel Burch's Institutional Mode of Representation (IMR).
2. *Lyrical montage*: Using the continuity of the actions provided by narrative montage, lyrical montage expresses over this fluidity the drama's transcendental ideas or feelings. It is the highest level of filmic construction.
3. *Montage of ideas, or constructive montage*: This is montage of the paradigm of Dziga Vertov. It takes place when montage is defined and resolved in the editing room, creating connections between the materials based on their viewing, and dispensing with a script or previously developed work that imposes a single form of construction in which montage does not have any creative involvement.
4. *Intellectual montage*: This is the same as Eisenstein's intellectual montage in that it forms the highest level that completely breaks the logic of continuity and, instead, develops a totally expressive story based on the dialectic contrasts of the scenes in an abstract phase of the representation of reality and purist imagination, in order to activate thoughts, ideas and deep feelings. This typology also includes the elements of montage aimed at evoking intense emotional reactions in the viewer through violent clashes produced by cuts between scenes.

Mitry's schema is extremely useful for two reasons. Firstly, because it includes both the figure of the creator and the viewer in the observation of the film. And, in this, value is given to the inclusion of the message as central to the common synergic process, which ranges from the cognitive to the perceptive, thus making it possible to identify the image's internal elements and their relationships. The combining of associative operations leads us to understand the exact meaning, which is inextricably tied to what is seen and heard. In this regard, it is the first time that the concept of the scene and its duration are analyzed with such thoroughness in a film theory. As we have repeatedly seen, the approach to

scene duration has been from a metric perspective and, whilst Eisenstein formulates more precisely the concept of rhythm when he refers to the relationship between the duration of the scene and the duration of the actions, he fails to be sufficiently explicit in identifying the criteria that define this duration. It is, therefore, a cell and/or entity that is always variable with regard to the objects being shown but framed in an organization, form and pattern of movement with a definable expressive orientation and characteristics. In other words, the film makes a meaningful audiovisual discourse flow in time, relating a sequence of information to previous elements that have already been seen and heard along with other information at the time of the sequence. The second point that should be highlighted is Mitry's four forms of montage. Without being overly ambitious, they attempt simply to define the areas of application of montage in diverse levels of meaning construction. While Narrative and Lyrical Montage are basic and serve to conserve the continuity of actions the advanced forms, Constructive and Intellectual Montage, on the other hand, deal with the constructions of complex meaning, conserving an autonomous role for their selection and achieving specific elaborate communicative effects.

Martin: Spectator Model

In his work *Le langage cinématographique* (2015), Marcel Martin creates a theoretical model specific to montage through an extremely precise and concise study that is far from a mere repetition of previous concepts. For Martin, montage is the most specific basis of cinematographic language and its dynamic reproduces perception through successive movements of attention. The viewer's impression that the montage *has been done well* lies in the similarity that the succession of images maintains with the logical movements of human perception, something that generates an impression of "real perception." This reproduction is based on the *tension*, or *mental dynamism*, that the filmmaker attempts to maintain throughout the discourse through diverse associations that can be shown along with the character. These associations include:

1. What he sees as real and present;
2. That which he thinks, remembers and imagines;
3. What he attempts to see or what his mind projects;
4. Something or someone that is out of sight, awareness or memory.

(Martin 2015, 175)

The author establishes the existence of an interaction between three dialects that allow the *narration of stories* through film (see Figure 2.12.). The first is determined by the shot's internal composition, in which the layout

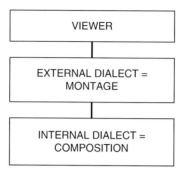

Figure 2.12 Marcel Martin's model of film dialects
(Source: author)

of the objects within the shot possesses deliberate symbolism for the film-maker. The second is the external interaction between these images and montage and, finally, the third resides in the viewer, who interprets these images, giving them a meaning and significance in terms of their referents and individual expectations.

In this way, films develop through a process in which the appearance of a new shot satisfies or complements the information that the previous shot had failed to do, developing thus a partially synthesized sequence that progresses smoothly until its end. Martin states that throughout its existence, montage has been approached from two angles: one narrative and the other expressive. "Narrative montage" is the simplest and most immediate aspect and consists of joining shots according to a logical, or chronological, sequence with the aim of relating a story, similar to that proposed by Mitry. There is also the so-called "expressive montage," based on the line taken by Eisenstein in the juxtapositions of shots, which aims to produce a direct and precise effect through the joining of two images. In this case, montage attempts to express in its own right an emotion or idea. Nevertheless, for Martin, there are three areas in which montage acts. The first level is the so-called Rhythmic Montage, which is regulated by the shots' metric length and the value of their intrinsic plastic and expressive components. The second is Ideological Montage, along the same lines as Eisenstein; that is, according to the meaning and significance produced by the relationships between these shots. The third is Narrative Montage, which is produced by the logical articulation of the scenes in a linear or even reversed sense. The following diagram (see Figure 2.13) shows the functions of Martin's three systems of montage.

By way of summary, Figure 2.14 shows the different montage models proposed by the leading theorists. Two dominant themes can be discerned. On the one hand, the Russian School, which is made up of Eisenstein's dialectic model, Pudovkin's constructivist model and Vertov's correlational model. And on the other, the French School of philosophy,

Rhythmic montage	Ideological montage	Narrative montage
Metric aspect Shot duration	Relational	Linear montage
Plastic components Internal composition	Intellectual: • Time • Place • Cause • Consequence	Reversed montage
		Parallel montage
		Alternating montage

Figure 2.13 Marcel Martin's montage models

(Source: author, based on Marcel Mitry's work)

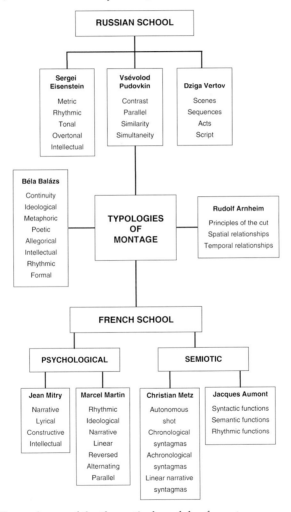

Figure 2.14 General map of the theoretical models of montage

(Source: author)

which in turn can be divided into two areas: the psychological aspect developed by Jean Mitry and Marcel Martin, and the semiotic tendency formulated by Christian Metz and Jacques Aumont. As mixed models, that is, those that bridge two main paradigms, we find Béla Balázs' literary formulation, which is closer to the Soviet schema, and finally the relational classification proposed by Rudolf Arnheim, which is closely related to the French psychological model.

NOTE

1. This was the greatest cathedral in Russia and once stood opposite the Moscow Art Museum and Lenin Library, but was demolished on Stalin's orders to make space for the gigantic Palace of the Soviets, which, however, was never built. On the site now is a large open-air swimming pool.

SPACES, FUNCTIONS AND POSSIBILITIES OF EDITING

In this chapter, we discuss the existence of certain units or divisions of film and television programs that constitute areas of reference for scene design and visual composition. Importantly, they also help to fragment storylines so that these can easily be reconstructed during the subsequent editing stage. Nevertheless, concepts can often seem confusing, depending on the author's perspective. In this chapter, therefore, we review the definitions that will allow us to clearly identify these units in order to provide a context for the application of the various editing procedures presented throughout the book.

THE NARRATIVE UNITS

Scene

The term *scene* is basically associated with the action or a part of the action that takes place in a particular time and space (Martin 2015, 178; Sánchez 2003, 62; Quinquer 2001, 157; Comparato 1993, 151; Comparato 1988, 147). A scene is composed of one or a group of shots (Casetti and Di Chio 2009, 139; Vale 2009, 47; Sánchez 2003, 62). For Eugene Vale "its length is not determined by physical needs but by the requirements of the storyline" (Vale 2009, 47); in other words, for reasons of drama, and to accommodate the changes in the number of characters as they enter and leave a particular scene. For David Bordwell, a scene is "a segment of a narrative film that takes place in a space and time or that uses parallel editing to show two or more simultaneous actions" (Bordwell 1995, 493). A scene, thus, is defined by the action and the space in which it takes place. It involves showing an entire event or one that has been deliberately interspersed by other scenes or storylines, thereby generating suspense until the story is picked up again. Similarly, disagreement has arisen over assigning parallel editing to this category, since the action occurs simultaneously in time but takes place in different spaces or settings. In terms of the storyline, a

scene is a unit in its own right, but from the point of view of production planning it can be created over different shoots to be joined later in the editing room.

Sequence

A sequence is commonly defined as a true film unit and in this respect it differs from a scene. "It possesses a complete meaning and is made up of a series of scenes or shots" (Martin 2015, 178; Sánchez 2003, 62). For David Villanueva, a sequence is an "identifiable intermediate unit in a storyline with an internal coherence that is not independent but integrated within the greater ensemble" (Villanueva 1992, 181–201). Michael Chion defines it as "a series of scenes grouped according to a common idea, a block of scenes" (Chion 2001, 147). Like its temporal length, the definitions of a sequence are equally varied. For Christian Metz, a sequence "presents a given number of short scenes that are in most cases separated from each other by optical effects (dissolves, etc.) and that occur in chronological order" (Metz 2002, 152). And, for David Bordwell, a sequence is "a moderately long segment of a film that shows a section of complete action. In a film, it often equates to a scene" (Bordwell 1995, 496). In a more generalized attempt, Lluis Quinquer tries to connect its meaning with the storyline's structure independently of the number of scenes making up the film: "each new place, each new setting, is a sequence. A sequence can be composed of a single scene or by various scenes that make up a dramatic structure" (Quinquer 2001, 158). A sequence is, therefore, formed by a set of scenes or shots that have dramatic coherence. Although these can take place in various physical spaces, they are connected by the movement of the characters or the storyline.

Shot

For its part, the term *shot* is universally used and agreed upon in the audiovisual world and is defined as the *smallest unit representing reality* whose content is associated with the space-time represented. In contrast to a scene or sequence, which are units mainly associated with a story's structure in terms of its plot and drama, the term *shot* refers to the portion of reality that is composed and recorded in order to form part of a scene or sequence. It therefore possesses a physical essence, since it corresponds to the time of the action shown or to the length finally assigned it by the editor such that it fits into a series of shots making up a film scene or sequence. For semiologists, a shot, and the filmic image in general, constitute highly polysemic expressive entities; in other words, they have more than one meaning. Nevertheless, in general, the explicit content of a shot—the visual representation—corresponds to actions, objects and elements that are real or that are based on logic and the natural conventions that either

usually happen to us or that we are easily capable of deciphering in order to understand them. This allows the audience to follow a film's storyline and to believe that the series of shots being shown attempts to reproduce a specific event from a logical order sufficiently well articulated that it can be understood.

Any possible confusion that occurs in attempting to define these units is the result of the structure of production genres and message formats and their development over time. A scene and a sequence are, in fact, concepts peculiar to fiction production. Stories are created and shot according to a theatrical structure made up of scenes—which can be complex in themselves, with many camera angles—that are broken up for filming purposes. However, these units do not have the same value or use in other areas, such as news or advertising, where fragmentation from a narrative perspective simply occurs through the use of shots recorded in different locations. Moreover, the current rise in new audiovisual formats for entertainment—small-screen animations, interactive formats and presentations—has been accompanied by new concepts in the use of audiovisual language that highlight the limitations of the practical functioning of narrative units in their conventional sense. Dislocated stories, short episodes, expressive explorations at the limit of the imagination and time, quite apart from the use of multiscreen effects, render impractical some of the theatrical limits and concepts, script formats and routine production practices that, when applied to other non-drama contexts, do not work as effectively.

EDITING AS A CREATIVE PROCESS

Having outlined a general framework, we now come to the problem of editing as a process. According to our operational definition, editing involves the assembly of different fragments of image and sound that are to make up a film or video. Or, as Valentín Fernández-Turbau states, "editing is a process that consists of ordering, cutting and splicing filmed material in order to create the final form of a film" (Fernández-Turbau 1994, 107). From this perspective, editing is, thus, a task that demands skilled handling of technological tools in order to manipulate and join the various shots that make up the storyline. It is for this reason that in various companies and media outlets the term *editor* is used to specifically refer to this type of professional and his/her work in analogue or digital post-production systems. Nevertheless, the process of editing, which is carried out in four main stages, is not just a process of cutting and sticking images together again: using it to its maximum communicative effect demands the professional and in-depth knowledge of audiovisual language and a capacity for the conception and creation of meaning that go far beyond mere operative skill. The next sections present step by step the process

of editing and its various contributions to the narrative improvement of storylines.

Stage 1: Selection

Selection involves choosing the various fragments of image and sound that are to make up a film, program, advertisement, etc. The selection of the material is carried out during viewing. The first phase consists of filtering out any defective material: cut, shaking or blurred shots, acting and dialogue errors, flaws in the sound recording, among others, which the producers, directors or cameramen reject after shooting or when inspecting the material in the editing room. The next stage is to select only one version of all the images and sound recordings made correctly. It is this stage that selection becomes an especially key process, going beyond mere discrimination on the basis of technical flaws: it entails employing artistic criteria of selection, including narrative desirability and value, dramatic adaption, esthetic contribution and functional use—variables that are weighed up according to the specific characteristics of the material, the scene, genre, format and communicative contribution within the general context of the product. However, the quantity and quality of the original material strongly depends on the general conditions under which it was recorded and is usually quite different in unique filming situations, such as live broadcasts, in comparison to the prepared and fragmented design layout of a film or TV program. For example, the scope of action of a cameraman filming a bank robbery from only one location whilst trying to remain unnoticed by the public is totally different to the filming of an advertisement or a chase sequence with various cameras and many takes. In the former, the speed at which the uncontrolled actions occur can make it difficult for the cameraman to find a good position from which to film, make any cutaway shots or clearly capture various actions of the news event simultaneously from different perspectives from just a single location and in conditions unsuitable for filming. The conditions for filming a fiction sequence or an advertisement are totally different: opportunities to rehearse, repeating takes until the perfect shot is obtained, composition design, lighting, the use of multiple cameras and contingency control allow a greater number of camera angles and perspectives of the scene to be obtained, which translates into better material for viewing, selecting and combining creatively during editing. These variables strictly determine the range of options for assembling a product correctly.

Stage 2: Ordering

The second stage of editing—ordering—consists of determining the exact placement of each of the selected shots within the sequence. Numerous authors assert that the ordering of shots determines the construction

of the sequence's meaning (Amiel 2014; Pinel 2004, 64; Millerson 1990; Aumont 1969, 47). During editing, the ordering of the shots has a syntactic function, generating primarily a logical, causal and progressive structure of the information. This harmonizing function is produced through the simple joining of one shot with another; in the overall result, a sequence's meaning is thus generated by successive relationships between all the shots that form it. This semantic construction can even be different or better than the original script and is the result of the exploration of different combinations of the available material. Meaning is created and guided by editing and its processes, which attempt to create ideas and sensations by reproducing the world as we experience it. The splicing of one shot to another should always convey to the audience new information and gain their interest through the causal relations established through the connections that mark a defined guiding thread. Thus, the following connections can be produced:

1. Shot A leads to shot B (sequential relation)
2. Shot A is explained by shot B (causal relation)
3. Shot A and shot B are understood through a third shot (motivational relation)
4. Shot A and shot B are the origin of a third shot C (consequential relation)

This power of the image goes beyond the narrow, unidirectional meaning evoked by the word. Its meaning is determined both by the nexuses produced through its individual value and content and the global meaning created by the new order produced through editing. The Kuleshov effect is a prime example of the creation of a relationship between shots. In the example of Mosjoukine next to three distinct shots (see page 17), the second shot conditions the interpretation of the two images. If this principle were applied to an action sequence using the same material but changing the placement of the images within the series of shots, completely different meanings would be created. Figure 3.1 shows the different versions that can be produced when three shots of differing content are ordered differently:

Shot No. 1: A moving car
Shot No. 2: A fire
Shot No. 3: An explosion

As can be seen, the main key to decoding the meaning in this sequence lies in the shot of the moving car. Its placement unambiguously conditions the idea behind the scene and what happens to the characters who find themselves in the midst of the explosion and flames. If the image of the car is the third and last in the series, we are given to understand that the characters themselves caused both the explosion and the fire. They

Editing options			
Order 1	Fire-Car-Explosion	**Meaning**	The men attempt to escape from a fire but the car explodes and they die.
Order 2	Fire-Explosion-Car	**Meaning**	The men cause the fire and the explosion and escape in the car.
Order 3	Explosion-Car-Fire	**Meaning**	The men cause the explosion but die when the car catches fire.
Order 4	Explosion-Fire-Car	**Meaning**	The men cause the explosion and the fire and escape in the car.
Order 5	Car-Fire-Explosion	**Meaning**	The men escape, starting a fire and causing an explosion.
Order 6	Car-Explosion-Fire	**Meaning**	The men escape, causing an explosion and then a fire.

Figure 3.1 Editing ordering formulas

(Source: author)

manage to plant the bomb, explode it, start a fire and flee. By contrast, if the shot of the car is placed at the start of the series, followed by the shots of the fire and the explosion, the meaning is totally different, since it is sequentially interpreted to mean that the characters are the victims of an explosion and a fire. However, the sequence's definitive dramatic effect is not brought about solely by the ordering of the shots, but by how long each one remains in front of viewer in order to evoke a realistic impression of a violent attack that conveys action, tension and a heightened sense of danger.

Stage 3: Duration

The third and last stage of the creative process of editing is to determine the exact time that each selected and ordered shot should be seen by the viewer on the screen. Firstly, the start and end of each shot should always be exact in order to guarantee the viewer three fundamental things:

(a) The smooth progress of the visual story.
(b) The creation of a realistic impression of the events shown through the series of shots.
(c) The generation of a rhythmic structure by varying the length of individual shots.

The issue of a shot's length, or *duration*, is determined by three criteria. The first is to apply a system of metric duration through the effective time a shot is shown without taking its content into consideration and which is only used to build a visual rhythm through repeated durations of the

image. The second is to consider the time required to interpret it. This is measured by estimating the time the viewer takes to absorb and decipher the content shown or expressed in the images and sounds he/she sees and hears. The third and last is determined by the shot's dramatic value and is related to the previous criterion, but in this case the task consists of regulating the shot's emotional meaning in order to construct the sequence's tempo. In other words, its suitability for showing the character's attitude, expression or reaction, or in the precise expression of realism or the character's attitude in order to reveal important details and express an effective dramatization of the story.

In order to decide how long to leave a shot on the screen, we should look at the different plastic aspects of an image that possess important intrinsic expressive values:

1. *The shot's original content*: From their conception to their filming, shots are constructed to show contents that have an informative value in which various levels of visual organization are expressively enhanced: set design, composition, color, lighting, etc. Taking into account each of these factors proves very useful in deciding combinations and constructing structures that are continuous, contrasted or alternating in time.

2. *The content to be shown*: This entails precisely regulating the time and information in order to show enough content so that the audience's interest is maintained. Cutting out part of the action at the beginning, middle or end can increase the sequence's visual dynamic by eliminating unnecessary information, or can create surprise or suspense when the following shot appears unexpectedly or is intentionally prolonged in the lead-up to the story's climax.

3. *The size of the shots*: The dimension of a shot conveys certain narrative connotations that are fairly well agreed upon amongst professionals in the film and television industry. Wider, general shots and sweeping movements by the camera are used to create descriptive context, while short takes or close-up shots are more expressive and are largely used to show facial expressions or gestures. In terms of duration, a shot's length should be enough for its meaning to be clearly understood. It should be longer if there is a lot of information or if the action, the dialogue or the movement made by the camera make it complex. Even action shots that show the same character in an identical context can be of different lengths depending on the moment.

4. *Internal movement*: A shot's internal changes can also be used expressively during editing. For example, the direction of movement of the characters or objects in dynamic actions can be used as opportunities to make cuts in the action or create contrasts between static and dynamic structures.

5. *External movement*: Camera movements, such as pan, traveling, steady, dolly and zoom, are creative angles used by the cameraman to generate expressive ways of viewing from distant perspectives or even imitating observation from other objects and directions. Big camera movements are often accompanied by dissolves to show changes in time, or by transitions that travel from the exterior to the interior in changes of scene. Both cases take advantage of the similarities or differences in the direction of movement made by the camera in both images.

6. *Duration of dialogue and action*: A simple but practical procedure that an editor can use when editing a dialogue scene is to define the length of the shot according to the natural length of the dialogue and action. If the most important thing in the artistic treatment of a scene is the action itself, the main way to control the shots and their combination is to construct a natural rhythm that shows the situation's progress through the dialogue and pauses so that the expressive elements are natural and fluid.

7. *Sound*: The final control element is sound. Understood as an expressive value, sound values represented by variations in the film's rhythm, such as the intensity and the tone of the voice or the music, can act as indicators that strengthen the image's value. Its use in specific situations will be discussed later in the analysis of sequences.

NARRATIVE CAPACITIES OF EDITING

We next look at editing as a narrative tool. We have looked at what it consists of, its stages and then some of the guiding criteria that can be useful in deciding a shot's length. We now take a look at the influence editing has on the product, its final form, and on how it brings variable information together and presents it in a single coherent unit so that it can be seen by the audience in a location and at a time that differ from where it was filmed.

Articulating

The selection and ordering of shots serves mainly to articulate a visual sequence. When just one camera is used for filming, the construction of the plot depends entirely on what editing can do. The shots may have been filmed in different times and places, but they need to be assembled one by one to create a coherent, comprehensible visual ensemble that shows only those details that need to be known by the audience so that they closely follow the action. Exploiting the relational capacities of editing serves to create clear, realistic ideas, which are essential prerequisites for the success of any subsequent communicative aim. If no prior thought

has been given to the plot's organization, any attempt to add value to the product, such as to inform, move or persuade, will be in vain, since an impression of reality will not be achieved.

Reducing

A second capacity of editing is its ability to condense. Selecting and calculating how long shots should be allows, for example, the real time of an event, which might happen over hours, days and even years, to be shortened and to create a filmic, or projection, time that is briefer, more dynamic and functional, as it preserves the story's key moments. Another straightforward example of this technique lies in the editing of news items. Broadcasting times do not allow an event, such as a parliamentary debate, which can go on all day, to be shown in its entirety. Nevertheless, editors identify the important speeches and gestures and use them to construct a summary lasting 1 or 2 minutes, thus eliminating pauses and long orations, which, from a journalistic point of view, are not interesting enough to be broadcast. Condensing ideas and actions is even more prevalent in advertising. An advertisement is capable of recreating in only 20 or 30 seconds an entire story that, in reality, takes place over a much longer time period. The ordering, the length of the shots and the moments in which the cuts take place are so precise that the viewer is perfectly able to understand both the message and any possible internal breaks in time and, despite its brevity, can follow the story's order and coherence and understand the advertisement's core idea. To achieve this, the editor can speed up the reproduction (fast motion) or use shots in which actions are at the limit of the audience's perceptive limit but show the minimum to be fully understood.

Expanding

In the same way that it is possible to condense time, it is also possible to expand or stretch time. This is an additional potential of editing in audiovisual recreation and is achieved by either including a number of shots that show the action in varied detail, including by maximizing a shot's screen time, or by using speed manipulation techniques, such as slow motion and freeze framing, through the deliberate repetition of certain shots and long dissolves. Expanding the action is also useful in cases where there is prior heightened expectation, where it would be useful to take advantage of time and to show the action in maximum detail, and occasionally repeatedly, from different angles and camera positions.

Intercutting: Constructing Causal Relationships

A fourth creative function of editing is to build different relations between shots. Editing does not create or build space or time. Rather,

it recreates situations and filmic perceptions of time and space from the relations and contrasts it establishes between the shots. This precondition for coherence is what makes it possible to aggregate the components of a message's meaning at a second level. As Jean Mitry stated: what is really creative is *the montage effect*, that is, what comes from the association, whether arbitrary or not, of two images A and B that, when related to each other, convey to the viewer an idea, an emotion or a feeling not expressed by either shot individually. We observed this in the previous section, in which we looked at the various meanings created by combining the shots in different orders and by associating looks, gestures and the location of objects. The correlation established between different elements through editing allows a relation to be filmically constructed via their similarity and to articulate an ordered sequencing of information from one or more events that, while different, are unified through their meaning.

Adding, Eliminating and Correcting

The fifth and last function of editing is perhaps its most basic and straightforward, and is what Julian Hochberg termed *cutting for economy or convenience* (Hochberg 1986). This consists of adding, correcting and eliminating portions of the action that are shown in different shots, whilst attending to the need for "visual improvement" or simply getting rid of technical or artistic errors that occur during shooting. This usually takes place during the viewing and selection of material, when decisions regarding screening and filtering are made. However, it is also carried out during the adjustment of the shots' length, since the subsequent viewing is usually the last opportunity to review how well the relations perform and to make adjustments to the series either by adding or reducing certain frames at the beginning or end of each shot.

The various functions of editing and its practical use is directly related to a film's *performance*, in that it is in the editing room where these basic details are specified and are translated into what the audience sees on the screen. Even when structuralists, staunch defenders of the script and pre-planning, attempt to minimize the contribution made by editing when they state that "editing is nothing without a good script," editors immediately hit back, claiming "without good editing, a script is nothing" or even "good editing can save a bad script and a bad shoot." Arguments aside, we believe that the various artistic and technical roles of editing need to be placed within their context and moment in the framework of the production process. Seen this way, each stage has its specific functions and contributions and if all the variables are carefully controlled and if the creative process is carried out to its maximum at each moment throughout the process of editing a film, we would probably have a competitive and, in terms of communication, effective product.

Self-study Exercises: Perfecting Editing Techniques

1. Obtain an edited sequence of a film or TV program of between 2 and 3 minutes long and carry out the following exercises:

 (a) Change only the *order* of the shots and try to either (i) maintain the original meaning or (ii) construct one or more different meanings.

 (b) Alter the *length* of each shot (in this case it will only be possible to shorten it). Pay attention to the contents. In a preliminary version, cut out the parts you consider unnecessary, and, in the second version, edit only the key actions. Check the result of both sequences from a narrative and dramatic point of view.

 (c) Construct different versions of 2 minutes, 1 minute and 30 seconds in length with the same original material. Control the exact adjustment of the timings while maintaining the action's storyline.

2. Choose original material from a sequence of approximately 2–3 minutes in length.

 (a) Repeat the three steps from exercise 1. Compare the differences between the results of working with original material and with material from a previously made sequence of a specific meaning.

 (b) Carry out a first edit, evaluating mainly the contents of the shots.

 (c) Make a second version, evaluating mainly the characters' dialogue.

 (d) Make a third version, trying to show the greatest number and variety of shots.

 (e) Make a longer version of the same sequence, using resources such as slow motion, dissolves, transitions and repeat shots.

 Compare the results of the different treatments.

3. Choose material for editing a news item of any subject matter of 1–1.5 minutes' length that contains reporter dialogue and interviews. Carry out the following exercises:

 (a) Try to improve the information by varying the order of the shots.

 (b) Try to improve the information by modifying the reporter dialogue but maintaining the statements.

 (c) Try to improve the piece by modifying the text, ambient noise and image.

AIMS OF EDITING

In this section, we take a look at the different communicative aims of editing. We explore how it contributes to expressing a series of principles and meanings characteristic of film and television programs. The question we ask ourselves, thus, is: *What should editing aim to achieve?*

To Preserve the Action's Continuity

> Montage assures first and foremost the continuity of a film. Organising the succession of the shots gives each sequence a meaning that it would not have if it were organised another way.
>
> (Mitry 2002, 423)

Continuity guarantees the visual fluidity between the shots and the sequence. During filming, the script supervisor, or continuity supervisor, is responsible for precisely recording the position, direction and speed of movements of the characters and the objects in the scene and the lighting conditions in each shot. This information is essential for the director to place the actors in their correct places, plan the scene and to guarantee that on editing the shots present a logical progression of the events. At the same time, this also serves to provide a greater number of options for precision cutting. By preserving the order, meaning and direction, the process of building the sequence will be relatively straightforward, since there will always be continuity between shots that guarantees the scene's progress through the systematic repetition of parts of the action. During shooting, margins are created by starting the recording of the next shot just before the previous shot finishes. The shots are linked together to form a sequence through the use of a procedure called the triple take (see Chapter 7). During the construction of the sequence, the editor takes advantage of this overlap in action in both shots to make a cut in fast-moving action. If filming is not planned with continuity in mind, the director and editor will run the serious risk of not being able to construct the sequence correctly, as a fraction of the movement will always be missing from one of the shots.

However, the concept of continuity is not solely limited to matching shots. If the editor or director also wants to achieve an expressive effect through cutting, attention should not only be paid to the physical continuity but also to the timing of the cut, especially if cutting at a particular point is the most appropriate from the point of view of its possible psychological effect or in terms of how much information should be shown. As Béla Balázs stated:

> He must not only see that a physical gesture begun in one shot should be continued without interruption in the different set-up of the next shot, mental movements must also flow smoothly from shot to shot if they continue at all.
>
> (Balázs 1931, 123)

Cuts should have, therefore, a purpose that goes beyond an exclusively physical function; they should aim for a narrative compression of the events whilst maintaining a logical coherence.

To Present Events in a Logically Coherent Manner

The second objective of editing is to construct logical coherence. Continuity is preserved in such a way that the assembled shots present a series of events logically, progressively and sequentially, especially if causal relationships are established between the elements presented. In this way, the viewer can be guided from the start to the end of a sequence via a rational inductive or deductive process: first the *Before*, then the *Now* and finally the *After*. However, this does not invalidate other types of non-lineal construction. Many films are structured following a schema of big temporal jumps that do not follow each other chronologically and relate to totally disparate events. However, the use of such schema is justified by the overriding needs of the storyline's structure, so long as it does not interfere with the viewer's logical and coherent interpretation. This logical coherence is achieved by respecting three rules during filming. These rules, which we look at in more detail later, are the 180° rule, the eyeline match and the 30° rule, which is the minimum variation between shots. By following these three rules, the director/editor guarantees that, in editing images of two people talking face to face, the unions maintain at all times the characters' line of vision, or sightline. Moreover, a realistic illusion that they are talking to each other in the same physical space can be created even in cases where the recordings have been made at different times.

The minimum perception of continuous change has been studied by Luca Tommasi in an experiment in which the camera positions in computer-generated animations were varied (Tommasi and Actis 1998). The results demonstrated that deliberate errors in editing generated through variations of the focal distance—jumping—are the main error in continuity in an animated sequence and are easily spotted by viewers. In terms of an audience's understanding of a plot, it is important that the joining of the shots preserves from the beginning a logical and coherent spatial configuration. Only in this way can we effectively apply the third aim of editing.

To Contribute to Narrative Clarity

Every editing operation should favor the narration of an event that is clear and comprehensible to the spectator. The organization of the shots, their length and the joining procedures should present new information at each union, with the aim of advancing the story in a certain direction and towards a specific conclusion. In order to achieve this, each shot needs to be carefully analyzed during the selection process, evaluating both their individual and combined expressive strength when placed in a series. Both operations should contribute to clearly presenting their creator's ideas through a series of smooth cuts. Paraphrasing Karel Reisz, a smooth cut entails joining two shots in such a way that the transition does not

produce a perceptible jump and that the viewer maintains the impression that they are watching a continuous action (Reisz and Millar 2003, 202). In order to achieve this, the transition from one shot to the next should not repeat or leave out information present in the first or second, or else an evident jump is generated that is perceptively jarring for the viewer.

To Generate Additional Expressive Values

The fourth aim of editing is to generate additional expressive values. This is achieved when the various transitions generate values or an additional emotional and psychological ambience. For this, the cut plays a role that goes beyond merely sticking shots together to give them an informative meaning. At the highest level of the construction of meaning, transitions act as tools to add expressive value to the overall context and the communicative aim of stories: to transmit the characters' feelings of anxiety, fear, aggression or humor, or to create suspense or terror, by selecting shots that show incomplete information, etc. Editing, thus, has capacities that cross into the strictly creative realm of filmmaking. The construction of an impression of movement and rhythm is achieved, then, through the associations between shots that make it possible to visually merge into only one perceived event two events that occurred in separate times and places. This construction can also show the transformation of a character's emotional state or simply the effect of the passing of time. Thus, we are expressing an idea via the visual association of two events that are discontinuous in reality but that are joined in the fictional recreation. This linking capacity is unique to editing; there is no way of constructing or relating two events that differ in time, space and content other than through action and the use of techniques to juxtapose images. The script and filming are incapable on their own of achieving this. Through these techniques, editing acts directly in the construction of meaning proposed by Marcel Martin: towards the creation of movement and the creation of ideas (Martin 2015, 181–183).

To Arouse Interest and Attention

An additional objective is to maintain the audience's attention throughout the film. This means that the previous aims of editing—to articulate, and to create coherence, narrative clarity and expressive values—should work together to pique the viewer's curiosity, which should gradually intensify as the storyline develops. As Timoshenko stated,

> through montage the director determines the route that guides the viewer's attention. Thus, while watching the film, the viewer is at the mercy of the director, who is able to direct their attention to one or other aspect of the action.
>
> (Timoshenko 1956, 173)

This entails emphasizing the dramatically important elements and rejecting those that are neutral, disruptive or negative to the construction of a smooth perception of increasing interest. One way to achieve this is to control the information the viewer is given. The inclusion of a shot should, therefore, be based on its suitability to satisfy the audience's expectations or curiosity. At the same time, however, the information it does show should be incomplete so as to create a sense of dissatisfaction strong enough to maintain their interest to the next shot and thereby guide them through to the end, resulting in an orderly and precise reading of the information. Thus, through the calculated management of the story's progression, the audience's attention can be maintained throughout.

To Provoke Emotions in the Viewer

The final aim of editing is to generate emotions in the spectator and is achieved through the generation of rhythm and the manipulation of the length of the images and sound, both of which aim to influence the audience's emotions. Prolonging a shot as long as possible can help to generate suspense, whereas a sudden cut can create surprise through an unexpected change. The repetition of a shot several times serves to reinforce an action's comic effect. At the same time, however, prolonging a shot excessively can have a counterproductive effect. The timing of a cut and the metric structure of a sequence of images, as we have noted, serve various functions in editing and represent two key resources in creating emotional states. This function is also controlled by the viewer's level of expectation. While much of a story's emotional and plot strength lies in the script's structure and the genre type, it is not only through these that a film achieves its artistic value, but by the joint participation of the film's other elements, such as the performance of the actors, the photography and the film's other elements, which are combined during editing in order to project with greater intensity and more effectively the various conflicts and situations being shown and their final resolution.

Self-study Exercises: Perfecting Expressive Techniques

1. Watch three or four scenes from films, TV dramas or from the Internet that have obvious editing errors. List and analyze the origin of these errors and indicate if they are technical, expressive or dramatic errors.
2. On paper, formulate an editing strategy to salvage or improve the sequence. You can add new images and sounds if necessary. Indicate where they should go.
3. Obtain the original material of a dramatic sequence; it can contain dialogue or action alone. Carry out the following steps:

 (a) Edit the piece, focusing only on transmitting the information in the best possible way.
 (b) Edit the piece a second time. Try to strengthen the gesturing and expressivity of the characters. You can combine reaction shots, reduce/omit pauses and other angles.
 (c) Edit the piece a third time, this time trying to control the timings and reactions through editing in order to increase the suspense and drama of the scene.

 Compare the functioning of each of the sequences.

4

CUTS, TRANSITIONS AND AUDIOVISUAL GRAMMAR

WHEN TO CUT

The characteristics that differentiate the shots selected and assembled during editing should be significant enough in terms of size, angle and position so that the viewer realizes that they correspond to changes in camera position. In this way the edited shots will appear natural, continuous and free of disruptions generated by joining similar shots. A minimum variation between contiguous shots creates what is termed a *jump*, which breaks the illusion of reality. For Ernest Lindgren, changes in shots reproduce the mental processes in which images succeed each other as our attention focuses on one detail or another. Assuming the filmic experience reproduces movement, then what we watch will appear natural. Montage reproduces as faithfully as possible the way in which we see the world that surrounds us (Lindgren 1948, 54). Karel Reisz states that this is not always achieved, since the various combinations planned during filming, and which are used during the subsequent editing stage, are not always shot from the same camera position (Reisz and Millar 2003). Therefore, there is never a true reproduction that corresponds to that of an observer witnessing the event in person. In this respect, Walter Murch highlights the perceptual approach of editing and maintains that the impression of rhythm generated by the succession of cuts and shots is equal to the frequency at which the eye blinks. Blinking occurs naturally every time the eye looks at another element in a scene (Murch 2003). The underlying issue surrounding the cut and its functions does not only concern the camera angle or positions, nor even the recording of reality as suggested by Reisz, but rather the way in which montage and its various narratological procedures are capable of expressing a visual coherence containing different elements and its development within a sequence based on the systematic organization of shots. The beginning and end of each shot, therefore, should be precisely located in order to guarantee the viewer three fundamental points:

1. The film's smooth progress.
2. A credible impression of the events shown in the assembled shots.
3. The generation of the sequence's rhythmic structure through the sum of the shots' individual durations.

The question of *duration* has been a recurrent issue in various montage theories. Nevertheless, the approaches taken have varied over time, since advances in other disciplines such as psychology have allowed montage to be related to other processes that are more complex in terms of information assimilation. For Béla Balázs, the important factor is the regulation of the scene's duration since its length directly influences its meaning and content (Balázs 1978, 96). Mitry states that a shot lasts, or should last, long enough to express its content (Mitry 2002, 483). Marcel Martin claims that, "if each shot is cut exactly at the moment the attention wanes to be replaced by another, the viewer will always be in suspense and the film could be said to have 'rhythm'" (Martin 2015, 197).

In montage, the criteria used to estimate the duration of a shot vary, as each decision has to be taken in light of, and satisfy, the scene's characteristics and specific communicative aim. The exact length is not determined prior to shooting but rather when the sequence is assembled; the impression of coherence is created along with meaning as a function of what Jean Mitry terms the *shot's intensity* and depends on the amount of physical, dramatic and psychological movement in the shot (Mitry 2002, 429). The decisions taken during the successive partial cuts determine the correlational rhythm—the sequence's overall rhythm—of all the shots that make up the sequence.

Why Cut?

One of the key factors in editing is to know when to make a cut or any other transition. *Where should the cut be made?* is one of the questions frequently asked by the editor, especially when television's rush to broadcast gives him/her to little time to experiment with different combinations of the scene that allow him/her to decide which is the most appropriate. It is a decision that may well be taken on a totally personal basis or is predetermined according to the director's wishes. However, a good way of determining where to cut is for the editor to step into the shoes of the viewer, watch the images and attempt to identify the places and opportunities in which to edit them and express a precise idea whilst, at the same time, giving thought to how the audience is to see and understand it. However, this is not an easy task and involves, as we have seen before, a process of evaluation and ranking necessary to produce a coherent, clear message. The following five criteria can be used as a guide to why make a cut:

1. To emphasize the plot at a specific moment.
2. To inform the viewer of the characters' changes in position in the scene.
3. To redirect the viewer's attention towards another area in the scene.
4. To keep the character's perspective of the action constant.
5. To eliminate technical and artistic failures that arise during filming.

Another formula is to use the experience and procedures of other editors and directors or to adapt or simply copy strategies used in films or television programs in which similar problems have been solved. Whilst it is almost certain that the scenes handled by the editor are always different, they are assembled very often using the same formulas, since the composition designs and filming methods are based on standard production templates. Therefore, we could say that the characteristics of editing material have similarities that lead us to repeatedly apply a previously used successful formula. These formulas aim to improve in one way or another the storyline's clarity, visual rhythm and changes in viewpoints or to simply eliminate technical or artistic errors.

Where Should the Cut Be Made?

Once the decision to make a cut has been taken, the editor is faced with a second question: *Where is the best place to make it?* There are two main positions that attempt to determine the precise moment a direct cut should be made:

A Cut Within the Action, or Match Frame

This consists of making a cut at an intermediate point in a movement or action. This type of cut gives the impression of continuity between two shots. A match cut is not, as it may seem, a physical match. It should not attempt to join two shots at exactly the same moment in the action, as this always produces a small, perceptible jump forward in the action, as the viewer would miss the action due to their eye movement. Dmytryk states that a perfectly smooth match cut is achieved by repeating the action from the previous shot over three or four frames, thus creating an overlap. This overlap accommodates the viewer's "blind spot" and allows him/her to situate him/herself in a scene and to be able to connect the action seen in the new shot with that seen in the previous (Figure 4.1).

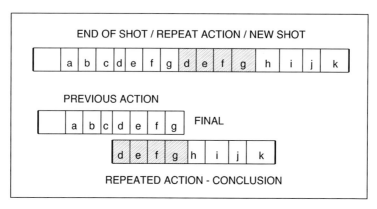

Figure 4.1 Adapted diagram of Dmytryk's minimum overlap of action
(Dmytryk 1986)

A Cut Before and After the Action

A second method is to make the cut well before the action has started or after it has finished. We will call these two types of cut *at the start of the action* and *at the end of the action*. In practice, both procedures are easier to carry out since they circumvent the need to look for instances in which the action coincides in the shots. Moreover, the join is more straightforward to resolve since it does not require the precision demanded by a match cut. Nevertheless, bearing in mind the variety of situations they can be applied to, a number of complications can arise. For example, when a character exits a frame. The question again arises as to the best place to cut. According to Katz, there are, in theory, three possible moments: before the character exits, in mid-action and once the character has exited the frame. For him, the precise moment to cut should be when the character is in the middle of exiting; that is, when 50 percent of the character is still in the frame (Katz 1991). By cutting at this point we guarantee the viewer a perfect perceptive continuity between shots A and B, as the action is resumed in the second shot in a similar position and direction, thus generating an impression of continuous movement. In Katz's opinion, the two other alternatives are unsatisfactory. In the first, cutting before the character goes out of frame creates a jump in the action, as part of the action that will probably be seen in the second shot will be missing in the first. In the second, allowing the character to go completely out of frame results in too much information being shown that would be irrelevant if seen in the following shot. Gerard Millerson also defends the advantages of this method, as it avoids, as he puts it, "jump cuts" when, for example, a static shot cuts to one showing movement (Millerson 2008, 296). While these editing decisions do not solve all the problems faced by an editor in his/her daily work, they do concern recurrent situations governed by repetitive filming

rules and, therefore, can be resolved satisfactorily through editing by applying and adapting them slightly.

Self-study Exercises: Perfecting Cutting Techniques

In various combinations of shots, film a character entering a library, walking up to a shelf, selecting a book and then sitting down in a chair situated a few meters away. Carry out the following steps:

(a) Edit the scene using match cuts only.
(b) Edit the scene cutting before the action only.
(c) Edit the scene using cuts after the action only.
(d) Edit the scene combining the three types of cuts according to the circumstances.
(e) Make cuts at the start and end of the shot, experimenting with the following options: an empty frame, variously sized shots of the character, the character exiting the frame and maintaining the shot until the character has completely exited the frame.

TRANSITIONS: CONSTRUCTING TIME AND SPACE

We will now take a look at the various audiovisual transitions, their symbolic meanings and some methods to relate the image to the sound.

1. *The fade*: The techniques *fade in* and *fade out* are used to visually establish significant changes in time and space of two consecutive actions. Changes in time include the passing of moments, day to night transitions or the passing of time over various days, months and years. Changes in space include, for example, passing from the outside to the inside of a house. Visually, a fade in consists of making an image gradually appear from absolute black, or any other color. By contrast, a fade out involves the progressive darkening of an image until it completely disappears and another color appears.

2. *The dissolve fade*: The dissolve fade is used to smoothen the transition between shots A and B and to visually compress two events into a shorter time frame that in reality took place over a longer time period. There is, therefore, a moment in the action's progress in which both images are superimposed as one image fades while the other appears.

For Roy Thompson, the decision to use a dissolve fade should be based on:

1. Motivation: There should be a motivating action or narrative need to apply a dissolve shot.
2. Information: The new shot should contain new information for the viewer to digest.
3. Composition: The two shots dissolved together should each have significantly different compositions that avoid visual contradiction.
4. Camera angle: A dissolve between two shots should present differing camera angles so as to emphasise the contrast between both.
5. Sound: The audio tracks should also be mixed together (cross fade).
6. Time: One second is the default duration, but a long dissolve can be on-screen for several seconds.

(Thompson 2001, 54)

In the first point, the reason for using a dissolve fade may be based on the difficulty of making a cut directly between two images. A more esthetic reason for using it is to symbolize the spatio-temporal change that separates the shots or the succession of information shown. The third and fourth reasons to use a dissolve fade are to juxtapose images showing various shapes or elements that acquire smoothness and balance through the perceptive effect of the dissolve. The sound can be synchronous in both shots and therefore reproduce different features that are linked to the image. The sound can be staggered, for example, by maintaining the first shot whilst its sound fades out and makes way for a character's voice. With regard to duration, we would add that the transition should suggest a relationship between the internal and/or external movement of the images, in addition to the interval in space and/or time.

1. *The wipe*: This is an optical effect that makes the transition between two images possible through a wide range of predetermined shapes and geometric patterns or custom designs. These shapes enter and disappear from any of the four sides of the screen either manually or automatically. Although the wipe is a decorative rather than expressive editing resource that has been mainly replaced by patterns and shapes that compress the image, in certain cases it is still used to create original relations by taking advantage of the direction of camera movements between the images or the movements of the characters and assembling them using a shape or pattern.
2. *The overlap*: Overlap is a method of editing in which two different structures are connected through the advance or delay of the sound corresponding to the second audiovisual structure. Consequently, there is a moment in which the sound does not correspond to the

image and another moment in which it synchronizes with the second audiovisual structure.

An overlap can be created in one of two ways:

Preceding overlap: The sound is heard ahead of the image $t=(-)$. During the transition, the sound of the second segment is heard first. The image and sound of the second segment then synchronize (see Figure 4.2).

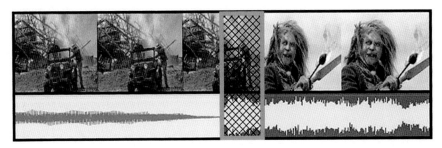

$t= (-)$

Figure 4.2 Preceding overlap

(Source: author)

Delayed overlap: The image appears ahead of the sound $t=(+)$. During the clip, the image of the second segment is seen first. The image and sound of the second shot then synchronize (see Figure 4.3).

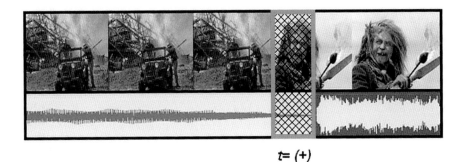

$t= (+)$

Figure 4.3 Delayed overlap

(Source: author)

According to its communicative aims, overlaps can be divided into two categories:

Natural overlap: This is based on the smooth joining of both structures and aims to create a direct semantic interconnection and an impression

of continuity in the storyline and action. In this case, montage creates a natural pause between the scenes by trying to replicate the brief silence in a dialogue. The intensity of the sound is low, moderate and stable. The tone of the voices or other related sounds allows the viewer to associate them within the same spatial and narrative context. This overlap is frequently used in editing news items or conversation scenes to relate the dialogue between the characters or to harmoniously and smoothly join in time two scenes that take place in different places and contexts. The following diagram (Figure 4.4) shows an example of a natural overlap. Here, the visual information shows individuals reading out statements during a press conference. They are different, but the uniformity of the background space creates coherence and an enhanced similarity that translates into equal levels of visual intensity, as seen in the histogram on the left. Something similar occurs with the sound. The structure of the dialogue of the journalist in the first image is stable and similar to the individual making the statements in frame 2 (the close-up of the woman dressed in black). Finally, the pause that separates both dialogues is deliberate, as can be seen in the sonogram (the central highlighted section), and attempts to recreate the natural dialogue in which various actors alternate by leaving pauses to show the change in the source of information.

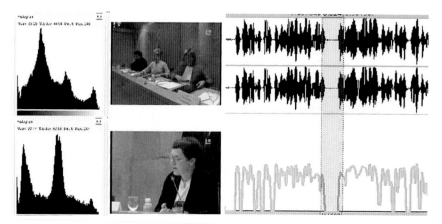

Figure 4.4 The physical representation of the audiovisual changes in a natural overlap

(Source: author)

Expressionist overlap: The expressionist overlap aims to deliberately create a reaction of fright or surprise by emotionally exploiting the change in intensity of the second sound, which occurs unexpectedly, breaking the continuity and concordance between the scenes. This type of montage usually takes the form of a deliberate decrease in intensity in sound towards the end of the first shot that ends with a brief silence to create a

false impression that the scene has finished. This generates a perceptual shock through the occurrence of a different sound and represents a new, unexpected event for the audience. In this second technique, the characteristics and resulting effect are exactly the opposite. While a natural overlap seeks continuity and natural smoothness of the actions, the expressionist overlap aims to produce a violent, instant perceptual impact through the expressive combination of contrasting sound and visual elements. In the example below, the image before the transition shows a medium shot of the face of a woman carefully examining a mollusk with tweezers. The image is quite dark, wide and static and without any action other than the slight movements of the hand as she examines the mollusk. The second shot, which shows a close-up of the mollusk suddenly moving against a white background, presents a complete contrast, which can be seen in the two histograms showing the instant perceptual shock from the darkness to the following all-white shot (see Figure 4.5). The two frames are highly contrasted and generate a marked audiovisual shock that is intensified even more as the audience does not realize that the animal is about to suddenly come back to life. The sound of the deliberate dialogue, which is natural, is totally stable in the first segment and fades out slowly to absolutely silence. Once the final impression is achieved through the dialogue and deliberate pause, an abrupt sound effect is suddenly heard that heightens the physical intensity of the sound and the psychological intensity of the scene, thus creating a considerable shock. The effect is greater due to the synchrony of sound and movement, creating a perfect perceptual blend. The sonogram on the right shows the increase in the sound, which is louder than any of the others in the scene. The dialogue between

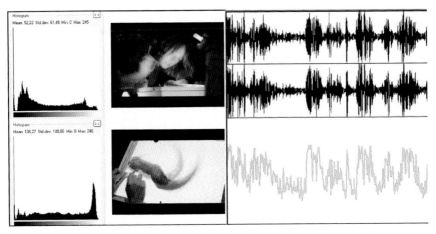

Figure 4.5 The physical representation of the audiovisual changes in the expressionist overlap

(Source: author)

the characters continues spontaneously, thus restoring the logic and structure of the scene until its conclusion.

Self-study Exercises: Perfecting Transition Techniques

1. Film pairs of images of stories that correspond to different spaces and times. Carry out the following transition procedures:

 (a) Fade out/in of varying transition lengths of, for example, 15–25, 25–35, 60–80 frames.
 (b) Dissolve fades of 30, 45, 60, 80 and 100 frames in length.

 Compare the results in all cases.

 (c) Carry out the same transitions, this time selecting the entry point and duration according to the action and movement of the characters.
 (d) Next, create transitions using wipes. Select the type of transition according to the content and movement of the shots to be joined. Vary the speed of the transition and experiment with its position at different points in the scene.

 Compare the results in all cases at the narrative and dramatic level.

2. Obtain approximately 10 scenes of differing subjects or news items and try to make an association between pairs of them using overlaps. Carry out the following options:

 (a) Preceding overlap:

 - Experiment with different lengths of preceding overlap according to strictly metric criteria of 15, 20 or 30 frames, etc.
 - Now vary the length of the preceding overlap according to the action and changes created by the sound of the second scene.

 Compare the results.

 (b) Delayed overlap:

 - Experiment by varying the lengths of delay following strictly metric criteria of 15, 20 or 30 frames. Now vary the length of the delay according to the action and changes created by the sound of the second scene and the content of the image in the first scene.

 (c) Create overlaps based on the relationship between the image and sound in both sequences. Experiment with:

 - Creating a complete sound-image relationship.
 - Creating a partial sound-image relationship.
 - Creating a contrasting sound-image relationship.

 Compare the results.

AUDIOVISUAL GRAMMAR

At various moments we have discussed the importance of continuity, the ordering of information and creation of meaning through editing by following a schema similar to our natural perception. When in any space, we make various movements of our eyes and body to gain a clear perception of our surroundings. Turning our heads creates a movement similar to a panoramic movement and, if at the same time we approach the object, we emulate perfectly what would be a dolly shot. Focusing on details would be the equivalent of a close-up. When translated to the world of filming, certain new rules need to be followed to ensure a coherent storyline, which is constructed following a protocol similar to that which we use to clarify the world around us. The grammar of filmic construction and television production (Sánchez 2003, 125 Millerson 2008, 110;) provides a set of rules to guarantee the audience logic, smoothness and spontaneity. In order to achieve this and to avoid complicating the subsequent stage of editing, the following rules should be respected when filming:

The 30° Rule

This rule states that two consecutive shots should have a minimum of 30° difference in camera angle. The reason is simple. If the camera angle changes by less than 30°, our brain perceives an unnatural jolt that seems to indicate that the camera has not moved enough to provide us with a noticeably distinct perspective of the action (see Figure 4.6). The breaking of this rule is interpreted as an error in which there is no warning of this perceptive dissonance. *Why do we perceive this type of cut as a jump cut?* Because the information in the two shots does not change enough to be seen as an evident and logical change and is interpreted as the insertion of an inappropriate image, which means that, due to its similarity to the previous shot, it is not interpreted as a continuous flow of action. During shooting, all shots considered appropriate by the director can be filmed, including those of intermediate and varied distances. However, the 30° rule must be followed when these are joined during editing, incorporating the changes in size of the shot and angle. In the following sequence of frames (see Figure 4.6), eight possible shots can be made of the woman on the left. The first four, at the top, are very similar, especially when combined with other slightly closer shots, such as those on the right. In this first case, we see a change that proceeds from a full shot to a medium-long shot, and a medium shot to a close-up. In this combination, the change is minimum and creates an unusual and strange sensation of a jump by similarity. The bottom half of the picture shows a combination that gives rise to a different impression. The variation in size is greater than the minimum 30° and in each of the two pairs there is a change in perspective

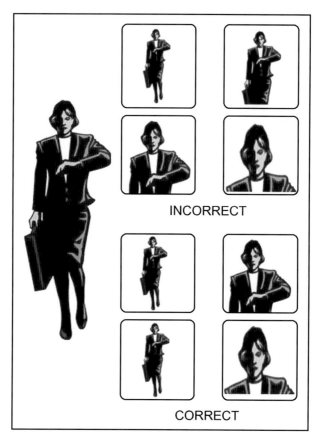

INCORRECT

CORRECT

Figure 4.6 Types of cuts following the 30° rule

(Source: author)

and distance that are sufficiently pronounced for the viewer to deduce that they are different shots of the same action.

The rule can be improved upon and, therefore, the scene itself if, in addition to using shots of different sizes, changes in camera angle are also included. As can be seen in the following pictures, the inclusion of the closer shots of the character has not only been used to create a dynamic change (top: medium shot; below: close-up; see Figures 4.7 and 4.8), but also, in the same two shots, the camera angle has changed from the far left to the far right of the character. The result is two additional combinations that enhance a simple variation in the shot distance.

Figure 4.7 Variations in angle in the 30° rule I
(Source: author)

Figure 4.8 Variations in angle in the 30° rule II
(Source: author)

The 180° Rule

The 180° rule consists of setting a limit for the placement of the cameras, thus avoiding a situation in which two contiguous shots are filmed from opposite sides of an imaginary line, or axis, that organizes the physical space in which the action takes place. Another way of defining the limits of the rule is to always position the cameras on the same side of the scene and to respect a line that cannot be crossed because otherwise the character is shot looking in the wrong direction. The easiest way to visualize the 180° rule is to imagine a conversation between two characters facing each other.

In the following diagram (see Figure 4.9), two characters are talking to each other face-to-face, and an imaginary line is drawn through them that fixes the 180° axis. Filming takes place in this example with three cameras. C1 captures a wide shot of the two characters. C2 films a close-up of character 2, who is looking to the left-hand side of the shot, while C3 shoots the reverse angle shot of character 1 using the same angle size as camera 2.

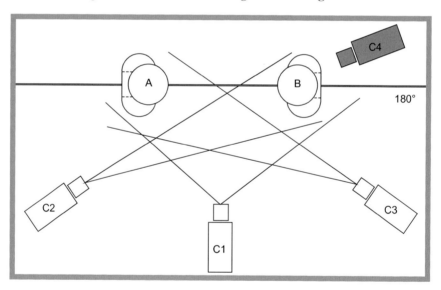

Figure 4.9 Camera positions to establish the axis of action

(Source: author)

The following diagram shows the result. The three shots show three coherent and different perspectives of the action. However, what happens if we decide to include an additional shot from camera C4, which is positioned on the other side of the 180° axis in an attempt to imitate the shot taken by C3 (see Figure 4.10)? The result is a reverse cut. C2 shows the character raising the cup and looking towards the right. However, the shot taken by C4, whilst the same size and content as C2, now shows the character looking towards the left, the same direction as C3. Therefore,

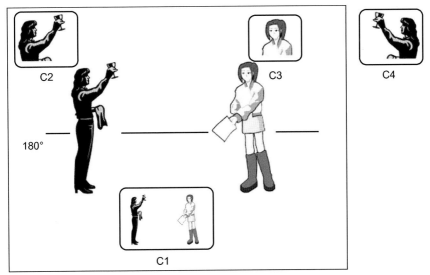

Figure 4.10 Camera positions to establish the axis of action
(Source: author)

the impression of a conversation taking place between two characters is broken in C4's shot.

These types of scenes are generally shot using lateral shots, close-ups, and over-the-shoulder shots. The imaginary line in this type of scene follows the line that joins the eyesight of the two characters. If we overstep this limit by, for example, placing the camera at 190o, we jump the line and the resulting image reverses position, as the character is now being shot from their other side. This should be avoided at all costs during editing as it creates the impression that the second character is not looking at the first but, rather, like the first, is looking at a third off-screen character or object. The impression of reality and continuity of the action is lost and the editing is considered incorrect as it has failed to naturally reproduce a simple situation. Another way of understanding this rule is in the filming of an action scene; for example, a chase scene between two characters, say, a policeman and a criminal (see Figure 4.11). In this scene, the policeman is trying to catch the villain who is running toward the left of the frame. If we now break the rule and jump the line, we change the side toward which the character is running, creating, therefore, the impression that the policeman is now running in the opposite direction to the villain. Even when the mistake is just one shot and may be corrected in the following, it will create a jolt that confuses the viewer as to which direction the characters are running.

Thus, a linear movement possesses a direction within the shot and marks a natural axis of action that should always be respected so as not to confuse the audience. There are, however, three "axis jumps" that do not create such a jolt:

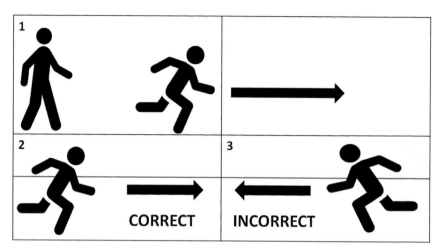

Figure 4.11 Jumping the line in a continuous action
(Source: author)

1. *When crossing the line is done by just one camera itself*: For example, by using a dolly camera movement that starts with the character looking at the right and following him/her until the camera crosses the line. In this way, filming can continue without problems from the other side of the line.
2. *With a buffer shot taken from the same angle as the shot before*: In this case, the character is facing straight towards or away from the audience, and then the action continues from the other side of the line without any disruption.
3. *Insert a neutral, or subjective, shot of the other character or object at which the first character is looking*: By omitting the reference in the second shot, continuity is maintained.

As we shall see later in the analysis of sequences, while "crossing the line" is not always approved of in certain editing models, it is occasionally broken to take advantage of the jump as a device to gain the audience's attention or simply as means to economize the language in order to give greater emphasis to the dialogue of an action.

Eyeline Match

When two characters look at each other, a line can be drawn between their eyes that is commonly referred to as the eyeline match. In order to maintain visual continuity, the characters on the left should look or move towards the right of the camera, and those on the right will look or move towards the left (see Sequence 4.1). When composing the shot, it is

important to make sure that the position, angle and height of the camera in the shots and reverse angle shots help build the impression that the two characters are looking at each other over a realistic distance that corresponds to the dramatic tone of the scene.

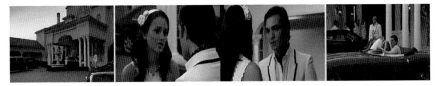

Sequence 4.1 Camera positions to create an eyeline match Blair Waldorf and Chuck Bass in a *Gossip Girl* scene

(© CWTV-ITV (UK))

Axis of Movement

This is an imaginary line created between the character and the movement he/she makes. For example, a man raises his hand and moves it to pick up a piece of a jigsaw puzzle. This movement has a line that guides it. In order that complementary shots of the same action appear real, they should follow the same direction and speed of the movement used in the original shot. This type of axis also serves to maintain the continuity in small spaces or actions of few movements.

Looking Room

This should only be included if the aim of the shot is to create the impression that the character is looking directly at the viewer. Since they are moving towards the camera, we should shoot a centered close-up. Each character should keep to his/her own space: to the left or right, according to his/her position. The closer the shot, the more restricted and complicated the lateral movement made by the camera should be in order to maintain the shot's stability. Some space should be left between the actor's eyes and the edge of the frame he/she is looking at in order to indicate the equivalent distance that separates them, similar to that in a long shot. Therefore, the actor's position should never coincide with the other actor's position in the reverse angle shot. If the character is moving, he/she will be displaced a little, in which case the shot's size will need to be carefully adjusted. These movements should not be sudden or long, as the image and the errors in close-up shots will be magnified considerably.

If we look at the two images at the top of Figure 4.12, we see that the framing of the man is better when he is positioned to the left of the shot looking towards the right. The camera deliberately leaves space to his right, to show that he is looking at the person with whom he is talking.

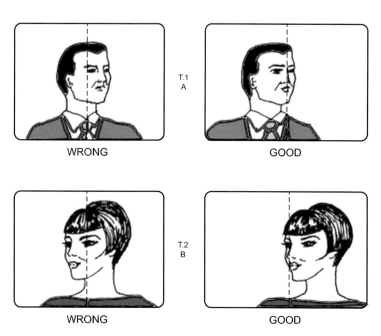

Figure 4.12 Looking room
(Source: author)

Notice the difference in the composition of the two frames. Whilst he is completely centered in the frame at the top left, in the other he is positioned towards the left of the frame, leaving space on the right. Something similar occurs in the images of the woman, who is the person the man is talking to. The camera shows her in the opposite position; that is, leaving space in the left of the frame. The space left by the camera reproduces the physical distance that separates the two characters and, at the same time, creates a relationship of distance with the viewer.

CAMERA HEIGHT

In a standard position, the camera is positioned at the same height as the characters' eyes and defines an equidistant relationship between the scene and the viewer. If not, we introduce an expressive meaning: if the camera is above the character looking downwards, the character appears smaller and reduces his/her importance, while if it is below the character, looking upwards, the character is emphasized, enlarging his/her image and importance. Interpreted another way, this equates to positioning the viewer at a height different to that of the action and the characters. Any angle from above or below eye level is in itself expressive. In a dialogue scene, the height of the camera is measured subconsciously

by establishing a relationship between the eyes of the two actors. If one of them is seated and the other standing up, then the actor looking up needs to look slightly above the camera, whilst the actor looking down should look slightly below the camera. At times, special, esthetic or purely mechanical problems may force us to modify the height of the camera, for example showing a character lying on the floor with the other who is standing up in a single shot. Occasionally, a slight change in camera height may be useful in hiding a physical defect or to increase the character's photogenic qualities, even though no expressive meaning is intended. It is important to always establish this relation of height so that, when editing, there is a natural correspondence in positioning that helps to smoothly articulate the images of the characters.

LIGHTING CONTINUITY

The lighting continuity is a detail that an editor should always control. Filming scenes takes place over many hours and there is always a risk that shots may be filmed under different lighting conditions. Whilst the angle and intensity of the light noticeably changes, the edited sequence needs to be presented as continuous and, in many cases, occurring in a defined time period. This can be especially complicated when filming takes place outdoors using natural light. Although the control of possible imbalances falls under the remit of the director of lighting and script supervisor, if the material contains any lighting errors, adjustments can be made during the reviewing stage. In the case of videos, light and color correction techniques are currently sufficiently well developed and precise to allow the editor to correct any mistakes that occur during shooting.

BREAKING ESTABLISHED RULES

Currently, the rules of continuity are undergoing a notable crisis, as they are no longer put to the same use and audiences are used to seeing them being broken. Rhetoric and narratives are evolving and we are approaching a point where creativity and originality are valued more with the use of novel techniques and the breaking of conventional editing rules. Moreover, a good part of the style and rhetoric of modern narratives is identified by the abrupt changes and discontinuity that underlie them. We believe there are two factors at play in this crisis. The first is the technological move towards digital formats. From the moment editing began to diverge into specialized areas, such as effects, editing and postproduction, new alternatives and creative possibilities have emerged, including touch-ups, image reduction and amplification effects, shape manipulation, multiscreen, all of which can be seen, for example, in simultaneous

broadcasts with several cameras in various locations and whose organizational logic goes directly against the principle of continuity and the sequential and logical treatment of the information. This has resulted in an evident enrichment of the audiovisual language, its finishing procedures—through postproduction software and image effects—and tools to creatively express complex ideas and concepts. Thus, the cut, dissolve and wipes are gradually being dispensed with: preference is being given to bright, visually impactive effects seen in video clips and commercials, shape manipulations and scene editing through the layering of sound and image, which before were impossible or extremely complicated to carry out. We have, therefore, a key technological component that has ended up influencing the narrative forms of films and television programs and the general esthetics of the media. The second factor is the development of formats and audiovisual designs that have emerged from the filming of diverse genres. Commercials present increasingly complex stories in which characters transform into monsters in the same shot and objects appear from nothing through unimaginable shapes and spin effects. Opening sequences of television programs are becoming increasingly suggestive, precisely because they jump the line or vary shot size; this jarring also defines their identity. Currently, there are several news formats that base their style on editing a guest's dialogue in which a range of deliberately similar jumps are used. These changes in the conception and exploration of new effects used to create meaning can be found in the following elements related to editing and montage:

1. *In-frame editing*: A direct cut between shots is completely absent in this type of editing. Nevertheless, although the cut can create rhythm, in this case the visual dynamic is achieved through a new way of constructing the scene, whether through a perceptible change in the size of the scene or with smaller images or objects (whether real or animated) of variable size that are overlaid on the real background. These can appear in the image in a variety of ways, including abrupt appearance, sliding in from the side of the frame, from above or below the frame, as happens with titles. In this way, editing creates a new communication code in which three independent systems simultaneously interact in such a way as to articulate a single, coherent visual scene with a defined meaning without the need for direct cutting between the images.

2. *Space reconfiguration*: The discontinuity of this type of editing creates a new notion and perception of non-linear space and time, since distinct visual elements coexist in an action and in a time, creating a new plastic spatio-temporal dimension. Since the editing procedures do not depend on the "shot" as the basic, conventional editing unit, a new, totally free and independent creative paradigm is created. In this procedure, the real, bimodal or virtual scene acts

as a basic narrative platform, while the superimposed elements are overlaid on it, generating a new dynamic and semantic field produced through fusions and insertions that enhance each other through the coming together of dynamic elements.

3. *Sequential logic*: This procedure involves breaking the traditional sequential logic, in that the ordering of information is not produced by splicing images together but by merging a series of elements that create meaning and that are situated at the edge of the screen. Nevertheless, its linear viewing aims to convey a coherent and sequential idea that is perfectly understandable to the viewer.

4. *Augmented reality*: This is a new technique used in non-linear editing that consists of combining real elements with virtual sensory inputs that complement each other through an interactive composition system. It enhances our perception of reality, since the natural image, whether live or archive footage, is assembled with computer-generated inputs, thus creating a new artificial visual format that is realistic and in line with the message's overall communicative meaning. Good examples of this are weather forecasts, where the presenter has an image behind him/her, and the reconstruction of a controversial shot in a football match.

Self-study Exercises: Continuity Rules

1. *The 30° rule*
 Film multiple shots of a static person against a decorated background and carry out successive edits, splicing:
 - Only close-ups with an eye-level camera angle.
 - Only long shots with an eye-level camera angle.
 - Alternating close-ups and long shots with an eye-level camera angle.
 - Alternating close-ups and long shots using high and low camera angles.

2. *The 180° rule*
 Film a scene following the 180° rule. Film a dialogue between two people using three cameras, two recording frontal shots and the third from one side of the axis. Then film one of the characters from the other side of the axis.
 - Try to edit the shots using this latter image.
 - Invert the shot in postproduction to correct the scene.

3. *Looking room*
 Film various close-ups of two characters talking face to face. Experiment with repeating the scene but adjusting the space above and to the side

of the characters. Edit the shots according to the rhythm, dialogue intensity and the characters' reactions. Examine the results.

4. *Lighting continuity*
Obtain a series of shots taken in different lighting conditions: daylight, nighttime, summer, winter, indoors and outdoors.

- Try to create a sequence that darkens, lightens or alternates light and dark.

5. *Create an opening sequence of a program in two ways:*

- Using conventional cuts and transitions.
- Selecting an animated background and manipulating the objects and images in static and moving frames.

5

A THEORETICAL MODEL OF EDITING

The existence of personal, ideological and esthetic models that attempt to descriptively and analytically define editing complicates efforts to create a satisfactory model that is both theoretical yet practical and that brings together all the elements and levels and ways these relate to each other in an audiovisual communicative dynamic. As we have mentioned before, *methods, categories, functions* and *procedures* are some of the terms used to define the stages of editing and the possible relationships between shots. This systematic error of classical theories has caused confusion regarding the concept of editing, since they rigidly follow a description that not only defines various editing procedures but also subordinates them in models that attempt to define editing globally without defining the basic concept behind it. These two points have formed the basis of traditional models— erroneously, in our opinion, since they have ultimately devalued editing by underestimating its capacities time and again by being based simply on personal criteria and a priori assumptions, lacking any credibility of personal judgment or practical experience. We do not know if this "contamination" is a deliberate act on the part of the authors or is simply the result of an attempt to explain editing within a global model aimed at providing a single solution to all of the problems associated with filmmaking, and so use editing as an instrument for a broader analysis.

We share the ideas put forward by Mitry and Martin in the 1970s, which, despite their years, are still original in incorporating psychological facets into their analysis of editing and stand out for the way in which the authors dedicate part of their efforts to a revision and validation of certain preliminary concepts and ideas of other authors. However, in addition to scientific validation, a model should also be practical as well as versatile in its use and should be able to answer to any developments within editing, technology, film grammar and messages. This leads us to propose a model of editing from the perspective of a compatible process similar to our body's senses. This model consists of three operational levels and proposes a series of possibilities and objectives based on narrative procedures that directly impact on the message's capacity to convey meaning.

FIRST LEVEL: OPERATIONAL

At its basic level, editing is an operational process in which an editor interacts directly with a series of images and sounds in the form of fragments of celluloid or magnetic strips that contain the shots with which he/she will create a narrative product (see Figure 5.1). It consists of four filtering and organizing procedures: Selection, Ordering, Transition and Duration. These procedures are further subdivided into phases, or sub-processes, that directly concern communicative functions.

Procedure	Phases or sub-processes	Communicative function
Selection	1. Capturing and transferring material. 2. Coding. 3. Timing.	Selects artistic material and technically improves it for its use in the construction of the final product.
Ordering	1. Linear succession. 2. Reverse succession. 3. Parallel succession. 4. Random succession.	Relates shots based on temporal structures and the creation of meaning.
Transition	1. Direct cut: the direct substitution of one image by another. 2. Fade: progressive darkening or lightening of the image. 3. Dissolve: progressive replacement of one image by another. 4. Overlap: deliberately advancing the sound or image in relation to the sound and image of the following shot.	1. Emphasizes an aspect of the action, a visual or sound change. 2. Incorporates visual resources within the narrative. 3. Creates the impression of spatio-temporal continuity or discontinuity.
Duration	1. Establishing the start. 2. Establishing the length of a shot. 3. Establishing the end.	1. Expresses information. 2. Builds rhythm.

Figure 5.1 First level of editing: operational

(Source: author)

Selection, as has been previously mentioned, consists of a filtering function in which defective material is eliminated. It is also the optimal moment to carry out a final edit. Selection therefore involves esthetic and dramatic criteria of evaluation. The first level is the ordering of the information. It consists of four stages of the sequential organization of the information: linear, reverse, parallel and random. All involve creating relationships based on the temporal structure of the sequence and the creation of meaning.

Once the images have been selected and ordered, we need to decide which transition is most appropriate to join them. We propose four

transitions: the Direct cut, in which one image is immediately replaced by another; the Fade: the progressive darkening or lightening of the image; the Dissolve, which involves the progressive replacement of one shot by another; and Overlap, which involves deliberately advancing or delaying the sound or image of the second scene with respect to the sound or image of the first. The choice of transition depends directly on the continuity, rhythm and dramatic and temporal context of the action as well as the particular structure of the shots themselves.

The final phase in the first level determines the duration of the shot and comprises three stages: establishing the start, establishing the length of a shot and establishing the end point. The first and third are defined by the physical continuity between the preceding and following shot, while duration refers to the length of a shot, and aims to create an overall visual rhythm.

This first level, then, consists of only four consecutive operations and includes general technical decisions that need to be taken in the editing of any type of product. Nevertheless, the column on the right lists the specific communicative functions that are used alongside the operational action and which are connected directly to the improvement of narrative clarity. Up until this moment, editing only acquires its value insofar as these steps determine the manipulation of materials for subsequent creative decisions.

As we have pointed out, editing also involves organizing the material to control the design of space and time and to make the product more visually appealing and effective. As part of this mission, the manipulation of the shots' duration serves above all to regulate the visual and audio information. It shows or hides aspects, details and other key elements in the information. These functions can be summarized in three specific and exclusive re-creative editing options:

Editing Options

These involve assembling and recreating the plot in its overall form and meaning through the manipulation of the duration of the images and sounds (see Figure 5.2). Each procedure has a specific communicative function:

The first option, adding/eliminating, is a selective process but in the basic sense of the operation. Here we are specifically referring to the deliberate showing or hiding of facts as a way of controlling the information. What should be said, shown or suppressed? And on what basis should the decision be made?

The second, expanding, has a re-creative function and draws on the constructive capacity of editing to expand actions in time, extending them by lengthening the shots but without losing the underlying dramatic and emotional thread.

Option	Description	Communicative function
Adding/ Eliminating	Modifies the selection criteria according to the communicative aims or through external needs. Determines what is to be seen or hidden from the viewer.	Controls the supply of information.
Expanding	Increases the length of the shots and action.	Recreates the sequence's development, adjusting it to temporal parameters.
Summarizing	Condenses the sequence in terms of theme and plot.	Systematically extracts relevant information of the action's development.

Figure 5.2 Editing options

(Source: author)

The third option is the summarizing, or condensing, capacity in which the events are compressed in time without losing the guiding thread so that the viewer quickly understands each of the elements he/she is seeing.

These first two tables represent the elementary application of editing and only include the basic associative functions. They do not include specific procedures used to create more complex meanings. In order to do so, we need to step up to a second level of articulation: intention.

SECOND LEVEL: INTENTION

In the second level, editing goes beyond its basic technical and operative functions to focus on the creation of meaning through the relationships that can be produced between the shots.

For this, we first need to ask ourselves the following questions: *What are we aiming to create through editing? To only tell a story correctly? To convey meaning? To move or frighten the viewer so that they identify with the plot or characters?* These procedures have different aims and involve distinct editing procedures (see Figure 5.3), which can be summarized in three communicative intentions that are in line with the main objectives of audiovisual products (fiction films, news, advertisements).

The first aim, to narrate, focuses on relating a story in a clear and ordered way, making it understandable for the audience. The structure and various cuts should facilitate the transmission of direct information.

The second communicative intention of editing is to create meaning, which involves transmitting more elaborate ideas and concepts in addition to the basic information. The cuts and the creation of the sequence's final meaning are carried out following specific associative guidelines that, on

Intention	Description	Communicative function
To narrate	Articulates actions logically, coherently and clearly.	Facilitates the transmission of information and improves understanding of the message.
To create meaning	Creates new ideas and concepts through associations.	Creates new meanings and concepts via the relations between shots.
To motivate and emotionally move	Conveys complex sensations and emotions.	Generates a heightened level of identification and persuasion. Provokes laughter or fear.

Figure 5.3 Second level of editing: intention

(Source: author)

their own, confer added value that is not necessarily unconnected to the implicit content of the image.

The third and final intention of editing is to excite and emotionally move the audience. It creates a higher level of meaning and involves generating complex feelings and motivations with the aim of stimulating the viewer and arousing intense emotions and expectations, including laughter, suspense, fear and compassion.

This classification of the communicative objectives of editing is useful from a practical point of view, in that the message's aim—its basic communicative objective—is always directly associated with the form of articulation, whether narrative or expressive, that defines it and which the spectator normally interprets in the same way, thus creating a bond between the two through the storyline. If we manage to express this compatibility of interests between the creator and viewer, it is reasonable to assume that the message will be accepted, favorably judged and successful.

Now that we have set out the communicative intentions, or objectives, we can now define the best editing methods to achieve them. Again, the shots are analyzed and each one is graded according to how closely it follows the script. This additional, deeper inspection evaluates the shot's specific meaning, its relevance to the storyline, how long it should be seen on the screen, and its meaningful content. The methods used are grouped into two main categories, Narrative and Expressive, which themselves are further subdivided.

There are four Narrative procedures that concern the basic assembly of shots (see Figure 5.4). Their primary function is to create internal coherence and make the storyline understandable. The first stage, Linear, involves placing the images and scenes in a strictly chronological order. The second phase, Reverse, deliberately changes the order of the events in which they occurred, starting with the end and finishing off with the beginning of the story. The third method, Parallel, develops two or more actions that occur in different spaces and times, but are shown simultaneously. Finally, the

fourth procedure, Alternating, combines two parallel actions that come together at the end.

On the other hand, the Expressive procedures concern the construction of meaning, and generate strong associations, or relationships, between two images in addition to the sequence's overall meaning. These procedures group together into one single formula the intentions, in terms of meaning and emotion, of the previous section.

Figure 5.4 shows the five categories. The first is Similarity and aims to create a sequence through shots of analogous content. It creates an impression of visual homogeneity, coherence and similarity over the series of shots. The second, Contrast, has the opposite function. It creates an idea through the contrasts and differences between shots. The contrast is not just formal and perceptive (lightness versus darkness) but also dramatic, since it arises from the characters, the context and specific way the information is presented to the audience. The third category is Symbolic and allows the expression of a new concept. It equates to Eisenstein's theory that the sum of two values creates a third, which comes from the juxtaposition of the shots. The next is Metric, which serves to create a regular structure from the shots' periodic durations. The final category is Rhythmic, which adds new meaning to the metric sensory effect by exploiting the coincidences and divergences between image and sound.

Editing Methods

Methods	Categories	Communicative function
Narrative	1. Linear: orders the images or scenes chronologically. 2. Reverse: alters the natural order, starting with the end and ending with the start. 3. Parallel: two or more independent events that are developed at the same time. 4. Alternating: combination of two actions that come together at the end.	Connects the events to narrate an action sequentially or by varying the logical meaning of the events.
Expressive	1. Similarity. 2. Contrast. 3. Symbolic. 4. Metric: regular duration of shot. 5. Rhythmic: interconnection between images and sounds.	Creates ideas and meanings associated with concepts, or a new impression independent of the images' content itself in order to build a mental association.

Figure 5.4 Editing methods

(Source: author)

In this second level we have focused on establishing editing tools that provide a narrative guide aimed at achieving precise communicative objectives. For this, the table lists a wide range of procedures that the editor can use to join the shots and to emphasize the narrative or expressive aspect of the storyline. Therefore, if the needs of the plot require the expression of several intentions simultaneously—as is usually the case, since in one way or another they are interdependent—the editor will need to go back to the first step in the process to check in each case the adjustment of all the subsequent steps (selection, ordering, transition and duration) and verify their conformity to the corresponding aim and editing method.

PREDOMINANT INTENTION

In the specific context of the production of messages and filmmaking, editing's practical dynamic provides an open work model, but one which is framed within the expressive limits of genre, format or other additional narrative factors, such as audience, schedule or medium among other things, which ultimately define the style and specific procedure to use. Taking all of these factors into consideration, editing contributes its own creative and associative strategies. For example, during the reviewing stage, features that were not planned during shooting may come to light that could require a rethink regarding a shot's selection, meaning or position within the audiovisual product. Nevertheless, despite these possibilities, there are guidelines that serve to establish criteria with which we can work. This will help to construct possible relationships with regard to making decisions on whether to take a narrative or expressive approach. We talk, therefore, of a predominant intention, which should always impose itself on the plot's rhetorical or functional approach, with one clearly predominating over the other. Once the predominant intention is established, it will be easier to organize and fix the duration of the sequence during the editing stage, since the values of the individual shots are exploited using an ad hoc structure in accordance with the predominant intention. We have presented two editing categories, narrative and expressive, but in practice neither intention functions separately from the other. Rather, they work in combination or overlap, but with one predominating over the other. The criterion to establish this intention constitutes one of the key principles for organizing the final structure and from which the message's meaning will take shape more clearly and efficiently.

THIRD LEVEL: SPATIO-TEMPORAL PERCEPTION

Once the message's narrative or expressive strategy has been established, we move on to the third and final level of editing, which aims to create

the impression of reality. While the two previous levels focus on the message's operative and rhetorical capacity, at this level we determine its conformity to perceptual coherence and plausibility. There are three specific categories: Spatial relationships, Temporal relationships and Visual relationships (see Figure 5.5).

Procedure	Categories	Communicative function
Spatial relationships	1. Change of shot. 2. Change of angle. 3. Change of shot and angle. 4. Relocation of character. 5. Through camera movements.	Focuses the audience's attention on specific areas of the scene.
Temporal relationships	1. Parallel actions. 2. Alternate actions. 3. Consecutive actions. 4. With the past. 5. With the future. 6. Non-temporal organization. 7. Ellipsis.	Connects the message's narrative threads and organizes the flow of time throughout the storyline.
Visual relationships	1. Darkness/Light. 2. Focused/Blurred. 3. Clear/Distorted sound. 4. Colour/Black and white.	Provokes sensory shocks and stimulations.

Figure 5.5 Third level of editing: spatio-temporal perception
(Source: author)

NARRATIVE COHERENCE AND PLAUSIBILITY

The first category, spatial relationships, defines the narrative coherence and the placement and displacement of the characters. There are five categories. The change of shot corresponds to the movement of the observer's eye. Close-ups correspond to focusing on important and specific parts of the action, while the change to general shots introduces important spatial variations. Changes in camera angle represent the relationship established by the director between the characters and the audience. The combination of both changes introduces a more rhythmic and dynamic element with which to direct the audience's attention. The displacement of the characters represents new placements within the scene due to physical or dramatic changes. Finally, the movement of the camera adds a descriptive and informative element that complements the meaning of changes in both shot and camera angle.

The second category concerns building the temporal relationships within the scene. It includes seven categories that are defined in the same way as for the narrative methods, but in this case they are specifically

aimed at the construction of a predominance and unity in time. The first is Parallel actions, which connects two storylines simultaneously. The second is Alternate actions, which relates the actions according to their dramatic attributes. The third category, Consecutive actions, is carried out through the cutting and ordering of two or more consecutive actions. With the past, the fourth category, involves the deliberate change of the chronological order. These scenes, referred to as flashbacks, can be variable in length but are usually of short to medium duration. With the future, the scene or characters are shown at a time in the future. The latter two categories express a break in time and the transfer of the action to a markedly distinct temporal context either visually or through sound. The sixth category is Non-temporal organization, which does not provide any indications or contextual elements with which the viewer is able to locate the actions within time. The last category, Ellipsis, is the deliberate omission of part of the continuous action, which maintains its coherence concisely by only showing key moments.

The procedures in this level also serve to consolidate and reformulate the decisions taken in the previous operational and intentional stages. To ensure the credibility of the storyline in the eyes of the viewer, the relationships outlined above should create a powerful connection between the plot and reality throughout the whole product that, in theory, should make it plausible as a message and, in turn, as an audiovisual media representation.

The model we present here (Figure 5.6) provides a systematic template with which to address the concept and process of editing from three

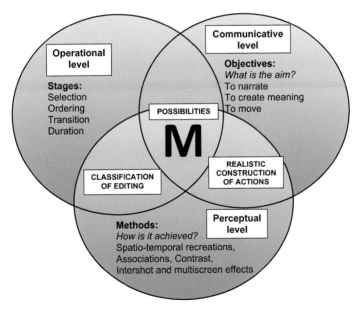

Figure 5.6 Model of editing

(Source: author)

distinct perspectives: operational, narrative articulation and as a strategy to express complex meaning. Similarly, it specifies the different techniques to physically join shots and create spatio-temporal relations by following the conventional formula of audiovisual messages. It has been designed to be applied to the distinct possible forms of editing, including transitions between shots and to improve the sequence's effectiveness independently of its genre or format. The information is organized in accordance with the rules of information comprehension and according to the perceptual and structural processing capacities of the audience.

TECHNOLOGICAL BEGINNINGS AND EVOLUTION OF EDITING

The manufacturing of editing equipment has revolved around two main operating protocols that can be divided into two eras separated by the advent of digital editing. The period prior to this is referred to as the analogue era and consisted of three procedures: recording, copying and editing. Magnetic tapes were used to record images and sounds and later served as the source for linear editing, which consisted of three different systems: cut editing, A/B roll and offline editing. The conversion to digital did not take place immediately nor at all levels of production. The first to appear were the digital editing systems. However, the original material continued to be recorded on analogue cameras, which meant that a design plan had to be drawn up taking into account the simultaneous use of these two formats. The cameras recorded analogically and the viewing and capturing was performed shot by shot using computer files. Even with the arrival of digital cameras, recording was still carried out using magnetic tapes; the transfer of information to the non-linear system required the selective capturing of the shots. Nowadays, all media and production companies use only digital cameras, resulting in considerable time-saving in capturing information. There is no longer any need for scrupulous viewing to choose only a few images, nor does it depend on the system's storage capacity. By recording onto a disk, the system automatically recognizes it as an external device and instantly accesses all the recorded material without any restrictions. However, the high costs of the technology means that they have not been adopted at the same rate across all sectors, meaning that even now various formats and video and sound qualities coexist. The manufacturers and retailers are perfectly aware of this situation. New models are fully digital but offer a range of interconnections for other makes of equipment with a variety of port types. This migration towards fully digital platforms does not, however, imply a superior quality of the final product, since various factors in the recording and exporting of the final edition determine the

outcome: the camera optics, the video format, capture sampling and output format, among others. Each manufacturer and model defines their products and work philosophy, offering enough functions to carry out a broad range of editing functions. Non-linear systems stand out for their flexibility in working with other programs and design, animation, image and sound treatment software—generally produced by the same manufacturer—thus increasing editing's creative possibilities. However, in our opinion, the most important factor is to assure that each system is compatible with the production equipment. It is equally important to determine the contribution various subsidiary applications have to the improvement of the narrative and expressive aspects of editing and the time in which tasks can be satisfactorily completed. This is an important subject, as editing is strongly conditioned by delivery and broadcast deadlines, which can be ameliorated by employing intuitive, agile, powerful and flexible systems for exchange and broadcast operations. In this chapter, we take a look at the development of editing systems over time, their basic characteristics along with their main advantages and disadvantages.

LINEAR AND NON-LINEAR EDITING

Linear Editing Systems

Linear editing involves the direct manipulation of video shots recorded on tapes inserted into videotape recorders (VTRs). It is referred to as linear editing precisely because cutting is carried out sequentially until the final product is obtained. In practice, each fragment on the original tape is selected between its start and end points—or edit-in and edit-out points—and are copied and transferred in order from the player to the editing tape in the recorder. As editing is a successive process from start to finish, it has its disadvantages in that the order and duration of the shots cannot be modified separately as this affects the construction of the whole sequence. If the piece is short with few cuts, the task is not excessively complicated. However, for a longer, more complicated product with many shots, cuts, transitions and effects, any correction would entail starting over the whole editing process again, wasting a considerable amount of time. Increasing a shot's length by copying over a previously recorded image can be carried out without too much difficultly. However, it is not possible to use a shorter shot, as some frames from the previous edit will still be visible.

There are three types of linear editing systems: direct cut, A/B roll and offline.

Single-source Linear Systems

Single-source systems are the most popular formats in media productions. They allow the simultaneous control of two video sources (playback and record) in a single fixed or portable unit. The original tape is placed in the playback VTR on the left-hand side, which has its own screen for viewing and selecting shots. On the right is the record VTR, which sequentially edits the selected shots to create the final, or master, version. The VTRs have mechanisms to control tape tension, separate audio input channels, etc. The edit controller has a system to view the tapes at different speeds, making it easy to precisely select the image/audio in/out points in both the playback and record VTRs. It can also determine the shots' exact length as well as audio input and output. There is also a preview function. The first single-source systems were the ¾-inch U-matic format produced by Sony in the 1980s. Later, VHS and DVCAM formats appeared, which performed the same functions but in a much more compact and portable device.

Multiple-source Linear Editing Systems

A multiple-source system consists of at least two videotape playback (VTP) units and a VTR unit. Similar to the edit controller in single-source systems, the multiple-source controller remotely manipulates the content of the source tapes located in two or more VTPs as well as the record VTR. Depending on the model, the video switcher, which can be controlled manually or remotely, precisely joins images and sounds from the source tapes using cuts, dissolves and other transitions. The switcher possesses an extensive range of effects with which to carry out these transitions. Moreover, the multiple-source system allows mixes and other combinations to be carried out in real time from the two sources, as if it were a multi-camera recording. For example, by marking the timecodes of the two tapes, the system can carry out a real-time edit of a sequence recorded on two cameras at two different angles simultaneously, combining the material from both sources and synchronizing the best details and moments as they happened in the real event. More recorders can be connected if the switcher has enough input connectors, which can result in a greater number of combinations.

Offline Editing Systems

This type of editing allows a list, referred to as the *edit list*, to be created of the edit-in/-out points, audio and video inserts and transitions. Guided by the in/out points, the system automatically creates a rough cut, splicing the edit-in and edit-out points and the durations of the selected shots according to a timecode recorded on the original recording copies and the

editing copy. Once the list has been compiled, the system starts to auto-matically edit through *auto assembly*, switching if necessary the audio and video input. The result is a rough copy that can be previewed to correct any possible input errors and to refine cuts and transitions according to continuity and rhythm. This second editing operation is called *online editing*. Once the corrections have been carried out, auto assembly is used to edit once again to produce the final version.

This type of editing is significantly autonomous and user-friendly and makes it easy to create various versions of a particular sequence. Offline editing saves valuable time when compared to the conventional manner of editing shot by shot in linear systems. Keyboard functions perform the main editing functions, including cuts, transitions, titles, color adjustment and pre-programmed actions on each shot. Nevertheless, in complicated edits with a lot of material from various sources these assets are probably not taken advantage of enough as the timecodes only correspond to a particular tape and, therefore, automation only works with data associated with the number of tapes recognized by the system. If there are a greater number of videocassettes than VTRs, the former need to be changed manually, which is one of the practical limitations of the system, as the work of editing in this system needs constant supervision. The initial viewing is more arduous and requires the editor to carry out a preliminary selection of the original audiovisual material to select images and sound step by step. Another disadvantage is that the final result and the effect of the sequence on the continuity cannot be confirmed until the process is finished, making it difficult to finely control mechanical and continuity factors when viewed rapidly in a linear editing procedure where they are fixed immediately according to the final visual result as the shots are joined.

TYPES OF LINEAR EDITING

There are two types of linear editing:

Assemble

Assemble editing is a form of strictly sequential editing and is carried out by simultaneously splicing the five data tracks of the source tape—audio 1, audio 2, video, control track and the sync pulse—and the timecode signal generated by the VTR (see Figure 6.1).

Insert Editing

To carry out insert editing, the sync pulse and/or the timecode first need to be recorded on a videotape. The process of insert editing involves first

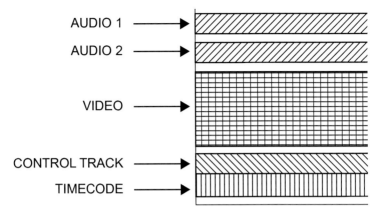

Figure 6.1 Layout of videotape tracks
(Source: author)

recording the bar signals, with the resulting recorded sync pulse occupy-ing the control track. Once both signals have been recorded to the tape, editing can be carried out by switching the three different editing options. The following editing combinations can thus be achieved:

AUDIO 1 ONLY
AUDIO 2 ONLY
AUDIO 1 + AUDIO 2
VIDEO ONLY
VIDEO + AUDIO 1
VIDEO + AUDIO 2
VIDEO + AUDIO 1 + AUDIO 2

EDITING IN THE DIGITAL ERA: NON-LINEAR EDITING

Non-linear editing, also known as random access, allows shots to be freely inserted, manipulated or changed at any moment of the editing process. In other words, performing exactly the same steps as in linear editing, but being able to freely alter the content through changes in shot length. In non-linear editing, segments from tapes or other devices are digitally transferred to separate hard discs, either internal or external, connected to a computer. This step is known as the *digitization phase* or *capture*. Once the various files have been converted to a digital format, the editing system can instantly place and present them in any order and add transitions and effects.

THE BASIC DIFFERENCES BETWEEN NON-LINEAR AND LINEAR EDITING

There are several important differences between both editing protocols. While linear editing is now practically in disuse, its long lifetime has meant that its precise work logic has remained imprinted on the non-linear model:

1. Linear editing allows editors to work directly on tape in Betacam, ¾ (U-matic), DVCAM, DVCPRO and Digital-S formats. Although some of these formats are digital, they have one important difference: they are tapes and, therefore, the access is sequential and not random. Editing is limited to choosing shots from a tape and copying them to another in a fixed order. The advantage is that it is easy to play back (broadcast) the recording immediately and to make quick retouches.
2. Non-linear editing takes place entirely virtually, with the material (digital files, AVI, MPEG, etc.) being manipulated using special software. In this procedure, digital video and sound files are stored on a hard disc for quick access.
3. With the technological and industrial development of software and current applications, non-linear editing allows any product to be created with rich and elaborate procedures, many of which are impossible to be made in traditional editing. Examples include effects and more eye-catching transitions, the creation and modification of virtual characters, animations, opening sequences with multiple image sources, adjustments and color pigment, true motion capture from an exterior source and overlaying it on a virtual set, etc.
4. Another important difference between both systems lies in the VTRs. In the linear system, editing can be carried out with one, two or more VTRs. Cuts can be performed with only two VTRs, using a player and recorder. A multi-source system with more than two VTRs—two or more players and a recorder—allows transitions to be created using a video mixer and controller. However, non-linear systems only use one VTR, since the mixes and effects are carried out directly through an editing program.
5. The non-linear system does not copy. Instead, it organizes the various filed shots to create the final sequence. All the material is then rendered and finally transferred to a tape or a video server to be launched, uploaded or distributed.

THE INTERPHASE

The interphase configurations of non-linear editing systems are similar between manufacturers and provide essentially the same editing

options from one machine to the next, although users are free to cus-
tomize the layout of the tools according to their needs and taste. The
default design has two work panels. On the upper left-hand side, we can
see a bar showing a list of files, or bins, containing the captured shots
stored on the computer's hard disk. The upper right section houses
two monitors: in the center, the player monitor in which viewing and
selection of source images takes place in order to edit them; and, on the
right, the editing or recording monitor, in which the edited sequence is
created. The lower part of the screen houses the second work panel. The
left-hand side shows a list of the system's available enabled applications,
including transitions, color correction, titles, etc. On the right-hand side
is the timeline, in which the various video and sound tracks, transitions
and titles that make up the final edited sequence are arranged. The layout
is the same for Avid and Final Cut used in Macs and for Adobe Premier
and Pinnacle, which are used in PCs.

NON-LINEAR EDITING OPERATING PROCEDURES

We now look at the various stages of editing:

Information Digitization and Storage

The first step is the digitization of the recorded material. Two things
need to be considered at this stage. Firstly, the sequential transfer of
audio and video information, preferably in the same order in which
editing is to be carried out. It goes without saying, therefore, that
only the material deemed really useful and necessary to our work
should be captured, since the rest will occupy valuable disk space. The
original files need to be methodically reviewed first, carefully select-
ing the images and sound tracks to be included in the project. A precise
timing, or running order, should be established to provide an approx-
imate guide to the parts and contents and their easy location. When
several tapes are being used, it is important to label them well. Captured
clips are organized in files, or bins, to facilitate their location within the
project's various resources. The second important factor to be consid-
ered is the input configuration and data digitization options. Various
cables can be used, including USB, Canopus, FireWire and RCA. It is
important to make sure that the video capture cards are compatible with
these input cables and to determine their quality. Moreover, if we wish
to capture in high quality, we need to be aware that more disk space will
be taken up and that the system will slow down due to a lack of working
memory. We also need to be aware of the source format and its compat-
ibility when choosing the most suitable capturing method. There are
various options and it is important to carry out the process correctly in

order to avoid problems later on or during the consolidation of the final sequence.

Labeling of Stored Information

It is important to be able to locate files and therefore we need to be organized at all times. Sound files should be stored in one part and video files in another, as well as the titles, effects, etc. Any files that we need to create should be labeled clearly for future identification.

The Editing Process

Once the work clips have been captured and ordered, editing can proceed. The number of video and sound tracks to be used needs to be determined and then created. By default, the software already displays at least five tracks for sound, video, effects, transitions and titles, which can be increased at any moment according to the editor's needs. The tracks are adaptable and, therefore, interchangeable. In the case of video, for example, multiple layers can be used, whether to create overlaps, embeddings or multiscreen effects. In the case of sound, the creation of different tracks serves to combine various sources, including speech, interviews, music, effects, etc., which are each calibrated separately.

The next step is to order the sequence. For this, we drag the various clips containing the original shots, which are located in the list in the upper left panel, to the preview monitor, located in the middle. We then start to copy the file in order to establish the corresponding enter or exit marks and thus choose the visual and sound-track content we are interested in extracting. This step can be done in two ways: either by marking them using the available options in the lower part of the play monitor itself and dragging them to the timeline, or by dragging the whole file directly to the timeline and performing the same operation using the control panel located in the lower part of the record monitor or through the keyboard functions. In this way, the sequence is built in the order in which we insert the files. The precise adjustment of the cut is done manually by marking the points in the copy itself or in the timeline, which displays the complete sequence. Once the video time structure has been completed, we now insert the transitions and effects. If we want visual effects or transitions in addition to consecutive cuts, we have to work with various tracks at the same time. The type of transition and direction and speed of the effect are chosen through the corresponding menu, carefully adjusting the precise moment it should appear and leave the frame. The same process is carried out for the insertion of color fades, backgrounds and fixed or moving titles. Once the visual editing has been completed, the procedure focuses on refining the levels of sound intensity between the voice, music and ambient sound tracks, synchronizing them in the images' space and

time perspective and according to the expressive demands of the piece. Complementary sound effects are also included in this step. Routines and the layout of the various tools naturally vary depending on the software and the differences in the commercial software versions. Therefore, we will not go into these specifics, which are learnt through practice and frequently change.

Rendering

Certain transitions and slow or fast motion (200 or 300 f/s) cannot be executed immediately. The result cannot be visualized in real time in the final sequence's timeline. Therefore, the product needs to be rendered, which can be carried out through the transitions menu. The time taken to render depends on the sequence's complexity and the number of superimposed textures and images. This time, therefore, should be taken into consideration when planning the editing process.

Exporting the Product to DVD, Videotape or Uploading to the Internet

Once the editing process is completely finished, we have to export it from the "virtual world" and convert it into a digital file for easy transport, upload it on to the Internet or store it on a physical device, such as a disk, DVD or videotape for live streaming. The following three adjustments need to be taken into consideration: firstly, that of the video; secondly, the export size; and thirdly, the sound.

The video compression adjustments allow four technical parameters—important for defining the visual quality of the transfer—to be calibrated. The first is the type of codec, which is expressed through an algorithm that defines the level of information coding/compression (see the most popular formats listed below). The second is to define the number of images per second—the frame rate—to be assigned to the video. If DVD reproduction standards are used, rates of 25 and 29.97 will yield an optimum quality. Thirdly, frame selection is key, since they will be used as reference images to be included in the video sequence, an operation termed "scrubbing." In this case, a key frame is obtained every second, which is a suitable adjustment for most purposes. The fourth is the adjustment of the export size, which should coincide with those of the sequence itself, including the aspect ratio, or screen size, which can be 4:3, 3:2, 16:9, 1.85:1 or 2.39:1. Finally, three sound parameters are also adjusted: the format, the number of channels and the file sampling (generally 44,000Hz).

Figure 6.2 shows a comparison of the main characteristics, the complementary applications and advantages and disadvantages of the non-linear editing systems widely used in the editing profession.

System	Characteristics	Applications	Advantages	Disadvantages
AVID AvidXpress Media Composer 5.5 Nitris DX Avid DS	Hardware and software specially developed for editing. Captures from FireWire and analogue and digital cameras.	Pro Tools (sound editing) Venue (direct sound). Interplay (content management). Avid and Pinnacle Studio (home editing). M-Audio.	Well positioned within the semi-professional TV and video production sector.	Closed system. Does not allow sharing with other non-Avid programs.
PREMIER Adobe Premiere CS5.5	Software that only works with commercial operating systems. PC and Mac. Captures from FireWire and analogue and digital cameras.	Adobe Video Collection is Adobe's digital video platform and consists of Premiere Pro, After Effects, Encore DVD and Audition. Adobe Premiere Pro (1.5).	With optional applications, multiple animation effects can be created and dragged directly to the timeline. Popular with independent producers.	Not widely used in the professional sector.
PINNACLE StudioHD	Easy-to-use powerful software with AVID technology.	Pinnacle Studio Ultimate Collection version 14. Chrome effect key.	Exports to Blu-ray, HD-DVD, HDV formats.	Not very practical or commercial within the professional sector. Only works on PCs.
FINAL CUT Final Cut ProX	Software for Macs.	Magnetic timeline. Clip connections. Compound clips. Inline precision Auditions.	User-friendly, powerful, adaptable capture and export formats.	Currently one of the most widely used systems.

Figure 6.2 Comparison of commercial non-linear editing systems
(Source: author)

VIDEOTAPE FORMATS

The origin of videotape formats goes back to shortly after the launch of commercial television in the 1950s, when all programs were broadcast live. The first company to commercialize videotape recorders was Ampex in 1953. These machines directly recorded output from either the camera or image mixer. The first basic edits were carried out by connecting recorders and were spliced through a direct cut on the "live" action. The technology evolved gradually over time. After several years, color cameras appeared and, along with them, the U-matic recorder followed by Betacam, until the advent of the current digital formats such as DVCAM and DVCPRO (see format evolution in Figures 6.4 and 6.5). Nevertheless, independently of the evident evolution of quality and performance that have been reached through technological advances, the color video signal consists these days of three basic parameters: luminance, chrominance and synchronization. The luminance is the quantity of light in the image, which ranges from absolute black (=0%) to complete white (=100%). Chrominance is the sum of two coefficients: saturation, or "quantity of color" and hue, which is the value of the color (e.g. red, blue, green, etc.) on the chromatic scale. Finally, there are three types of synchronization: line, or horizontal, synchronization; field, or vertical, synchronization; and color reference. Line synchronizations indicate the start and finish of each line that each video image is composed of. The horizontal and vertical synchronizations indicate the start and finish of each field. The color is regulated by various television color encoding systems: NTSC (North America), SECAM (France) and PAL (the rest of Europe). The physical representation of these video intensity and luminosity values is seen on a waveform monitor and the chrominance is displayed on a vectorscope. The calibration/adjustment is carried out either through the camera's menu options or later with the time base corrector (see Figure 6.3).

Figure 6.3 Representation of video intensity and luminosity on waveform monitor and vectorscope

(Source: author)

Video reel to reel	Model	Characteristics
1956	Quadruplex Tape format: 2 inch (5 cm). ©Ampex Corporation	Designed by Ampex in 1956. Only recorded in black and white, and in NTSC. Technology: vacuum valves. Weight: 500 kg. Direct editing on tape.
1960	1-inch tape format: 1-inch type C ©Ampex Corporation	1-inch open-wheel magnetic tape, also developed by Ampex. Possesses two audio channels plus an additional one for the timecode. Superior image quality and complete operational compatibility. Editing is carried out through a computer that automatically controls the VCRs and image mixer.
Cassette	Model	Characteristics
1969	U-matic ©Sony	¾-inch tape format of two classes, BVU and BVU SP, which are of different quality. The U-matic allowed for the first time totally independent recording through a shoulder camera connected to a portable VCR. Heavy but allowed some portability.
1982	Betacam SX ©Sony	An analogue video component system that stores the luminance (Y) on one track and the chrominance (R-Y, B-Y) on another. This separation of the signals confers broadcast-quality recording and 300 vertical lines of resolution.
1986	Betacam SP ©Sony	Resolution improved with 340 vertical lines and two audio tracks. SP stands for "superior performance."
1993	Digital Betacam ©Sony	Digital Betacam records using a compressed digital component video signal. Improved video sampling and four channels of 48 KHz/20-bit PCM audio. Includes two additional linear tracks, one for track control and another for the timecode.
1996	DVC ©Panasonic	DVC digital videocassette v8 is the generic version. There are two tape sizes: DV and MiniDV. All manufacturers distribute DVC with a MiniDV tape, which is for home use.
	DVCAM ©Sony	Has the same characteristics as the DV, but Sony amplified the track width and increased the tape speed by 50 percent. From a mechanical point of view, this improved reliability, since tapes lasted a third longer than the original format. Can record on DVCAM and MiniDV tapes and copy on DV and DVCPRO.

1996	DVCPRO ©Panasonic	DVCPRO is a DVC variant developed by Panasonic. Unlike Sony, Panasonic opted for this format and became a major franchise with three versions as of 2006. Its main difference is that it uses tapes with 18mm tracks and a different emulsion with metal particles instead of metal evaporate (used in DVC and DVCAM).
1997	HD CAM HDCAM SR ©Sony	This is a high definition (HD) version from the Betacam family, and uses the same 1/2-inch tape. Uses a sampling frequency of 4:2:2 and 8 bits of color depth on a video component system. This HD format allows recording at higher resolutions of 720 and 1080 lines.
	DVC PRO HD ©Panasonic	DV100 is a variation of DVCPRO 50 with HD resolution. It uses the same 4:2:2 sampling, but, as for HD, allows a resolution of 1080 and 720, both in progressive and interlaced recording. Also has eight audio tracks.
2001	BETACAM IMX ©Sony	As with Betacam SX, it uses MPEG compression, with up to eight audio channels and a track for the timecode. Comprised of a compressed component video system with MPEG-2 4:2:2 compression. Allows three different bitrate levels: 30 Mb/s (6:1 compression), 40 Mb/s (4:1 compression) and 50 Mb/s (3.3:1 compression).
2003	HDV ©Canon ©Sharp ©JVC	HDV-1 format: Based on the progressive 720 (720p) format, with a native resolution of 1280x720 pixels. HDV-2 format: Based on the 1080 interlaced (1080i) format, with a native resolution of 1440x1080 pixels.
	DIGITAL S ©JVC	Digital-S, or D9, is a professional digital video format developed by JVC. Its main features are recording on 1/2-inch tape, 4:2:2 sampling, 3.3:1 compression and data flow of 50 Mb/s.
	HDV ©Sony ©Panasonic	New digital recording and copying HD format on DV tape termed "HDV." Based on the progressive 720 (720p) format, with a native resolution of 1280x720 pixels. HDV-2: Based on the 1080 interlaced (1080i) format, with a native resolution of 1440x1080 pixels.

Figure 6.4 Evolution of analogue and digital videotape formats

(Source: author)

Digital video format	Manufacturer	System	Video rate/ Format	Frame size	Aspect ratio	Sampling frequency	Compression ratio	Tape width	Audio channels
Betacam Digital	Sony	Component digital SD	DigiBeta	720x576	16x9	4:2:2	2:1	1/2	4
DVCAM	Sony	Component digital SD	525i	720x480	4:3	4:2:0 (PAL) /4:1:1 (NTSC)	5:1	1/4	2/4
BETACAM IMX	Sony	Component digital SD	H262/MPEG2	720x576	4:3	4:2:2	6:1	1/2	8
HDCAM SR	Sony	Component digital HD	SMPTE 409M-2005	1920x1080	4:3	3:1:1	3:1:1	1/2	12
DVCPRO 50	Panasonic	Component digital SD	Digital Interface Format (DIF)	1920x1080	16x9	4:2:2	3:3:1	1/4	4
DVCPRO	Panasonic	Component digital SD	Digital Interface Format (DIF)	1920x1080	16x9	4:1:1	5:1	1/4	2
DVCPROHD	Panasonic	Component digital HD	Digital Interface Format (DIF)	1080x720	16x9	4:2:2	6:7:1	1/4	8
DIGITAL S	JVC	Digital S	VHS form factor	1920x1080	4:3/16:9	4:2:2	3:3:1	1/4	2
HDV 720p	Canon, Sharp, Sony and JVC	Digital HD	720/60p, 720/30p, 720/50p, 720/25p (720/24p)	1280x720	16x9	4:2:0	MPEG2 video (profile & level: MP@ HL)	1/2	2/4
HDV 1080i		Digital HD	1080/60i, 1080/50i (1080/30p, 1080/25p, 1080/24p)	1440x1080	16x9	4:2:0	MPEG2 video (profile & level: MP@H-14)	1/2	4

Figure 6.5 Comparison of the main digital and HD video formats

(Source: author)

Film format models	Characteristics
Super 16mm	Super 16 mm is a single-sprocket film, and takes advantage of the extra space for an expanded frame area, giving a wider aspect ratio of 1.67. "Ultra-16" is a variant of Super 16 in which the image is captured by the space between the perforations, yielding a frame size of 11.66mm x 6.15mm. The advantage is that it gives a wider image than the regular 16mm.
35mm	35mm film is the most used format, both in filmmaking and photography, and has survived practically unchanged since its introduction in 1892 by William Dickson and Thomas Edison, who used film material provided by George Eastman. Its name comes from the fact that it is cut into strips measuring 35mm wide and, depending on the use, has four perforations on each side per frame so that it records at 24 frames per second.
70mm	Created by Todd-AO using a 70mm negative with a ratio of 2.21:1. Anamorphic lenses not needed. Its big rival was the Ultra Panavision 70, promoted by MGM but developed by Panavision. There were less well-known formats, including Technirama (1957) and Supertechnirama 70, which, instead of creating cinema copies in 35mm film, enlarged it to 70mm.
Sony CineAlta ©Sony Inc.	The Sony CineAlta developed HD cameras equivalent to Betacam, but aimed at filmmaking. Records at 24 images per second. Its CCD sensors have a resolution of 1920x1080 pixels, and are capable of capturing more than 10,000 pixels horizontally.
IMAX ©Imax Corp.	IMAX technology uses the biggest commercial film format: 15 perforations per 70mm, ten times bigger than the conventional 35mm format seen in normal cinemas and three times bigger than the normal 70mm format. The 15/70 frame size combined with IMAX's unique projection system is the key to the extraordinary sharpness and clarity.
Panavision ©Panavision Inc.	Panavision Genesis is Sony CineAlta's main rival. Possesses a resolution of 1920x1080 but uses a CCD sensor of the same size as a traditional standard 35mm camera.
Arriflex D20 ©Arri	Uses a CMOS sensor of the same size as a 35mm analogue camera, which allows the same lenses to be used and yields the same field of view and field depth as a traditional camera. The Arriflex system can reach resolutions of 1920x1080 pixels. Possesses a film and video output mode.

Figure 6.6 The evolution of film formats

(Source: author)

Figure 6.6 shows some of the relevant technical information of digital formats, such as system,[1] sampling,[2] compression ratio,[3] tape width and number of audio channels.

Let's now take a look at film formats. Traditional commercial cinema uses two film formats, 16mm and 35mm, which refers to the width of the film. The larger the film size, the greater the definition, due to a lower density of grains. The film length—that is, the time the filmmaker has to shoot a continuous scene—is limited by the canister size. The problem lies in the fact that the can needs to be loaded into the camera every time the tape runs out.

16mm film is used in particular in the production of news reports and documentaries, since the equipment is light enough for fieldwork. It has also been extensively used in the production of short films, since it is easier to use and cheaper than the 35mm. There are two types of 16mm film: one with perforations along the two edges; the other, just one side, leaving space for a soundtrack along the other side.

Finally, 35mm film is more expensive but has a superior definition. It is used mainly for feature films, big-budget short films and television commercials. However, in many cases HD digital cameras such as Red One are increasingly replacing it.

HD

There are various resolution standards in high definition format (HD). However, the most popular are the 1920x1080 and 1280x720 pixels (see Figure 6.7). The signal scan in this recording mode are of two types: progressive (p) and interlaced (i). The progressive scan values are achieved for each sensor pixel and each image data line is drawn sequentially, yielding a complete image every 1/16 second. It is widely used in digital cameras. In interlaced scanning, the image is generated from a CCD sensor in two line fields—a field that displays the odd lines, and a second field that displays the even ones—which work together to create 24 images per second with no perceptible difference to our visual system. This system is mainly used by analogue cameras. As can be seen in Figure 6.8, there are clear differences with respect to the sharpness of an object. If we freeze a frame showing a moving object, the superior quality of progressive scanning is clearly noticeable.

There are various frames per second available to satisfy the different needs of users: 24, 25, 30, 50 and 60. Their aspect ratio is always 16:9. Since the format is digital, PAL and NTSC defects are eliminated. Surround sound is achieved by recording in combined tracks of 5.1 or higher.

There are various video standards throughout the world. The United States and Japan use NTSC with a resolution of 538x480 pixels at 30 frames per second in a 4/3 screen format, and 720x480 in a 16/9 format.

Standard	Frame/s	Scan	Vista	User
1920x1080	24	(p)	Cinema	Cinema
1920x1080	25	(p)	Film for television	Television DVB 50Hz
1920x1080	30	(p)	Film for television	Television ATSC 60Hz
1920x1080	50	(i)	Television	Television DVB 50Hz
1920x1080	60	(i)	Television	Television ATSC 60Hz
1280x720	25	(p)	Film for television	Television DVB 50Hz
1280x720	30	(p)	Film for television	Television ATSC 60Hz

Figure 6.7 Comparison of HD formats in commercial use

(Source: author)

Europe uses both SECAM and PAL at a resolution of 720x576 at 25 frames per second in both the 4/3 and 16/9 formats. But not everything is so easy. Within the so-called HD format, there are four configuration options based on the number of pixels making up an image and the way they are reproduced. In the immediate future, the industry plans to standardize screens with two resolutions: the first, HD at 1280x720 pixels, representing a total of 921,600 pixels per shot, and the second, Full HD at 1920x1080, totaling more than two million pixels, or two megapixels.

SMALL-SCREEN FORMATS

The determining factor for digital video aimed at computers, tablets and mobile devices is the size of the file, since this strongly conditions download operations, online viewing and even streaming. Thus, whilst practicality needs to prevail, it must do so without affecting the optimum quality, so that content can be reproduced without any image or sound distortions. The pace of evolution of small-screen formats has been determined by the developments of Microsoft, through Windows, and Apple, through their iPad devices. Brands such as Adobe, Real and others have developed their own, adding to a long list of existing formats. These, along with the corresponding application users are required to download, are described in the following table (see Figure 6.8).

Digital video		Characteristics
.asf	**Advanced Systems Format** Created by Microsoft.	ASF files can be coded with any audio/video codec with no change to the file type. The most popular file types are Windows Media Audio (WMA) and Windows Media Video (WMV). Suitable for streaming.
.avi	**avi** Audio Video Interleave Created by Microsoft in 1982.	The AVI format allows a video and various audio data streams, interpreted by a Microsoft codec, to be stored simultaneously. The multimedia player decides which of these tracks to play, according to the user's preferences. The AVI files are divided into chunks, each of which has an identifying label.
.mov	**QuickTime** is a multimedia format developed by Apple. Compatible with MPEG-4.	QuickTime is a complete multimedia system capable of playing and, in certain cases, transmitting, high-quality contents through the Internet and other devices. Apple decided to include the new HD video MPEG-4 technologies and a new codec that implements the H.264 standard, also known as AVC (Advanced Video Coding), which can handle contents much sharper than the DVD and DivX standards or other high quality formats.
.mpeg	**Moving Pictures Expert** Developed by Apple.	Uses an Apple codec that has quickly evolved via successive versions. This file type can also have a *.qt extension. Ideal for displaying videos on the Internet for its reasonable quality and size. Allows streaming.
.rm	**Real Media** Developed by Real Networks.	Uses an own brand codec for audio compression. This file type has an *.rm or *.ram extension. Videos played by Real Player, a free version of which can be downloaded from the Internet. Can be used to post videos on the Internet due to its acceptable quality and file size.
.flv	**Flash Player** Developed by Adobe Flash.	Can be used on various players: MPlayer, VLC media player, Riva, Xine, etc. The most popular video storage systems, including YouTube, Google Video, iFilm, etc., use this file format for playing videos. Allows various video parameters to be configured to yield an acceptable quality/file size. Allows streaming.

Figure 6.8 Comparison of video formats in general use

(Source: author, based on information from manufacturers)

Self-study Exercises: Perfecting Non-linear Editing Techniques

1. Capturing

Compare the results of video capture varying the following video input parameters:

 (a) FireWire card, i.LINK, IEEE 1394, RS-232, RS-422, SDI input and component.
 (b) Modifying the video and audio capturing preferences: digital/analogue, stereo/mono, batch capturing. Some options are predetermined by system's installed card model.
 (c) Varying file source: digital or analogue camera, VTR, HD, other data storage files.
 (d) Varying the sound capture buffer for microphone recording.
 (e) Configuring the recording parameters on the audio input console.

2. Project creation

 (a) Simple editing combining sound from video and voice recordings via a microphone.
 (b) Inserting support images.
 (c) Advancing or overlapping the sound with respect to the image.
 (d) Incorporating various video tracks.
 (e) Including image transitions: fades, dissolves, various sweepings, sound mixes and titles of varying styles.
 (f) Effects that need rendering in order to estimate the waiting time within the total project time.
 (g) Balancing the tracks' audio levels.

3. Exporting projects

 (a) Explore the end result of the project, modifying the export parameters.
 (b) Check qualities according to file compression.
 (c) Reproduce and/or convert into different formats to determine the resulting quality.
 (d) According to the screen format.
 (e) According to the resulting file size.
 (f) Check the quality of the product uploaded onto the Internet.
 (g) On YouTube or Vimeo.
 (h) With various reproduction/quality options.
 (i) In a P2P transmission.

NOTES

1. SD, standard definition. HD, high definition. The SDTV resolutions are 480 horizontal lines in the NTSC system and 576 in PAL and SECAM systems. The aspect ratio is always 4:3.
2. The number of frame samples recorded by the system in a particular unit of time.
3. The average by which the recorded information is reduced by the VCR.

FILMING WITH EDITING IN MIND

DISCONTINUOUS FILMING WITH A SINGLE CAMERA

Most TV programs are produced with a system of multiple live cameras or pre-recordings. Nevertheless, an effective and complete filming process does not necessary require this level of complexity and infrastructure as traditionally occurs in cinema, where films are made shot by shot and the action and changes between images are scrupulously managed through dramatic control and transitions. In video making, there are two situations in which only a single camera is used:

1. In the first, the decision to use only one camera is a deliberate one. The action, set, staging and filming rhythm are adapted accordingly to obtain a greater variety of material available for editing.
2. In the second, limited resources means only one camera can be used.

The normal procedure for shooting with a single camera is to divide the filming into shots that are recorded individually. The action and staging are arranged for each shot and their final articulation is determined during editing. The key in these circumstances is planning: it needs to be thorough, with all the variables that occur during shooting needing to be tightly controlled, as they may lead to errors that cannot be corrected post-filming. In discontinuous filming, particular care needs to be taken to control the continuity of actions, positions, expressions, etc., since directors often have to repeat them to record them from a different camera position or when there needs to be a change in the emphasis of expression or the speed of the action. However, additional tools such as tracks, hydraulic tripods or cranes used in the filming of more spectacular scenes also require more specialized personnel and greater planning. There are three widely used procedures in film and video production. Since these are used by directors to plan filming, it is important for editors to have a thorough grounding in them too so that they know the theory behind them and know how

to join shots, create continuity and highlight certain aspects in order to strengthen the characters' personalities, the transmission of information or the narrative's emotional charge.

Procedure 1: The Triple Take

The entire scene is shot in sequential order, controlling at all times the overlap with the preceding and proceeding shots. In this procedure, the end of each shot must always be repeated at the beginning of the next shot and so on until the end of the film. This "overlap" will be used by the editor as an opportunity to directly join shots. We can see this in the following sequence of frames (Figure 7.1):

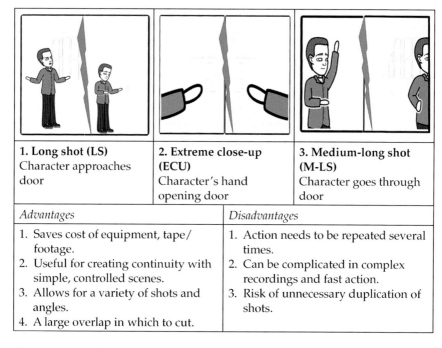

1. Long shot (LS) Character approaches door	2. Extreme close-up (ECU) Character's hand opening door	3. Medium-long shot (M-LS) Character goes through door
Advantages	*Disadvantages*	
1. Saves cost of equipment, tape/ footage. 2. Useful for creating continuity with simple, controlled scenes. 3. Allows for a variety of shots and angles. 4. A large overlap in which to cut.	1. Action needs to be repeated several times. 2. Can be complicated in complex recordings and fast action. 3. Risk of unnecessary duplication of shots.	

Figure 7.1 Procedure 1—the triple take

(Source: author)

Procedure 2: The Split Sequence

This procedure consists of shooting the whole scene from several positions to obtain an equal number of shots that can be combined during editing. For example, if we film the scene above of the character opening a door using this procedure, it will not be necessary to interrupt the action but to film it in its entirety from as many different angles as required. In

Figure 7.2 we can see the action repeated in three different shots: (1) a long shot, (2) an extreme close-up and (3) a medium-long shot. By combining them, we can create, for example, a sequence of nine different shots in which the camera angle varies and the action is shown in its entirety.

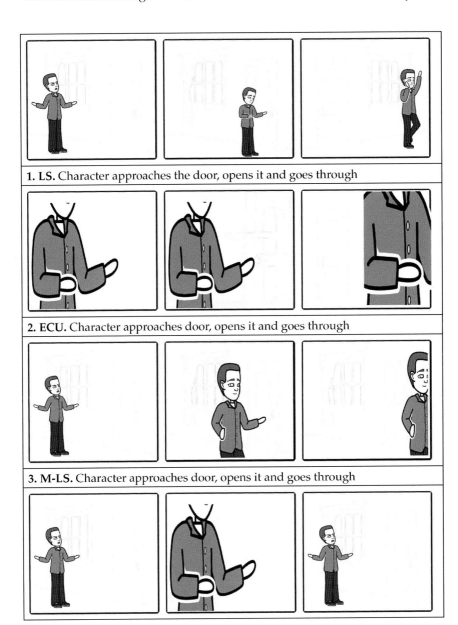

1. LS. Character approaches the door, opens it and goes through

2. ECU. Character approaches door, opens it and goes through

3. M-LS. Character approaches door, opens it and goes through

(*Continued*)

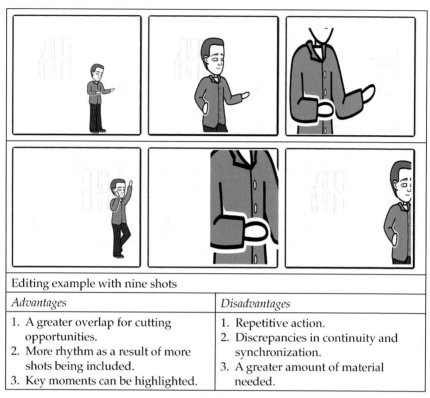

Editing example with nine shots	
Advantages	*Disadvantages*
1. A greater overlap for cutting opportunities. 2. More rhythm as a result of more shots being included. 3. Key moments can be highlighted.	1. Repetitive action. 2. Discrepancies in continuity and synchronization. 3. A greater amount of material needed.

Figure 7.2 Procedure 2—the split sequence

(Source: author)

Procedure 3: The Establishing Shot

In this procedure, a master shot of the entire scene is recorded, generally in the form of a long shot, which acts as a reference. Different supporting shots of the action are then recorded from a variety of angles to complement the master shot (close-ups, extreme close-ups, medium shots, etc.). The task of editing, then, is to insert these more detailed shots into the master shot (see Figure 7.3). In this situation, complete action and dialogue are available in different shots, which can be assessed for their inclusion according to individual or joint expressive values or whether there are important reactions or changes in positions within the scene that need to be included.

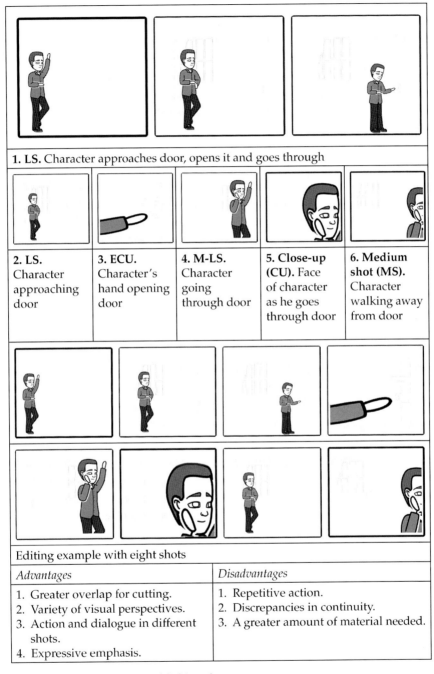

1. LS. Character approaches door, opens it and goes through

| **2. LS.** Character approaching door | **3. ECU.** Character's hand opening door | **4. M-LS.** Character going through door | **5. Close-up (CU).** Face of character as he goes through door | **6. Medium shot (MS).** Character walking away from door |

Editing example with eight shots

Advantages	*Disadvantages*
1. Greater overlap for cutting.	1. Repetitive action.
2. Variety of visual perspectives.	2. Discrepancies in continuity.
3. Action and dialogue in different shots.	3. A greater amount of material needed.
4. Expressive emphasis.	

Figure 7.3 Procedure 3—establishing shot

(Source: author)

CONTINUOUS SHOOTING WITH SEVERAL CAMERAS

Filming with Two or More Cameras

Filming with two or more cameras is somewhat similar to the split sequence procedure. In other words, the action is filmed from several angles. However, in this case, filming occurs from various perspectives simultaneously so that several recordings of the same action are generated with no repetitions over various shots, as occurs in the split procedure (see Figure 7.4). The editor therefore has a broad range of images from

1. LS. Character approaches door, opens it and goes through

2. ECU. Character approaches door, opens it and goes through

3. M-LS. Character approaches door, opens it and goes through

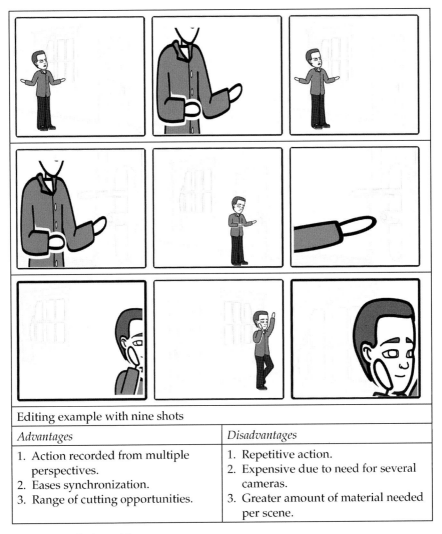

Editing example with nine shots	
Advantages	*Disadvantages*
1. Action recorded from multiple perspectives. 2. Eases synchronization. 3. Range of cutting opportunities.	1. Repetitive action. 2. Expensive due to need for several cameras. 3. Greater amount of material needed per scene.

Figure 7.4 Filming with two or more cameras

which to select and can combine parts of the same action shot from two, three or more cameras.

Multi-camera Filming

Using two or more cameras connected to a video mixer allows filming to take place continuously. Important visual changes can also be made using shots of differing sizes, perspectives or camera movements. This

procedure also allows directors to include new, more recent information, change emphasis, highlight new details, show reactions, draw the audience's attention to a different aspect, make comparisons and create greater visual variety. The greater the number of cameras, the greater the options to present complete information to the audience, even from surprising perspectives, or to record spontaneous events. There is no restriction to the number of cameras that can be used, although the budget may be a limiting factor. In fact, multiple cameras are being increasingly used in all types of productions. In programs aired on a daily basis, such as news programs, the director needs to control a range of additional video inputs that need to be combined "live," as occurs in the broadcast of a football match (see Figure 7.5). The director defines the camera positions and sizes of the shots—which are composed by the cameraperson—and the changes and movements planned according to each shoot: changes of scene, position changes of characters within the scene, emphasis and reactions, incoming video signals and additional sound recordings, etc. The content, combined and built according to the director's decisions, is recorded on a hard disk or videotape, which is subsequently used in postproduction, where details are retouched according to needs and style.

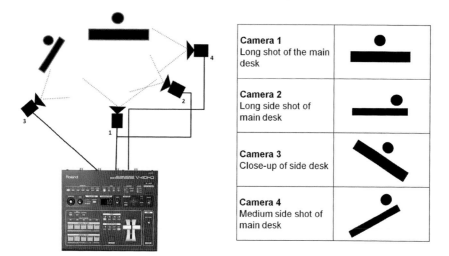

Camera 1 Long shot of the main desk	
Camera 2 Long side shot of main desk	
Camera 3 Close-up of side desk	
Camera 4 Medium side shot of main desk	

Advantages	Disadvantages
Multiple perspectives of the scene. Action recorded in real time. Continuous filming with no interruptions.	More technical staff required. Longer rehearsal time. Risk of loss of control of complex scenes.

Figure 7.5 Multi-camera recording

8

EDITING
IN PRACTICE

In this chapter we focus on analyzing editing and assembly procedures in various audiovisual pieces, including fiction, news items, commercials, video clips, etc. We also take a look at examples of new formats designed to be viewed on the Internet and mobile phones. These are of interest because they are an indication of current trends. Although the choice of examples is somewhat arbitrary, the grouping by formats provides a reference to the types of sequence and their functions, which helps us determine in each case the various styles and formats with which to approach them. While each clip represents a particular distinct action, what interests us at this juncture is establishing the general principles that can be used to come up with creative and effective solutions in order to improve their narrative, audiovisual or commercial functioning.

All the videos used in the examples can be watched in their entirety at http://fermorales.blogspot.com.es/

ACTION SEQUENCES

Situation	Aim	Scene construction
1. Chase 2. Fight 3. Unexpected	1. To increase tension 2. To frighten 3. To surprise	1. Parallel editing (intercalation) 2. Following the continuity 3. Multiple angles of action 4. Inclusion of reactions 5. Shortening of shots

Case Study No. 1

CSI (2008) S9 E4	Director: Brad Tanenbaum
CBS	
Episode: "Let It Bleed"	Editor: Alec Smight
Sequence: The chase	Duration: 2'10"
Male and female voices, background noise, music, effects.	

Summary: A robber races out of a nightclub with his takings unaware that there are two police officers at the door. The two officers give chase. The robber attempts to escape through the back door of a warehouse. They run through several alleyways. When it seems that he is about to be captured, the assailant throws himself through a window and falls to his death on top of a rubbish container. Another police officer at the scene confirms his death.

1–2. LS. Nightclub exterior 6"7f
The camera is facing the nightclub door. The robber runs out suddenly, violently pushing a woman to one side. A police officer starts chasing him until they leave the frame.

3–4. General shot (GS). Exterior street view 4"4f–3"2f
Cut. The frame is now wider. The assailant runs in front of a couple leaning against a car and pushes past them. Further on he trips over an object but carries on. When he exits the frame, the police officer can still be seen, maintaining the perspective of the route taken.

5. CU of robber 1"8f
6. CU of police officer 2"2f
7. CU of female officer 1"14f

In this first segment, the scene clearly establishes the space, action and characters. The first shots show a normal street situation followed by the unexpected appearance of the robber (1–2). Note how the editing structure goes to great lengths to define the positions and points of interest based on the routes taken by the characters: the direction, the speed of the chases and the obligatory pass through set locations. For example, the car (3–4) is repeated and becomes a reference point for the action's route. We see that the direction of the action moves towards the left, which is the case in all shots except front-on shots showing important detail or those showing a change in direction of the chase. We then see three consecutive close-ups (5, 6 and 7) of the robber and the two officers chasing after him. Pay special attention to the order: when new action is being shown, it should be the first character doing that action that should be seen.

8. MS. 2"5f
Footfalls of the female police officer as she chases the assailant around the corner.
9. GS. 1"10f
Assailant inside the warehouse. The police officers arrive immediately on the scene and open fire.

10. LS. 3"1f
Robber opening door. He enters and continues running, moving leftwards across the frame.
11. CU. 2"14f
Police officer talking to his colleague. Shots are seen and heard coming from the assailant. The officers attempt to hide.

The female officer then runs round a corner and we enter a new space, the warehouse (8). Note how the displacement of one of the characters in close-up is used as a means to completely change the scene. The action now comes from the opposite direction to the camera, since the robber is running into a new space in an attempt to flee the officers. When he exits the scene, the camera is now located behind the officer to copy the relocation of the viewer (9). There is now a pause in the scene to calm the situation down. The female officer is waiting. Another cut now takes us to a new scene. Now, the robber is entering through the door (10) and comes to a smaller room. Parallel editing takes us back to the shot of the female officer, who decides to go in. At this moment, she is talking on the phone and over the audio of the conversation the officer can be seen entering the room (12). The assailant is then seen looking up and now enters a dark alleyway (13A). The police officer chases after him, keeping him in sight (13B).

12. LS 2"18f
Police officer lighting up the alleyway with a torch.
13A. LS
Robber runs towards another alleyway.
13B. LS (TT 13A + 13B: 6"22f)
Police officer continues to give chase.

The following shots (14–21) show the final moments, which happen at a clearly faster pace. The assailant turns into another alleyway (14) and is seen close to the officer, who attempts to hide to avoid being shot (15). The closeness of the characters heightens the dramatic tension. A cut takes us abruptly to another scene showing the inside of the room. Then a close-up of the robber entering, breaking a thin partition (16). He falls over, dropping his gun. At this moment, the police officer appears practically on top of assailant, who is unable to react (17). The following medium shot (18) shows the robber throwing himself unexpectedly through a window. In the following shot (19), we see a reverse shot of the officer looking down at the street from the window. The last two shots (20–21) show the robber, dead and bleeding on top of the container. Finally, the female police officer's expression confirms his death.

14. ¾ shot. 2"3f 15. LS. 5"5f 16. LS. 3"10f 17. MS. 1"5

18. LS. 2"4f 19. LS. 2"14f 20. CU. 1"23f 21. CU. 3"5f

This is an unmistakable police chase that shows a complete sequence shot from various locations taking place at various interconnected scenes. Although it is the two police officers who start the chase, once inside the warehouse the situation focuses on the two men, while the female officer, after talking on the phone, momentarily abandons the scene. Editing consists of a series of cuts in the action to create an extremely realistic situation and to mimic the natural changes in viewing angles of the "ideal spectator." The chase by both men is tortuous, going up and down, entering and exiting, but perfectly clear, because the action is uncomplicated and centers on the chaser and chased. Although occurring in semi-darkness, we can still identify them and feel the progressive emotion as we approach the final scene. The frenetic movement and the changes in setting are key to increasing tension. The way the close-ups of the faces and feet alternate with the longer, contextual shots is also interesting, as this makes for a natural flow of events and provides various diverse details for the viewer. Advantage is taken of the changes and intense movement of the shots to include cuts and changes in angle and directions of the actors. For the most part the camera is at a normal angle. To break the monotony, the camera movements become shaky mid-chase. The angles only change in the final section, when the positions of both characters are not only different, but also the composition of the scene denotes the defeat of the assailant and his inevitable death. The twists and turns, stairs, windows, objects and slamming doors are also exploited to change the space and to shift the viewer's attention from the scene to the other character. The distance, the acting and the way they close in on the robber while the situation accelerates towards its denouement brings about a progressive increase in dramatic quality. The camera captures this from several positions, but it is the change in location that makes it possible to vary the action's rhythm. The key moment occurs in scene 16, when both characters are shown in the same place, anticipating the showdown. Shortly after the death of the assailant, the female officer makes a reappearance. Sound also plays an important role in the scene's narrative function: the street sounds, the objects, the footfalls and the gunfire all combine with the music and shouts at decisive moments, especially in the warehouse scene and when the robber runs through various alleyways. The strength of the sounds is in strong contrast to the silence of the end.

Case Study No. 2

The Cave (2005)	Director: Bruce Hunt
Sony Pictures	Editor: Brian Berdan
Sequence: Definitely a predator	Duration: 25"
Male and female voices, background noise, effects.	

Summary: Five biologists study a creature found inside one of the caves. The setting is dark, with an echo typical of an old, deserted cavern. All are focused on their work. Leaning over the table, one of the biologists examines a mollusk with a pair of tweezers. The creature reacts, moving suddenly. The biologists jump with fright, leaping away to avoid any possible aggression.

1. ECU. 4"7f

The mollusk lies motionless on a white-lit table. The hand of the biologist is seen behind it holding the tweezers.

2. LS. 7"24f

The group of five explorers looking closely at the creature on the table.

3. MS. 3"18f

One of the scientists observes the girl examining the mollusk from a distance.

4. CU. 12"8f

The scientist with the tweezers manipulating the mollusk on the table.

The sequence is brief. After a short silence, a close-up shot shows the mollusk on the table, immobile and apparently dead (1). At this moment, the scientist examining it begins her commentary. The image then changes to a long shot of 7"24f (2). The dialogue continues. While the camera gradually closes in on the center of the scene and the action of the female biologist, the dialogue between the five characters is interrupted by pauses. The woman, concentrating on her work, briefly looks up to talk to her colleagues. A cut to one of these briefly interrupts the conversation (3). The camera returns to the previous action (4) and the same woman is seen leaning over to concentrate on the mollusk again. This shot is much wider than the previous.

5. MS. 2"20f
Two of the scientists observe their colleague examining the creature from the right.

6. CU. 1"9f
The same as shot 4 of the girl manipulating the mollusk. It suddenly moves and she leaps back, startled.

7. CU. 10f
The mollusk moving on the table.

8. MS. 2"10f
A continuation of the scientist's reaction.

Drawing out the action, another cut takes us to a shot of two of the group (5) that is slightly wider than the shot of another companion. When they stop talking, the scene cuts once again to the girl, who continues her analysis, getting closer and closer to the creature (6). She suddenly jumps back and the mollusk is seen moving violently. Another cut shows the final movements of the mollusk (7), while a cut to a medium shot shows the woman leaping back from the table (8). We then see a close-up of the reaction of her female colleague (9) followed by a further close-up showing the mollusk lying still on the table (10).

9. CU. 1"20f
The look of surprise on the girl's face in response to what has happened.

10. CU. 1"19f
The mollusk immobile on the table.

In this sequence, the filmic aim is totally different to the previous example. The photographic technique is similar—a play on backlighting and shadows—but now serves to create a feeling of mystery. The elements are organized precisely to bring this about. The shot of the creature at the beginning serves as a clue for the viewer as to what might happen (1). At the start, the approach taken—the use of a long shot—is classic (2) and helps define the location of the characters and the place. We see that the situation has started beforehand, with the biologist continuing her careful examination of the animal. We can see how the camera's slow but stable advance towards her subtly directs our attention towards both the girl and the mollusk. The frame zone is exactly in the center and noticeably better lit than the rest of the scene. A slight noise is heard in the background and the girl's account is measured, assured and convincing. She addresses the rest of the group with authority. The echo, however, lends the situation a somewhat mysterious aura. The three following shots (3, 4, and 5) serve as a complement in order to quicken the action and to briefly turn our attention to the other characters looking on. The short explanatory dialogues continue in order to stress the feeling of evident fear and uncertainty. The following bridging shot (5) takes us towards the denouement and consists of a brief unbroken dialogue that serves as a link in order to cut once again to the girl (6), who continues her examination, gradually becoming more animated and assured and moving closer to the animal. When it suddenly moves, she leaps back instinctively. Here, it is interesting to note how the editing conveys the action, joining the three shots to perfectly follow the characters' movement, while in the next shot (6) she jumps back, creating a cut to where we see the creature thrashing about on the table (7). The whole scene lasts only 10 frames but it is long enough to produce a violent perceptual shock. Furthermore, the visual action is accompanied by a sound effect similar to the crack of a whip heard in the first shot, increasing even more the feeling of alarm. Next, the editing takes us to the girl leaping back from the table in a wider shot (8). Another cut shows one of her colleagues rubbing her forehead in an evident sign of fright (9). A final cut takes us back to a close-up of the mollusk making its final moves (10). The audiovisual effect of the shock of the creature moving is generated through a slight overlap in the transition and contrast, which merge with the change in general lighting, since the previous shots are dark and in shadow.

Case Study No. 3

Freddy vs. Jason (2003)	Director: Ronny Yu
New Line Cinema	Editor: Mark Stevens
Scene: Final fight	Duration: 46"
Shouts, background noise, music, effects.	

Summary: This clip shows the final fight of the film. Freddy and Jason face each other inside a burning cabin. At the same time, Lory and Will are desperately trying to escape. When the fire begins to spread, Freddy and Jason confront each other in a fierce fight. Jason drives a sword into the floor. Freddy lacerates him with his claws. Jason reacts, grabbing him and throwing him against the wall. Lory and Will flee from the cabin. Freddy falls to the ground and Jason picks him up and pushes him through the window. He then carries him over to the door, holding him by just one hand, and throws him violently into the lake.

1. MS. 2"25f
Jason slowly approaches Freddy.

2. CU. 4"24f
A high-angle shot of Freddy attempting to pick himself up off the floor in front of Jason. The camera moves and in the background Lory and Will can be seen trying to escape.

3. LS. 1"4f
Jason and Freddy face each other among the flames of the burning cabin.

4. MS. 24f
(Continuation of shot 1) With a sword in his hand, Jason approaches Freddy, who is lying on the floor.

This section sets up the rest of the scene. The music is frenetic, with long pauses in the moments of change. Jason appears on the scene just when Freddy is closing in on Lory and Will, preventing their escape. Jason is framed in a medium low-angle shot (1), while Freddy is seen in a close-up from above, the frame being slightly narrower (2). The camera movement helps highlight his fear. Jason manages to stand up and looks about him. The action is slightly longer, which is reflected in the length of the shot (4"24f) to show all of his movements and gestures. The next shot shows the pair facing each other among the flames (3). While Freddy remains motionless, Jason advances firmly, taking two steps. The fight is about to start. The next shot (4) is a continuation of shot 2, but now serves to show Jason in a position of attack, crouching down to pick up the sword with his right hand.

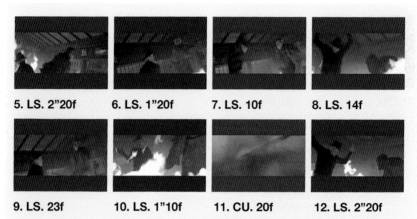

| 5. LS. 2"20f | 6. LS. 1"20f | 7. LS. 10f | 8. LS. 14f |

| 9. LS. 23f | 10. LS. 1"10f | 11. CU. 20f | 12. LS. 2"20f |

Shot 5 shows the fight in full flow. The sequence strictly follows the action, which is marked by the axis despite the characters changing place. Jason attempts to attack Freddy, who dodges out of the way and now finds himself behind Jason. From here, the scene changes position and remains so for the rest of the sequence: Freddy on the left, Jason on the right. Cuts are made during the clashes between the two or when they are close to each other. The camera exploits, through the framing, Jason's greater size and strength (6). Freddy, in contrast, is suppler and easily dodges Jason's attacks, which are shown in brief shots (7, 8, 9 and 10). The next shot shows in detail the instant Jason attempts to slash at him with his sword but which ends up being driven into the floor (11). At this moment, Freddy is motionless and the sound stops, leaving the scene in a brief moment of absolute silence. The deliberate lack of a close-up showing clearly "where he drove the sword"—the viewer is led to believe that he has seriously wounded Freddy—serves as a dramatic element to fragment the action. The sword is then seen thrust into the floor (13). Freddy first stops and then backs off (14). There is then a pause in the action. Jason grabs him and hurls him against the wall (15).

| 13. CU. 1"5f | 14. CU. 1"26f | 15. CU. 1"10f | 16. LS. 1"12f |

| 17. CU. 18f | 18. LS. 1"10f | 19. CU. 20f | 20. MS. 3"10f |

21. CU. 1"25f 22. MS. 2"10f 23. LS. 1"5f 24. GS. 1"20f

The action continues from the previous image (16) in which we see Lory and Will desperately trying to escape. They manage to get out of the cabin. A new cut takes us back inside. Freddy is lying on the floor, having fallen (17, 18). Jason picks him up (19) and pushes him into the window, crushing every piece of glass, steel and wood in his path. The action is seen from inside (20) and outside (21) the cabin. Finally, Jason makes his way out of the cabin through the flames. A close shot shows him dragging Freddy (21). Here there is a natural ellipsis, as Jason has had to get him down from the window and carry him to the door. This part of the action is deliberately left out by the editor. A cut takes us instead to a middle shot of Jason's legs and behind them, Freddy being dragged out towards the road (22). A new cut takes us to a long shot (23) and finally the shot of Jason hurling Freddy into the lake (24).

It is interesting to analyze the differences between this type of scene and the previous two, because here the aim is to always keep the two characters, their actions and movement in sight and to see how they make physical contact with each other during the fight: Jason's strength and violence, Freddy's skill and cunning. All this should blend in the scene's progression. The editor has various elements to hand to assess and decide what to include to give it rhythm and color through the positioning of the characters in the scene. By always using long shots and close-ups and following the eyeline, the editor manages to define the desired perspectives, eyelines and dominant hierarchical relationship. Although everything occurs at high speed, the close-ups are not too long. Rather, they complement, following the referential utility and constant nexus of the long shot, the movements and the cuts to the two characters fighting. However, in the midst of all this, close-ups of their hideous faces are inserted, alongside their weapons. The parallel action is also important, as it breaks up the fight sequences and provides narrative information, since it gives us information on what the two captives are doing. The scene continues just when Freddy seems to be beaten, lying on the floor. This is a deliberate act. The fight continues onto the window scene. Remember that it is being filmed from two positions—from the inside and outside—with the shots short enough to emphasize the complete destruction caused by Freddy being dragged along the floor. The final is shown in its entirety, since the action is completely controlled by Jason. Freddy can neither answer nor react. At least, during this part.

Case Study No. 4

Game of Thrones (2016) S6 E9	Director: Miguel Sapochnik
HBO	Editor: Tim Porter
Episode: "Battle of the Bastards"	
Sequence: The battle	Duration: 10'38"
Male voices, background noise of battle and open space, music, effects.	

Summary: Meereen is under siege and the fleet of the masters is attacking the city. Daenerys wants to destroy their cities but Tyrion convinces her not to make the same mistake as her father in King's Landing. They schedule a meeting with the masters to discuss the terms of surrender. However, the masters misunderstand and believe Daenerys want to surrender. She rides Drogon and, together with the two other dragons, they burn part of the fleet. Meanwhile, Daario and the Dothraki attack the Sons of the Harpy. Then Yara and Theon team up with Daenerys to accept the independence of the Iron Isles and to overthrow Euron.

1. MU of Jon 3"10f
2. CU of Ramsay 4"15f
3. CU of Tormud 2"10f

The first three shots show defiant faces waiting for the moment of attack. The first shows Jon (1). The camera angle is normal but is accompanied by a slight movement to give the impression of being followed by the opponent. The shots are long to exploit the characters' body language. The middle shot of Ramsay (2) is followed by a gentle panoramic. Shot (3) shows a close-up of Tormud. In the following two shots, the visual narrative structure is similar, although the size of the frames varies slightly, becoming wider to show the background scenery. The construction of the sound track plays a key role in the scene's functioning. The deep, slow chords increase the impression of suspense. Tormud is heard to say firmly: Jon!!!

4. CU of Ramsay turning 3"14f
5. MS of Davos yelling his battle cry 5"15f

The scene shows perfectly the preparative atmosphere of the battle. An initial visual skirmish shows us the position of the characters in the battle space and their desire to win. The body language shown in the first shots are very important here. Close-ups clearly show the eagerness for combat and the contained anger of the four main characters. Note the camera angle and how the axis is precisely maintained to indicate the locations and distances between them. The shot of Jon turning in frame (4) marks the start of the battle. Davos also turns (5). Note how both turn away from the camera to prepare their men for battle. At this point, the scene reaches its climax in the development of the conflict.

6. LS of the front row of the battalion 25f
7. LS. General view of the troops 2"5f
8. CU of burning torch 1"10f
9. MS of Jon advancing on horseback 1"

The change in music matches the change in the scene's tempo. The fighting now starts, but we still see other battle preparations that are included to increase the audience's emotions. In frame (6) we see a side-on long shot of the first battalion raising their bows. These two consecutive shots—similar in composition to the "Odessa Steps" scene in Eisenstein's *The Battleship Potemkin*—create a change in visual perspective. Shot (7) changes the perspective to an aerial long shot showing the size of the battlefield and the military power of one of the groups in the conflict. Although the image is static, it possesses an internal dynamic, as the arrows are fired towards the camera. Shot 8 shows a close-up of a flaming torch, and is the prelude to the action. Finally, shot (9) shows Jon advancing on horseback, determined to win.

10. CU of Davos 1"20f
11. CU of Tormud 1"20f
12. LS of horses 6"20f
13. CU of man advancing towards the battle 2"

At this point in the scene, we clearly see the reaction of Davos (10). Note how the camera angle is maintained to clearly define the exchange of glances between rival groups. Shot (11) is a close-up of Tormud looking on in horror. The clash is imminent. The following image (12) shows the chaos of the battlefield in a long shot, of nearly 7 seconds, in the form of a collage. The shot is deliberately blurred and shows men on horseback charging in everywhere. Two inserts of close-ups of faces alternate with the action. The camera zooms in and out several times and even loses focus. Finally, shot (13) shows a low-angle close-up of one of the warriors. The camera angle denotes superiority and decisiveness in the hand-to-hand combat.

14. LS of horses 11"
15. LS of plain 4"10f
16. MS of Jon 1"20f
17. CU of Ramsay 3"10f

This section is quite interesting. The first image (14) shows horses rhythmically galloping towards the right of the screen. It is in slow motion to fully exploit the chaos of the battle. It lasts 11 seconds but clearly shows the advance of the troops. The following shot (15) shows Jon at the head of his army. He appears quite alone but decided. We then see a panoramic shot advancing over the barren plain. We see the pursuit from another angle, this time side-on (16). This time Jon is seen traveling to the right of the frame. The countershot (17) shows Ramsay, colder, moodier, mounting his horse, waiting as Jon approaches. We then see his men firing arrows into the air to frighten the opponents.

18. LS of Jon 10"20f
19. LS of Jon 4"10f
20. CU of the battle 25"10f
21. CU of the battle 3"10f

The scene continues. In shot (18), we once again see Jon in action. This time, he is waiting on foot as the opposing army comes charging towards him. He raises his sword to virtually single-handedly take on the entire battalion of armed soldiers approaching on horseback. Shot (19) shows a continuation of the same shot but from the side. Note the perfect continuity created from the motion of the sword. The image is a fairly long slow

motion shot that shows, from Jon's position, the entire army charging past (20). He defends himself fiercely. The editor constantly emphasizes the impression of confusion and chaos. The camera also makes some changes in the distance of the shot, but really they are the peripheral objects passing on all sides of Jon (21). Then a new cut takes us to another longer shot in which we see Ramsay's sword, shot from below, slashing to either side as if it were the one who shot the scene.

This is an excellent battle scene. The editor has worked carefully to create a typical war-like atmosphere, aided by the music and the sound effects, which give it a good impression of realism. The task of editing here attempts to create an appropriate context. For dramatic reasons, the "battle scene" does not start with the battle itself, but with the preludes. It is important to build up an atmosphere from the previous images—for example, how the warriors approach the battlefield and the positions taken up by each of the armies. For this, the exact choice of camera positions is vital to create a perfect impression of the scene and the relative distances between the warring parties. The long shots also serve to maintain the panoramic perspective of the entire space of the scene and to easily introduce the battle to the spectator. The pursuit is seen in sequence from all directions: left, right, from above and even below. Imagine how arduous it was for the editor to select the shots, all of which in the end have been joined in perfect continuity through editing. Indeed, a battle between various warring factions provides a broad range of options to change position. Any relevant action can serve as a "dramatic motive" to indicate a change in perspective of either the same character or a change to another. The use of slow motion is frequently used in these types of scenes, as it significantly heightens the impression of drama. The sequence progresses quickly, not for the speed of the cuts but for the internal action and the contribution of the camera as a narrating element. The events have their own rhythm and generate a powerful visual impression. However, the changes in editing also help strengthen this smooth rhythmic perception. The inserts of faces (13) are good examples of a change of perspective with respect to the image of the charging horses. A view from within, and to a lesser extent from outside, the battlefield is achieved through a change in the type of shot. The play between cuts seen at the beginning, when we see the close-ups of the characters' faces, is clearly expressive and is exploited to its maximum. The cut in the action is also of a high standard (17–18), taking advantage of the movement of Jon's sword. In fact, looking over the entire scene, we notice that the scene concentrates mostly on him: if we measure the time, we see he appears on the screen longer than the others. The use of music and background sound gives the scene greater realism. The deep sounds of the orchestra easily situate us within the temporal context and highlight the sequence's visual progress. Voices are practically non-existent; it is action at its highest.

What to Remember in Filming Action Scenes

1. Distances: we should always show the space separating the characters as well as the build-up in tension as the two close in on each other, with one of them likely to be captured.
2. The cut: The match frame is always made at the moment of action or when contact is made.
3. Continuity: all the characters have to pass through the same locations, though not at the same time.
4. Perspective: the view one has of the other. Characters may or may not see each other, but the viewer must always see them.
5. Detail: close-ups help to strengthen the effect of the reaction (e.g. the mollusk) or the facial reaction from a stab wound, gunshot, punch, etc.
6. The unexpected: either the adversary or the underdog should attempt to regain control of the situation. This should be clear to the viewer and be exploited dramatically to reset the balance of the action.
7. Synchrony: the key moments should always be emphasized with sound effects: blows, sword slashes, falls, gunfire, etc.

Self-study Exercises: Perfecting the Editing of Action Sequences

Obtain uncut scenes and carry out the following exercises:

(a) *Chase*: with the same material, edit a scene of varying lengths for example, 30 seconds, 1 minute or 2 minutes—in order to assess which shots to choose, delete and how to control their length, distances and reactions during the progress, climax and ending.
(b) *Fright*: test the audiovisual reactive effects of a scene in which a character or object suddenly appears, changing size, regulating shot length, with a sound effect, music, varying the intensities or combining elements.
(c) *Fight*: work on a scene between two or more people, for example, a martial arts scene. Try to remake it, paying attention to, and making cuts in, the action, including detail, the expressions of the fighters and onlookers, controlling the axes, etc.

DRAMATIC SCENES

Situation	Aim	Scene construction
1. Static dialogue 2. Dynamic dialogue 3. Mixed dialogue	1. To follow the action 2. To define the character 3. To develop the conflict	1. Low-angle shot 2. Maintaining continuity 3. Eyelines and references 4. Reactions

Case Study No. 1

House (2008) S3 E8	Director: Pamela Davis
Fox	
Episode: "Whac-A-Mole"	Editor: Dorian Harris
Scene: Case presentation	Duration: 47"
Male and female voices, background sound of conference.	

1. LS. 3"5f 2. MS. 1"8f 3. LS. 2"18f 4. MS. 3"7f

5. MS. 3"8f 6. CU. 6"18f 7. CU. 5"20f 8. CU. 1"16f

9. CU. 1"20f 10. CU.3"20f 11. CU. 3"18f 12A. MS. 3"19f

12B. CU. 3"19f 13. MS. 2"10f 14. CU. 2" 15. ECU. 7"

The scene schema is a fairly classic controlled dialogue situation and is, therefore, a good example to follow in similar cases. The action is of static characters and is consequently well controlled for the filmmaker and editor, who do not need to do any more than be guided by the dialogue's increasing dramatic strength. The first shot (1) is a long shot showing the auditorium in full. At the top of the frame is Dr. House, standing in the center of the stage midway through questioning. There is then a medium shot of House (2) in which he is seen raising his head and looking calmly at the audience. During these first two shots there is a deliberate silence and then, for 2 seconds, a voice-over of Wilson asking him *whether he was really dead* (in reference to the patient). At the end of the sentence appears a long shot of the group with Wilson on the left towards the back (3). Note the dimensional selection of frames, which is carried out as a function of the distances separating both characters. The beginning of each scene follows a descriptive scene-setting approach. We then return to a medium shot of House (4), followed by another brief silence before giving his answer. House is in a complicated situation and has to convince those present. He replies: "Defines that … were real experiences …" This method is used to establish a relationship between the two characters. The shots of both speakers are limited to close-ups (5–6) that attempt to highlight House's expressivity and Wilson's pernicious attitude, which is shown through his smirking. The plot then takes us back to House presenting his side of the argument, alternating with close-ups of various others present in the audience, with the interest in the debate increasing all the while (7–9). Note that while the shot of House is totally static, the others include slight movements of the camera, from left to right, in an attempt to reproduce the observers' perspective of House. Foreman now intervenes (10), while Chase observes him (11), looking to the left of the screen. Notice how all the close-up shots of the doctors are of the same size, fixing an equal distance with the corresponding shot of House (8), who pauses once again to introduce another aspect of his defense. The shot now widens (12A) to allow his movements to be seen more clearly (he takes two steps forward). Meanwhile, the camera follows him, closing in on him slightly (12B). The scene then cuts to a shot of another observer (13). A further cut takes us to Beth, who asks: "Is it more comforting to think that that is everything?" (14). The final shot shows a close-up of House, who concludes by saying: "It comforts me more to think that this is not just a test" (15).

What are this scene's points of interest and how are these highlighted through editing? The action focuses mainly on Dr. House's defense and the expectation generated by his claims in those present. It is important, therefore, to define from the outset the scene and the interrogative storyline marked by Wilson. The script involves a detailed explanation that in this case serves to emphasize the conviction of House's behavior, which is visually translated into approaching shots as his discussion advances and House himself becomes more animated. Similarly, the reverse shots, attentive looks and interventions of the other doctors present help to intensify the interrogation initiated by Wilson at the beginning of the scene.

Case Study No. 2

The Sopranos (2000) S2 E6	Director: John Patterson
HBO	
Episode: "Happy Wanderer"	Editor: William B. Stich
Scene: Case presentation	Duration: 1'13"
Male and female voices, background sound of conference.	

Summary: Furio Giunta has organized a game of cards, which is being held in the Teittleman motel. Present are Sunshine, Frank Sinatra Jr., Johnny Sack, Silvio Dante and Dr. Ira Fried. Tony Soprano is sitting in a chair watching and controlling the situation. Tony calls Lillo Brancato to clean the table around where Silvio is sitting, with the aim of annoying him and making him lose the bet. The game has already started and continues with a bet of $800. Silvio is ahead of his rivals in the game. He turns to talk to Sunshine, Frank Sinatra Jr. and Ira Fried. Lillo suddenly arrives with his broom and starts cleaning under the table. Silvio, already uncomfortable with the situation, stands up, furious, and starts lambasting him, hurling insults at him. From his chair, Tony pretends to calm him down, but fails. Silvio carries on shouting and throws a plate of food to the floor to completely humiliate Lillo. Finally, he throws Lillo out of the room and sits down and carries on with the game.

1. MS. 4" 2. LS. 24f 3. LS. 25f 4. MS. 1"24f

5. CU. 1"8f 6. CU. 1"16f 7. MS. 1"12f 8. MS. 1"10f

9. LS. 2"9f 10. LS. 1"12f 11. MS. 16f 12. ECU. 20f

The filmic aim is approached correctly from the beginning when the shot is shown of Tony Soprano whispering into Lillo's ear telling him to clean where Silvio is seated (1). From here on, the scene takes on a circular dynamic in which some of the characters briefly intervene. In the shot of Silvio (2), the voice-over of Johnny Sack can be heard asking: "What's your bet?" The shot cuts to Sunshine (3), who answers: "Eight hundred." Silvio, who clearly dominates the situation, interrupts.

He curses Frank Sinatra Jr. about his luck (5) and in the next shot, we hear his answer: "Incredible luck" (6). Silvio then turns and attacks Dr. Ira Fried, who is smoking to his left. A new cut takes us back to Tony, who is sitting back, smiling (7). Sunshine speaks again, this time to hurry the game up. He is sitting directly opposite Silvio (8), who tells him to shut up (9). Johnny Sack now talks (10); Tony's sarcastic expression can be seen in the background. Sunshine now says to John: "It's not your turn, John." Dr. Ira interrupts with "The one whose turn it is controls the game" and throws a chip onto the table (11–12).

13. MS. 2"7f **14. CU. 1"5f** **15. MS. 1"5f** **16. MS. 1"3f**

In new shot of Sunshine (13), we see the shoulder of Silvio, who takes Dr. Ira to task for his cigar smoke. Lillo approaches with a broom to clean the area (14). Silvio suddenly stands up to upbraid him (15). There follows an argument in which Dante Silvio verbally abuses Lillo (15–16). He continues to insult him, throwing the plate of food to the floor. He swears at Tony, who continues sitting, unfazed (17). Insults continue to fly (18). Lillo leaves (19) and Silvio sits down once again (20).

 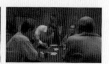

17. MS. 23f **18. MS. 2"20f** **19. CU. 2"2f** **20. LS. 1"20f**

Here, the situation is set out in two clearly defined parts: on the one hand, the group conversation during the game itself and, on the other, the focus on the argument between Silvio and Lillo, which culminates with Lillo leaving the scene and the resumption of the game. The characters' distribution and hierarchy within the scene helps us follow the scene with ease. In the first part, we see Lillo approaching Tony, who whispers instructions as to where to clean. The group is already sitting around the table playing cards. Silvio is also sitting and the camera frames him in the center of the group so that, from the other end, Tony can follow his movements closely. Medium and close-up shots are mainly used in this part to highlight the characters' expression as well as their position at the table. This method is quite practical, as it helps to smoothly guide the conversations through the spatial axis and the sideways looks. Nevertheless, long shots and extreme close-ups are used in certain passages. A cut is defined either by the dialogue or the specific reaction to what the speaker is saying. However, the visual dominance of Silvio at all moments is clear, together with the image of Tony in the background. Let's take a look at the shots. In shot 2, Silvio is located in the center, with Frank Sinatra Jr. to the left of the screen. Shot 3 shows Sunshine towards the back, with Silvio's shoulder acting as a reference. Shot 4 shows Silvio's hands.

Shot 5 is a close-up of Silvio himself, while shot 6 shows Silvio talking to Frank. Shot 8 is a continuation of shot 3, while shot 9 is continuation of shot 2. Shot 10 shows the entire group, with Silvio closest to the camera and Tony in the background. Shot 11 shows Silvio with Dr. Ira Fried, whilst shot 12 is the only extreme close-up and shows Ira throwing a chip onto the table. As we have seen in the theoretical principles, the axis is fundamental to following the scene, but in those cases in which the action does not allow the camera angle due to the characters' circular distribution, the criteria is determined by a key element, whose position serves as a reference for the action and viewer's eyeline. The second part starts in shot 13, which shows Sunshine in what is to be his last intervention. Shot 14 shows Lillo with the broom and it is at this point that Silvio stands up to start his verbal onslaught. The dialogue comprises mainly insults, with Lillo limited to submissively justifying his actions. Editing is carried out using intercuts in which medium shots of Sinatra Jr., Ira and Tony (15–18) are combined with close-ups of Silvio's hand throwing the plate to the floor. The final part of the action is in the form of two long shots showing Lillo exiting (19) and Silvio returning to his seat (20).

Case Study No. 3

Criminal Minds (2008) S4 E1	Director: Edward Allen Bernero
CBS	
Episode: "Mayhem"	Editor: Farrel Levy
Scene: Police diligence	Duration: 40"
Male and female voices, music, effects.	

Summary: A series of terrorist attacks has taken place in prelude to a potential massive attack. Tension is high. David, Emily, Jennifer, Spencer and others are in the police station trying to find clues in the search for the criminals. David and Spencer are in front of a window trying to decipher some written codes. Emily suddenly arrives at the scene to warn them that Penelope Garcia had called but that the computer's network had failed. Before she finishes her explanation, she is interrupted by Jennifer, who arrives from one of the locations of the attacks. Emily asks her if she is OK. A conversation starts in which Spencer also takes part. Suddenly, a new call from the computer is heard. It is Penelope giving details of the location of a bomb. They all turn round and hurry towards the screen. David asks her about the car and whether they have managed to identify one of the suspects. He then turns to Jennifer, telling her to talk to national security. She obeys and hurries from the scene. David turns, looks at the computer and asks Penelope how they can help Morgan, who is alone at the scene of events.

1. MS. 4"13f 2. MS. 20f 3. LS. 2" 4. MS. 3"3f

5. MS. 1"8f 6. LS. 2"5f 7. ECU. 2"2f 8. CU. 1"10f

9. MS. 1"10f 10. ECU. 1"2f 11. LS. 2"10f 12. MS. 2"12f

13. MS. 3"13f 14. MS. 1"10f 15. CU. 22f 16. ECU. 2"3f

The scene is frenetic, typical of a hectic day in a police station. The dynamic is complex, since the characters enter, exit and move in different directions in front of the camera, which constantly changes its point of reference. This could be seen as a complication in editing terms, but this movement is used to introduce cuts and to redirect the attention onto some of the main characters. The first shot (1) shows David in front of a window alongside Spencer looking at some of the places where the attacks have taken place. The camera makes a smooth, descriptive panning movement, moving to the upper left, finally framing David. When the dialogue finishes, Emily, who has just arrived to warn of Garcia's call, is heard in the distance. She can be seen approaching but is out of focus. Although her voice can still be heard, a cut takes the viewer to Spencer, whose expression is one of surprise (2). This way, the editing combines the action of both elements and characters. Jennifer then arrives at the scene, just after shot 3. Emily turns and for the first time is seen in a medium shot. A brief intercut between the two ladies, but the attention is mainly on Jennifer (4), who risked her life by being at the scene of the attack. She talks slowly and her gaze is directed at Spencer in particular. She asks after Morgan. Spencer answers that nothing is known about him (5). The narrative cuts to Penelope, who is talking via the computer. Note the way in which the situations and characters are alternated through the combination of voices and gestures, which act as joining elements. Penelope talks nervously. When Spencer hears her, he and the entire group turn to the screen (6). A cut takes us to Penelope, who can be seen talking on the computer screen (7). Everybody is

now in front of the screen. The camera, from David's location, makes a slight panoramic to show the group (8). A new cut takes us back to David, who is talking mainly to Penelope over the Internet (9). An intercut shows Penelope (10). Another cut shows David asking about the car. A further cut takes us back to the computer, followed by another showing the group (11), with Spencer approaching the window. A close-up shows Spencer writing on the window (12). The camera makes a slight panoramic to the right. A cut to the laptop, followed by another to David, who is talking to his colleagues to the right of the screen (13), especially to Jennifer (14). David turns once again to the computer and finally asks Penelope how to help Morgan (15–16).

In this example, we see some innovative features that are useful for shooting similar scenes. Firstly, note how the scene is guided by the script such that short conversations, dialogues and location changes take us to other parts of the office. Shot 1 is especially important, as it adds an initial camera movement and works on the field depth such that David and Spencer can be seen close up while Emily and Jennifer can be seen in the background. The scene has been planned thus to bring the four characters together in just a few frames. The following segment is, in fact, the most controlled of the entire scene. Shots 2 to 5, which show the dialogue between the two female police officers, watched on by their male colleagues, are fairly solid. Spencer's impact is important. Jennifer's expression is another important component in the action and both factors lead to the close-up of Spencer, who then cuts in. Due to the strength of the group dialogue, there is a preference for close-ups and reverse shots, which allows the tension and connection between all the characters to dominate. Then the shot to Penelope is used to change all positions. A long shot showing the whole group looking at the computer is used to resituate the viewer. The voice-over of Penelope over the shot of Spencer and David is essential to connect the turn in the storyline. Once again, we see mostly static shots and reverse shots combined with a slight panoramic. We then see the final part in which David talks to Jennifer and turns back to question Penelope. Here, the camera movements are extremely useful as they help to incorporate onlooking characters into the scene, converting them into active participants in the events but allowing them at the same time to cut in, even before they are seen. For example, from Spencer's vantage point, shot 12 laterally tracks the characters, passing through David, who is in the middle. Then, before finishing, the shot unobtrusively cuts once again to David. This play adds dynamism and another perspective to the relative monotony of the static shots that characterized the first part.

What to Remember in Filming Dramatic Scenes

1. The location, entrances and exits of the characters in the frame.
2. Show clearly the changes in position (situate with wide shots to show movement and to justify a cut to a new place or element).
3. Define during shooting a shot-sized scheme to create intercuts that show balance or the control of a character over (an)other closer or more distant character(s).
4. Include close-up shots to show reactions and to add variety to similar, repetitive shots or shots with little expression.
5. Use the direction of the dialogue, looks and turns to make cuts which show that something important is happening.

Self-study Exercises: Perfecting the Editing of Dramatic Scenes

Obtain complete dialogue scenes: arguments, emotional, etc. Carry out the following exercises:

1. Make cuts according to various motives: to follow the dialogue, to show the dramatic importance of the speakers' dialogue or the passive onlookers.
2. Edit sequences based on the emphasis of looks, movement and characters' positions.

SCIENCE FICTION SCENES

Case Study No. 1

Avatar (2005)	Director: James Cameron
20th Century Fox	Editors: James Cameron, John Refoua and Stephen E. Rivkin
Sequence: Trailer	Duration: 1'45"

Summary: When his brother is killed in a robbery, paraplegic marine Jake Sully decides to take his place in a mission on the distant world of Pandora. There he learns of greedy corporate figurehead Parker Selfridge's intentions of driving off the native humanoid "Na'vi" in order to mine for the precious material scattered throughout their rich woodland. In exchange for the spinal surgery that will fix his legs, Jake gathers intelligence for the cooperating military unit spearheaded by gung-ho Colonel Quaritch, while simultaneously attempting to infiltrate the Na'vi people with the use of an "avatar" identity. While Jake begins to bond with the

native tribe and quickly falls in love with the beautiful alien Neytiri, the restless Colonel moves forward with his ruthless extermination tactics, forcing the soldier to take a stand—and fight back in an epic battle for the fate of Pandora.

1. LS. 3"15f
Arrival of the spaceship.
2. LS. 3"
General view of ship crossing space.
3. LS. 4"18f
Outside view from within the ship traveling over a landscape.
4. MS. 2"10f
Jake entering on his wheelchair.

The editing in this trailer frequently makes use of fades in and out from/to black. The first shot (1) shows a lateral view of the ship moving downwards across the screen from left to right. The movement is slow. The image closes with a fade out to black. A fade in brings us to image (2) and another space. The spaceship is smaller compared to its surroundings. It is also now moving in a different direction, traveling downwards from the top of the screen, disappearing into the darkness of the clouds. Here this effect of natural darkening resembles a fade out to black. These two shots show different stages of the ship's journey. Shot (3) shows the view from inside the spacecraft of woodland, which it crosses slowly above. Another dissolve fade out to black takes us to image (4). The camera moves to the right in a slight panoramic, revealing Jake going down a ramp in his wheelchair and moving to the control center.

Shot 5 shows a continuation of Jake coming down the ramp. The camera descends and, at the same, follows Jake from the front and side, allowing us to see the inside of the ship. A transition of 2 seconds (6) joins the image with the view of the outside seen in shot 7. The transition is smooth and the merging effect helps create a form of visual cadence. Another fade brings in shot 8, which once again shows internal action: the movement of people lowering the cover of a spacecraft. The camera makes a gentle panorama.

5. MS. 4"10f
Jake tours around the inside of the spacecraft.
6. LS. 2"
Dissolve fade towards the view.
7. LS. 2"5f
View of the outside from within the ship flying over the landscape.
8. MS. 2"
Man lowering the cover of a spacecraft.

We are now shown a series of views of the ship's interior. The narrative structure is once again based on the movement of the objects and the camera. The editing here acts to organize a new sequence from what is happening inside the ship—a double perspective of the action (9) and a cut to show the reaction of one of the characters (10). Note how the editing here addresses the sectioned structure of this sequence and the variety of spaces once again through fades of varying length—long to finish, short to start a new shot. The same transition is used to take us to an image from within the camera (11). Another deliberate darkening to black facilitates a cut to a countershot of a man lying on a stretcher (12). Lighting dominated by blue colors defines this series and some of the special effects to surround the human shape at the end.

9. MS. 12"10f
View through a window.
10. MS. 2"
A countershot of two men looking through the glass.
11. LS. 3"
Interior view of the ship. An object moves towards the camera.
12. LS. 1"10f

13. MS. 1"10f
Scientist looking closely at a computer screen.
14. ECU. 2"
View of the computer screen showing an intense light at the center.
15. CU. 1"
Face of a man woken up by the lights.
16. MS. 2"20f
Raised hands.

The scene changes drastically to the control center. First, we see the relationship with the previous shot—a scientist looking closely at a transparent computer screen in a slight panoramic towards the right (13). He is followed by a shot of what is on the screen (14)—flashes of light of varying color and intensity. We then see a shot of one of the characters (15), who opens his eyes and lifts his head in an indication that he has just woken up. The lighting effect is used as a transition element to move to this shot. Lastly, shot 16 shows hands raised in a sign of a return to life.

Let's now take a look at another section, closer to the end of the trailer. All shot changes occur through dissolve fades of a little over a second in length. We see a small aircraft (17) flying through a jungle. The cuts help to establish the angle between the object and the observer (18)—in this case, a humanoid watching it as it passes

appearance that the craft is close to him, but he is not alarmed by its presence. Once again, the movement and directionality of the objects and looks play an important role in the scene's functioning. A change of angle takes us this time to an enormous animal (19), which tries to kill him. The shot is long and the camera moves rapidly to reproduce the chaos. The last shot (20) shows an extreme close-up of a woman's face, which slowly looks up through the trees.

17. MS. 1"10f
Small craft flying through a jungle.
18. CU. 1"10f
Face of a humanoid looking up to the aircraft.
19. CU. 4"10f
Figure of a roaring monster.
20. ECU. 1"10f
A "woman" observing the scene inexpressively.

This example of a film trailer introduces some interesting elements to our theorizing and is evidently an example that, due to its short, impactive format, can be used successfully in other situations. The narrative structure has some similarities to the language and grammar of the previous examples of action or dialogue, but also specific techniques that should be explained in more detail.

Due to its short format, a trailer has to be a synopsis. In other words, it has to explain a lot of information and show various places in a short period of time. This means that various relevant sequences must be chosen and then joined, using certain factors not only of dramatic value but also uniformity, possible causal, thematic and even pictorial relationships that are different from the order of the whole film. Indeed, the filmmaker has had to weigh up the impact in the choice of these scenes in this trailer: the atmospheric scenes, the characters, the situations, and the rhythm and movement are some of the constant elements found in this example. The narrative connection occurs in the sense of a classical, logical and natural continuity: look-object, observer, object, change in angle and even visualization. However, this style is strengthened by other elements: the movement of objects (the spaceship), the characters and the constant movement the camera makes in every possible direction. All of these features serve to create the final narrative construction of the trailer. Within the organizational framework, the editing in this example joins the sequences through alternating long and short fades. This has been a deliberate decision, since it would have been too sudden for the viewer if the changes had been made to the ship or the characters in different geographical spaces. It is therefore more practical to use a classic procedure to join the shots, as it helps lend more strength to the movements. The lengths of the transitions have been designed to create a direct relationship with the camera movements and in particular with the smooth movement of the displacement of objects. Notice how the ships travel slowly in space.

This speed should not change between sequences; it should be maintained through harmony and natural external rhythm. In contrast, the actions within the same space—the jungle, the laboratory and the workshop—are in themselves very controlled spaces with a uniform background. They therefore condition a direct continual procedure to emphasize looks and reactions to a new world. Here, the cuts tend to be rapid. If the dissolve fades or fades to black are not enough to mark the timing, the trailer format can also make use of inserts with descriptive writing—for example, the director's name, actors or other strong features—to avoid possible visual clashes or changes in rhythms. As in other examples, the music plays a reinforcing role to the characters' emotions and the spaces. The audiovisual synchrony, both in terms of music versus image or effects versus image, is fundamental in science fiction to increasing the impact of new, important stimuli.

Case Study No. 2

Star Wars VII The Force Awakens (2015)	Director: J.J. Abrams
Walt Disney Studios Motion Pictures	Editors: Maryann Brandon and Mary Jo Markey
Sequence: The destruction of the New Republic	Duration: 1'52"

Summary: On Starkiller Base, a snowy, mountainous planet, General Hux addresses legions of First Order stormtroopers. He angrily declares the death of the Republic. The planet has a massive trench around the equator, and a continent-sized aperture. The base fires a massive red beam from the center of the planet, traveling across space, and splitting into four separate beams which destroy individual planets. We see crowds of people on populated planets look up into the sky to witness the conflagration as their planet is destroyed.

1. ELS – CU. 13"20f
General Hux's speech.
2. ELS. 6"20f
Rear view of general Hux talking to his followers.
3. LS. 3"18f
Countershot of the esplanade where General Hux is giving his speech.

The scene shows the moments before a large ground attack. General Hux, escorted by his guards, gives an important speech to his legion. The camera shows in detail the spectacular nature of the space: an open area surrounded by high, snow-clad mountains. The image is created through an extreme long shot and makes a sweeping panoramic combined with a direct close-up of Hux. His fury and expressivity on addressing his soldiers are highlighted (1). Just

4. ECU. 8"
Hux passionately
addressing his soldiers.

5. LS. 1"20f
Hux addressing the
multitude.

6. LS. 1"15f
Technicians sitting in front
of screens.

when the camera captures him slightly off center, a cut takes us to another shot from behind him (2). Through a panoramic movement of the camera, we see the entire background scenery—a wide expanse full of soldiers ready to attack. With the aid of a crane, the camera rises over Hux and shows the multitude in an ELS. Another general shot with a panoramic movement towards the right (3) emulates the direction in which the soldiers are looking. Once again we return to Hux (4), who is coming to the climax of his speech. We see the rise in euphoria and passion, which is shown in an extreme close-up of Hux shouting, "It's the Republic's last day."

The sequence now continues with a view of the soldiers responding vigorously to their leader's call (5). Here the effect of action-reaction is created in perfect mechanical continuity. Everything is ready for the immense attack on the Republic's base planet. The following shot (6) shows the inside of the weapons control center with a quick panoramic in a medium shot showing two technicians in front of computers. Shot 7 involves a cut to a countershot from another angle with a slight zoom to show two women working attentively in front of the computer, waiting for the order to attack. The woman at the front turns to look above the camera, controlling another screen showing the action outside. A cut at this precise moment takes us to a view of the outside. The soldiers line up with their weapons. The camera follows the action from above to show in perspective the "power" of the entire battalion. Hux shouts, "Fire!!!"

7. LS. 1"10f
Other technicians
carefully watching the
screens.

8. ELS. 1"20f
Esplanade and the end
of Hux's speech.

9. LS. 2"23f
The Starkiller launching
its attack.

10. LS. 2"15f
Forest lit up by beam.

11. LS. 10"
The Starkiller launching its
attack.

12. ELS. 3"20f
Nuclear beam traveling
through space.

This section shows how the work of the editing here focuses on the use of weapons and their effects at the start of the attack. Intensely bright lights in different directions attempt to recreate the nuclear attack. The sequence emphasizes the use of color

as a destructive radiating element. Shot 9 shows an intense light that slowly comes out of one of the holes in the spacecraft, with shot 10 showing its devastating impact on a forest. The light is blinding and attempts to reproduce a nuclear attack. A new cut takes us back to the Starkiller (11), which continues its attack. There is no camera movement; it is simply a fixed image of the Starkiller firing its intense beam. Another lightbeam crosses the screen from one side to the other. The shot was totally dark, the lightbeam crossing it from bottom right to top left (12), heading towards a populated area.

13. MS. 1"10f

Man watching the nuclear attack in horror.

14. ELS. 2"

General view of approaching nuclear attack.

15. MS. 1"

Group staring in panic at the nuclear attack.

16. MS. 2"20f

An over-the-shoulder shot of the fireball approaching the crowd.

17A. ELS. 40"16f

The Starkiller attacks with a powerful beam.

17B. LS. 2"

Closeup of the fireball looming over the onlookers.

We now see the image of a terrified man who attempts to flee up a flight of stairs (13). The camera zooms in to show his expression of horror. Shot 14 shows the object they are staring at. The image is completely red and steadily advances. The camera suddenly sweeps rapidly to the left to show a group of people staring horrified at the scene (15). Desperate screams are heard and the music anticipates the imminent tragedy. Just as the camera composes the faces of these characters in close-ups, a new cut takes us to shot 16, which shows the immense ball of fire approaching out of control. When the image is completely covered, it goes white.

 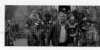

The attack on the Republican planet is shown in this part of the sequence. We see a change in the choice of shot to other more open ones to improve the perspective of the action. The projection of the lightbeam is shown from the beginning (17A). The nuclear light strikes the surface of the planet, producing a

18. MS. 4"10f

A group of individuals coming out of their houses to see the attack.

19. LS. 1"10f

A countershot of the blue sky, the fireball slowly disappearing.

giant, blazing ball of fire. The planet explodes in the same continuous image (17B). A group of people, headed by Han Solo (Harrison Ford), come out of their base to see the attack (18). They look on in horror, with a small red light disappearing into the blue of the sky (19).

What to Remember in Filming Science Fiction Sequences

1. The use of transitions such as dissolve fades or fades to black can be very useful to emphasize prolonged changes in space and time.
2. The length and speed of the transition should be decided according to the rhythm and speed of internal or external movement indicated by the image or the sound. If we fail to match them, the result will create a noticeable jolt.
3. Choose shots with camera movement or action and respect the end points of the shot. It will be easier to apply accurate cuts.
4. Exploit the spectacular images of spaceships, attacks and other strong visual elements, combining them with dialogue or conventional scenes to generate a change in narrative rhythm.
5. Introduce expressive details between the more open shots. Combine the emotions and include a change of angle to other dramatically relevant features.

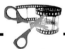

Self-study Exercises: Perfecting the Editing of Science Fiction Sequences

1. Combine various audiovisual elements such as static and moving images. Try cutting before, during and after the action of the main object.
2. Create various versions of the sequence, varying the sense of displacement of spacecraft and objects. Connect and disconnect the previous and following shots and observe the effects on the emotions and physical continuity of the cuts.
3. Explore synchrony, with the music or effects inserted afterwards.
4. Make use of changes in light (day to night, space, moons, etc.) as opportunities to create an impression of mystery, fear or happiness. Science fiction makes much use of unexpected spectacular effects.

COMEDY SEQUENCES

Case Study No. 1

Coming to America (1988)	Director: John Landis
Paramount	Editors: Malcolm Campbell and George Folsey Jr.
Sequence: The club scene	Duration: 2'22"

Summary: Akeem Joffer (Eddie Murphy), the prince and heir to the throne of the fictitious African country Zamunda, is discontented with being pampered all his life. The final straw comes when his parents, the stuffy King Jaffe (James Earl Jones) and Queen Aeoleon (Madge Sinclair), present him with a bride-to-be (Vanessa Bell) he has never met before, trained to mindlessly obey his every command.

Akeem and Semmi are in a luxury disco in Queens, New York. They sit at a table and several women approach them, showing off their various qualities to win Akeem over. The first part of the scene establishes the context. Akeem and Semmi enter accompanied by a woman and pass along an aisle until they reach a table. We then see a series of conversations with various women. The narrative structure shows various and somewhat absurd declarations to show the reactions of Akeem. Disco music is heard in the background while the characters are talking.

1. ELS-CU. 2"
The Devil Woman.
2. SMS. 3"25f
Akeem and Semmi sitting at a table.
3. MS. 2"15f
Woman having a drink at the table.
4. MS. 8"
Lisa MacDowell talking to the camera.

Shot 1 introduces the Devil Woman, who says, "I have a secret: I adore the Devil." Akeem and Semmi (2) listen to her in surprise. A cut introduces another woman, a little older and more forceful, to the scene (3). There is an intercut to the two men and the conversation is slightly longer. This second dialogue is joined with an overlap to see the reaction of the main characters. The Devil Woman drinks several glasses of brandy and when she talks she says men do not satisfy her. The next shot shows Akeem and Semmi sitting at another table and even in different suits. They listen to the woman they are with carefully. The image cuts to three other consecutive shots of women. The first is Lisa MacDowell (4), who casually says, "the ideal man should have a big BMW."

Another direct cut to shot (5) reveals another woman with a somewhat defiant manner, who says, "I'm single – my husband is on Death Row." Twin sisters follow in shot (6), who say, "this is our first date since the surgeon separated us." A new cut takes us back to Lisa (7), who is dressed in a more seductive dress and says "I like groups." Once again, the camera returns to close-up of Akeem and Semmi (8), who look on, smiling. We see the sequence of shots with the same background but in which only the characters change. Akeem and Semmi's general expressions are simply as observers of what each woman is explaining.

5. MS. 4"10f
Akeem.
6. MS. 3"14f
The twins.
7. MS. 3"5f
Lisa.
8. MS. 1"15f
Akeem and Semmi sitting at the table.

9. MS. 6"10f
The red woman.
10. SMS. 2"10f
Akeem and Semmi sitting at a table.
11. MS 6"20f
The twin sisters.
12. SMS. 3"
Akeem and Semmi sitting at a table.

This section shows a new round of interviews with the same characters once again explaining their opinions, which are not so much about their views of men but about themselves. The red woman starts the series (9). Holding her hand over a cigarette lighter, she declares, "in my previous life I was Joan of Arc." Following a slightly longer pause, a new cut shows the shocked reaction of Akeem and Semmi (10), while the lighter is still heard in the background, which is used to masterful effect as a connector— in the background, we hear the twin sisters snapping their fingers prior to starting to sing a short song "everyone wants to touch me ..." (11).

Another cut to Akeem and Semmi, who are still in the same position. The shot is the same as (10), although this time the two are seen with their jaws dropping in surprise.

We now come to the final part of the scene, in which once again we see Lisa (13), who says, "I don't want to make videos, but I do want to be the star. I would love to be a singer ..." The long dialogue connects with the image of Akeem and Semmi asleep (14). We now see another temporal-spatial jump. A large lady, looking very much like a man, is sitting middle shot to Akeem (15), seductively eating a cherry. She suddenly blows a kiss at Akeem. A cut shows Semmi's reaction (16), who spurts out his drink in surprise.

13. MS. 10"6f
Lisa.
14. MS. 8"
Akeem and Semmi asleep at the table.
15. MS. 1"
Akeem sitting next to a woman.
16. MS. 4"30f
Semmi violently spluttering in surprise.

The editing in this scene mainly exploits the expressions of lead actor Eddie Murphy and his co-star, who plays the part of Semmi. The situation progresses from the narrative point of view through the use of a collage between the main actors and a series of women talking about their lives and emotions through a succession of images between small temporal jumps. We start with a scene-setting sequence. Akeem and Semmi enter the disco, taking in the atmosphere, looking at people sitting at tables either side of them. Throughout this part, the camera follows them in a long shot so that the viewers can familiarize themselves with the place. The disco music is loud but not so loud that voices cannot be heard. The editing's visual play here is the change in function of the women's conversations. The characters change in both location and time and even wardrobe, but in medium shots the narrative thread of the testimonies of each woman is what gives the scene perfect unity. Each woman's interview is connected logically yet distinctly with the following, which avoids any disruptive jumps in continuity. The story flows basically because the thematic thread of the women's interviews is the "ideal type" of partner, what type of women they are, and what they expect of Akeem. Note how the women are quite distinct. Cuts use this feature as a storyline connector based on "type" and the variety of women who want to marry the prince. In other words, they are different women, with their own styles and tastes in men, but we always see their "qualities" grouped together. It is interesting to note that, except at the start of the scene, Murphy and his co-star do not talk.

There is no need for them to do so in terms of the functioning of the sequence; what is important is what the various women say. The characters vary in their visual characterization so that they appear fairly distinct from each other. Both what they say and the way in which they say it is also important in creating this impression, as is the way the series of matrimonial attributes has been assembled through editing. As we have previously mentioned, in shots 6 and 8 the sound of a cigarette lighter has been used as a connecting element between two interviews. The overlap merges with the whispering of the twin sisters before singing. The similarity is used well as a nexus. Indeed, it also helps to increase the impression of continuity of action when this transition occurs over the image of Akeem and Semmi. The comic effect lies in the visual reactions and expressions of the two men to what they hear. The complicity between the two reinforces the comic effect of what each of woman says. We therefore see a mutual strengthening of attributes for the functioning of the scene.

Case Study No. 2

Mr. Bean's Holiday (2007)	Director: Steve Bendelack
Universal Pictures	Editor: Tony Cranstoun
Sequence: The chicken chase	Duration: 2'35"

Summary: The scene starts partly through the sequence, with Bean on his way to look for a ticket, which has accidentally stuck to a chicken's foot. Bean steals a nearby bicycle and follows the pick-up, and passes a cycling race in the process. When he reaches the farm, he finds a large chicken pen with thousands of chickens and realizes that he'll never find the ticket. As he leaves the farm, he finds the bicycle destroyed by a passing lorry. Bean attempts to hitch a ride on a moped, but it wouldn't go since it can't take two people. Ironically, a VW van with Stephen in it passes by when Bean accidentally locks himself in an old outhouse by the side of the road. After almost getting killed by a passing truck when he has managed to move the outhouse out on the road, Bean sets off for a place to settle for the night. The scene takes the classic form of a chase but with comic elements that Mr. Bean normally delivers.

1. ELS. 6"10f Bean on the road.
2. LS. 5"30f Bean riding a bicycle.
3. LS. 3"10f View of the road from Bean's perspective.
4. CU. 2"15f View from behind Bean on the bicycle.

As usual, this first part of the situation sets out the scene for the audience. Bean is in the middle of a vast open road. Shot 1 is a long panoramic of the chase and shows the distance that

separates Bean and his target, which is fundamental in evoking the dramatic nature involved in recovering the ticket. A cut shows the bike in detail (2). The shot starts with the wheels and opens gradually to fully show Mr. Bean. Both shots maintain the continuity of Bean's speed on the bike. In the following shot (3), we see, from Bean's perspective, the truck carrying the chicken. The distance between the two is now shorter. Shot 4 meanwhile shows Bean chasing the truck from behind.

There is now a change of angle. The camera is now in front of the pick-up truck (5), with the driver on the left and in the background towards the right, Mr. Bean, who is catching up. The first comic situation occurs as they go round a bend. Another pick-up, which enters in shot (6), suddenly appears and tries to overtake Bean, who is in the middle of the road. Bean lets it go past and, as it does so, he grabs hold of the tail end to get a tow. Shot 7 shows him looking somewhat nervous at the speed at which the truck is going. The following shot (8) shows the road racing past underneath.

5. CU. 2"20f
Driver at the wheel of the pick-up.
6. LS. 8"10f
Bean next to the second vehicle.
7. MS. 1"
Bean grabbing hold of the tail end of the second truck.
8. MS. 1"2f
View of the road from the bicycle.

The second truck suddenly stops, launching Bean forward (9). The camera maintains a wide frame to give preference to the context of Bean with the other cyclists (10 and 11). Here we see Bean's look of happiness, which produces another comical moment when we see him on his little bike passing a group of

9. CU. 1"23f
Bean overtaking the second pick-up.
10. LS. 4"20f
Bean passing a group of cyclists.
11. ELS. 3"25f
Bean passing the cyclists.
12. MS. 3"20f
Rear view of the chicken van.

professional cyclists. Note how we see him in full from the moment he enters the frame to the moment he leaves it. His greater speed creates a difference with respect to the other cyclists—Bean always stands out against the others. We now come to shot 12. Bean's acceleration allows him to catch up with the chicken truck, with the shot showing in detail the image's content.

13. LS. 1"15f
Bean catching up with the chicken van.
14. ECU. 2"
The chicken.
15. CU. 2"15s
The ticket stuck to its foot.
16. CU. 3"
The van driver eating a chicken leg.

Mr. Bean is just about catching up with the pick-up (13) and can see inside it. He now grabs hold of the van and finds the chicken (14) and the ticket stuck to its foot (15). Notice how the relationship of distance between the two elements has been built up shot by shot. Bean's center of attention, and the scene's raison d'être, is gradually emphasized. A pause allows the audience to take a break from the drama. Note how this is applied just as Bean notices the ticket he has been chasing down. Both shots are close-ups and are quite short in comparison to the previous shots. The camera also moves in an attempt to emulate the movement of the bicycle. A change to shot 16 shows the van driver calmly eating a chicken's leg. Note how this is the same as shot 5 but without Bean; there is no need to show him, as he has practically caught up with the van.

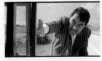 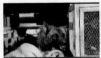 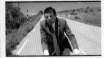

17. CU. 1"10f
Bean opening the truck door.
18. CU. 12f
The dog jumping out from behind the cage.
19. ECU. 15f
The dog barking.
20. MS. 1"15f
Mr. Bean, shocked.

We finally reach the denouement. The comedy chase continues. Mr. Bean finally manages to grab the cage holding the chicken with the ticket. He has to stretch to reach it (17), his face reflecting the effort. All of a sudden, and without having seen it before, a dog leaps out from behind the chicken cage (18). There

is then a close-up of Bean, who backs off, surprised, followed by another shot of the dog (19). These three shots are very short. Shot 20 shows a shocked Mr. Bean, who stops suddenly. Two further shots show him dropping behind the truck. Bean continues the comedic chase. The sequence culminates when, moments later, he comes to an enormous chicken farm with hundreds of chickens, at which point he has no idea where to start looking for the ticket.

In this example, we see some interesting editing elements. The scene is part of a longer sequence that centers on hunting down a chicken. The editing employs expressively all the features in the scene: the road, nature, truck, bicycles. We see how Mr. Bean reaches the van, overcoming various adverse situations through sheer luck. This is a key feature, typical of Mr. Bean films, that at the filmic level needs to make its present felt to produce a comic effect for the audience. Note that we can divide this sequence into two parts: Bean's attempts to catch up with the chicken truck and when he finally grabs hold of it. In the first part, the work of editing is in clearly building the impression of relative positions and distances between the main elements (Bean and the chicken van) without showing details, as we already know from what we have seen before that the chicken is there. Notice how the first shots are general: the road, long shots showing Bean and the relative distances between the two central elements. The multi-perspective combination of close up/far away and then whole shots is key here. There are no detailed shots, so the comic effect must come from Bean's actions: being launched by the second pick-up and speeding past a group of cyclists. This creates an immediate comic effect, not only because he overtakes them but also because he manages to do so on a rickety old bike. Having established the distances, the action starts to use close-up shots: his face, the wind ruffling his hair, his immense effort in catching up with the van and his suit. Note how these are all combined to intensify his usual expressions to great comic effect. The two shots of the driver eating the chicken leg act simply as a break from the comedic actions of Bean and to remind the viewer that there is a second element in the action. Notice how this shot helps to take us to the scene's key part—that of him reaching the chicken van, which is the high point of the scene. There is a new play here between the now shorter distances, which are shown by equally shorter, briefer shots, as they show concise information for the spectator and because they form a brief part of the situation: the chicken, Mr. Bean, the dog. Notice how the effect of surprise is achieved between the image and the dog. It has not been seen before in the scene; only the cage with the chicken in it. As it is a new, sudden element, it works well as a surprise effect. The shots here are much shorter and mobile, trying to emulate Bean's shock and nervousness. There are also several intercuts between the two to combine the dog's ferocity and Bean's fright. A new shot shows Bean slowing down to indicate the new distance between the two. The zoom-out shows this event well, finishing off with Bean's expression. However, the story of the ticket continues for longer on the screen.

What to Remember in Filming Comedy Sequences

1. Make maximum use of the lead actor's/actors' expressions and gestures, using close-ups or medium shots to show his/her/their movements. Do the same for the reactions of other actors to show action versus reaction.
2. Lengthen the shots to prolong the comic effect and to give the viewer time to laugh.
3. Introduce dramatic elements or changes of angle to recover with greater intensity the comic section with the lead actor.
4. Introduce multi-angle shots to define positions and distances.
5. Reproduce the previous movement in a countershot to show the viewpoint and action of the main character.

Self-study Exercises: Perfecting the Editing of Comic Sequences

1. Experiment with versions of editing using different shot lengths: expressions and reactions.
2. Assess the comic effect of a scene using close-ups and longer shots.
3. Create versions of scenes, varying the position of the shot. Test its final effect by locating it earlier or later in the sequence or even joining it with another situation.
4. Explore the comic effect of connecting situations showing simultaneously action and reaction. For example, visual action versus spoken reaction, or spoken action versus visual reaction.

NEWS ITEMS

Situation	Aim	Structure of news item
1. Current news	1. Chronology of events	1. Off-screen voice
2. News summary	2. Multiple perspectives	2. Live interviews
3. Report	3. Following the action	3. On-location reporter
	4. Scene construction	4. Archive images

Case Study No. 1

News	CNN International (5/26/2011)
Oprah Winfrey's retirement	Duration: 45"
Female voices, background sound, music.	

OW: "I won't say goodbye. I'll just say, 'until we meet again.' To God be the glory."
VO: "With those words Oprah Winfrey stepped off the stage and into TV history, with today's finale of the Oprah Winfrey Show."
OW: "I thank you all for your support and your trust in me."
BACKGROUND SOUND OF SHOW/VO: "Unlike the rock-concert vibe of the two previous shows that featured star after star after star, and surprise after surprise after surprise, today's Oprah finale is striking in what it lacked."
Kelly Zink: "They're expecting tons of celebrities, or even a new audience or her life in flashes, that's not going to happen. It was just Oprah on stage all the time."

1. LS 3"21f 2. MS 12"16f 3. LS 1"8f

4. MS 3"23f 5. BS. 3f 6A. LS

6B. TT. 5"20f 7. 1"21f 8. CU. 23f

9. CU. 21f 10. MS. 2"3f 11. CU. 5"20f

This example consists of a news item reporting highlights from the farewell program of ABC presenter Oprah Winfrey. It shows clips from shows and is structured around emotional and spectacular aspects associated with the end of this emblematic US program. The CNN news production includes complementary subtitles throughout. The first shot (1) is a medium shot showing Oprah giving

her closing words. The camera shot widens to a general view of the stage and follows her rightwards from a distance. A cut to image 2 shows her in a long shot. At this moment, the reporter's voice-over begins, while we see her exit through a vast audience. The video then show another shot of an emotional Oprah: "I thank you all for your support and your trust in me," firstly in a long shot (3) and then in a medium shot (4). At this moment, a brief summary of her career highlights her immense presence. The clip then includes a short transition effect, which is the image itself spinning and acts to link one shot to another (5), as happens in broadcasts of dance programs or shows. The effect only lasts four frames. There follows a very long shot from the stage itself that takes the form of a semicircular traveling combined with a gentle zoom-in to emphasize the size of the TV set (6). The shot finishes with the image of Oprah herself, this time in a close-up. There follow a series of clips from the show of politicians and artists such as Madonna and Jennifer Lopez (7–10). The piece then takes us to the presenter Kelly Zink (11) saying, from the CNN set, "Everything comes to an end," and we then see the final action of the shot. We also see other important details. Most of the visual elements in this piece are clips from the program itself to show well-known celebrities. The news item combines real testimonies from Oprah, who acts as the main reliable source, along with summaries by the CNN presenter. The images of Oprah form the center of the news report. She is the protagonist and the piece highlights her emotions through clips of expressions and gestures and of her voice shaking at her "farewell to the screens." This summarizing first part is followed by the second part, which aims to explain why Oprah decided to bring to an end one of the most iconic television programs. Finally, as a way of bringing the piece to a closure, we return to the reporter, who says: "A farewell and no coming back ..."

Case Study No. 2

News	Spanish Television (07/20/2011)
Teacher strike in Madrid	Duration: 1'38"
Female and male voices, music, effects.	
Commentary	

OS: "Three hundred public institutes, in which 400,000 secondary, baccalaureate, professional trainee and special education students study in the Community of Madrid, are on strike today. However, all have minimum services in place and have opened with at least the director or head teacher in attendance. The four unions that have called for strike action say that 90 percent of more than 20,000 teachers called to strike have backed the action. The Community, however, reports that the figure is lower, standing at 43 percent."

Presenter: "Good evening. Teachers talk of cuts. The regional government says there haven't been any and is only asking that teaching staff make a little extra effort in such a delicate moment. The President of the Community claims that the strike is political and believes the Socialist party to be behind it. The Socialists, however, say the strike is the result of unjustified cuts."

Esperanza Aguirre: "General elections are looming and the Socialist Party, United Left, the unions, all of them are extremely interested in prolonging this conflict, a conflict that is purely political and that should not be taking place."

Tomás Gómez: "It is Mrs. Aguirre and her government who are responsible for this strike action. Basically, they are the ones who have caused this action, with those brutal, drastic and unjustified cuts to education."

Rosa Lacalle: "Grants, of course, ten teachers less in our center. We can't divide classes, we can't broaden any subjects, so it affects those who have difficulties. But it also affects those that don't."

1. CU. 1"15f 2. MS. 1"6f 3. LS. 3"23f

4. LS. 1"20f 5. LS. 2"3f 6. LS. 2"

7. LS. 2"1f 8. LS. 1"23f 9. MS. 20"20f

10. CU. 13"16f 11. MS. 15"12f 12. CU. 17"15f

This is an interesting example of a descriptive and multi-perspective treatment of events. The news piece combines various visual elements: images of coverage, interviews and information from the news set. In the first part, we see a brief review of events accompanied by the TVE news program's theme tune. The visual sequence shows a close-up of a digital watch displaying 08:00 (school start time in Madrid) (1), followed by a series of shots of the outsides of the schools taking part in the strike in an attempt to present an unusual occurrence in the school timetable. A series of cuts are made between shots of the day's strike. Shot 2 is a medium shot showing the school gates closing, while shot 3 is a long shot showing a small group of strikers apparently arriving at the gates of a state school. We then see various images of students gathered outside schools, whose gates are either closed or slightly ajar (4). Shot 5 shows students inside a school building looking out of the windows, while shot 6 shows them grouped behind closed gates and shot 7 shows them sitting in virtually empty classrooms. Shot 8, meanwhile, is of students arriving at the doors of a school with the long shot showing a group of young people sitting outside another center. This sequence is used to complement the first part of the news item, with background music.

The news clip then shows a series of three interviews that complement the information:

Esperanza Aguirre (President, Community of Madrid) (10).
Tomás Gómez (General Secretary, PSM) (11).
Rosa Lacalle (Teacher) (12).

The interviews summarize the views of the events from three distinct perspectives: the Madrid government's (Esperanza Aguirre), the opposition's (Tomás Gómez) and teachers' (Rosa Lacalle). No superimposed images are used and the presence of each part relating to the strike is balanced by the duration of each section.

Case Study No. 3

News	TELECINCO (07/20/2011)
Re-election of Barack Obama	Duration: 1'34"
Background noise, male and female voices.	
Commentary	

BACKGROUND NOISE/VO: "Celebrations following the success of the winners, but heartbreak for the losers. Yesterday put a full stop to an extremely expensive sprint race that was made all the faster by Republican expectations after the

Democratic defeat in the 2010 legislative elections and which the ballot boxes brought to a crashing halt. Obama, the first Democrat since Roosevelt to be re-elected with more than 50 percent of the votes, has another four years. He will continue to travel in Air Force One, planning a second mandate in which the White House occupants try to leave their mark in history. Reagan did it with Gorbachev, Clinton in Camp David and Bush with varying success in his own war against terrorism. And his goal seems to point towards the Asian giant, which is experiencing a radical change."

BACKGROUND NOISE: "The large Democratic coalition has won thanks to women voters, young voters, but above all to the Hispanic voters."

INTERVIEWEE: "He was going to win because the other wasn't."

VO: "They have forgiven him for not going through with his migration reform."

INTERVIEWEE: "Obama has paid a little more attention to the needs of the Hispanic community."

VO: "And he mustn't fail this time, as there are more than 12 million votes at stake."

INTERVIEWEE: "The Republicans need to make more of an effort in this respect."

VO: "Also, their anti-abortion stance and rejection of contraceptives have lost them a lot of the women's votes. They've alienated the young through their indifference to the environment and the middle classes because of their attacks on public spending and their failure to tax the wealthiest. The Republicans represent white men, the country's fastest decreasing demographic group, and a radical change in their ranks is needed."

1. LS. 2"8f	2. LS. 1"14f	3. ECU. 4"6f	4. LS. 2"8f
5. MS. 2"	6. LS. 1"19f	7. MS. 1"14f	8. LS. 6"22f
9. MS. 1"14f	10. MS. 1"14f	11. LS. 4"	12. MS. 2"6f

13. LS. 4"8f 14. CU. 3"5f 15. CU. 3"22f 16. MS. 1"24f

The news piece attempts to visually indulge in the post-electoral atmosphere by observing the reactions of the various parties involved. The situation is put into context through a short sound clip of background noise followed by commentary. VO: "Celebrations following the success of the winners (1 and 2) but heartbreak for the losers." The first two shots show the jubilations of Obama supporters, while the next three show the losing presidential candidate, Mitt Romney (3–5). "Yesterday put a full stop to an extremely expensive sprint race (3) that was made all the faster (4) by Republican expectations after the Democratic defeat (5) in the 2010 legislative elections (6) and which the ballot boxes brought to a crashing halt." At this point, the images show the triumph of the Democrats in more detail. "Obama" (7) "the first Democrat since Roosevelt to be re-elected with more than 50 percent of the votes, has another four years." The images coincide perfectly with the commentary. "He will continue to travel in Air Force One (8), planning a second mandate in which the White House occupants try to leave their mark in history. Reagan did it (9) with Gorbachev, Clinton in Camp David (10) and Bush with varying success in his own war against terrorism (11). And his goal seems to point towards the Asian giant (13), which is experiencing a radical change." Pause filled by BACKGROUND NOISE. "The large Democratic coalition has won thanks to women voters, young voters, but above all to the Hispanic voters." An insert shows an interview with a woman with a Hispanic accent. INTERVIEWEE: "He was going to win because the other wasn't" (14). The voice-over continues: "They have forgiven him for not going through with his migration reform." A man with a Hispanic accent speaks. INTERVIEWEE: "Obama has paid a little more attention to the needs of the Hispanic community" (15). VO: "And he mustn't fail this time, as there are more than 12 million votes at stake." A second cut to a speaker. INTERVIEWEE: "The Republicans need to make more of an effort in this respect." VO: "Also, their anti-abortion (16) and rejection of contraceptives have lost them a lot of the women's votes. They've alienated the young through their indifference to the environment and the middle classes because of their attacks on public spending and their failure to tax the wealthiest. The Republicans represent white men, the country's fastest decreasing demographic group, and a radical change in their ranks is needed."

Here we can see a style of treatment that attempts to strengthen both sides of the argument in the North American Presidential Elections. The reporter's commentary opens with the following assessment: "Winners and losers." Shots of opposing content are shown of each side: images of joy for the Democrats (1–2) and sadness for the Republicans (3–4), followed by a shot of Romney (5).

In the second part, the news report focuses on explaining the defining arguments of the Obama victory, accompanied by various shots of post-results celebrations. At this point, the reporter briefly summarizes the achievements of the North American ex-presidents and how they defined their governing styles. Text showing their names is complemented by corresponding archive images: Reagan, Clinton, Bush and the measures under Obama's consideration in his approach with the Asian giant (China) (9–13). The third part shows interviews with Hispanic voters only (14 and 15), who, according to the presenter, were decisive in the Democratic victory. In the last part of the report, the presenter focuses on explaining why the Republicans lost a large part of their traditional voters.

Case Study No. 4: Sports News

News	WPTV News (07/27/2015)
Jacoby Ford training	Duration: 1'04"

Summary: Cardinal Newman graduate Jacoby Ford training for NFL rebirth with XPE founder Tony Villani in Boca Raton, Florida on ESPN 106.3. WPTV's Emerson Lotzia reports.

1. MS. 15"
Presenter Emerson Lotzia in front of the camera.
2. LS. 5"
Jacoby working on a pulley and running in front of the camera.
3. LS. 2"15f
Image of Jacoby training under the supervision of Tony Boloña.
4. CU. 12"8f
Image of Jacoby training under the supervision of Tony Boloña

It is five days to go to the 2015 Super Bowl. In the first part, the presenter Emerson Lotzia (1) explains the background to the news of Jacoby Ford's recovery for the final of the Super Bowl ("a miracle"). Behind the presenter, we see images of Ford's injury and a fast sprint in an earlier game. We see emotional expressions to provide a good news item. The footballer is about to celebrate his 28th birthday and may also sign a new NFL contract. A sweep shot starts the piece along with the presenter's voice, but this time edited with images.

The camera makes a panoramic shot (2) to show Jacoby's efforts working at a pulley. The shot is notably descriptive of the situation. The following shot is

shorter (3) and shows his workout being monitored by his trainer, who appears in the previous shot in the bottom right of the screen. Shot 4 shows a similar situation. No background sounds of the gymnasium or conversations are heard; only the voice of the presenter reporting the news. Titles complement the narration.

The introduction finished, we then see more specific details of the sportsman's training. The editing structure this time consists of close-ups from various angles to highlight on the one hand the effort involved and, on the other, Jacoby's condition having recovered from injury, in a close-up showing him pushing weights (5). The camera moves from his feet up to his face (6) or focuses on his face only (7) to match the dynamic of the workout and to see him using the training equipment. Jacoby is seen therefore from various angles (looking in different directions and from various positions). As the physical effort involves his entire body, shots panning up from his feet to his head or showing his entire body are shown (8)

5. CU. 2"20f
Close-up showing Jacoby pushing weights on a rail.
6. CU to LS 1"9f
A close-up of Jacoby's feet as he runs on a running machine. The camera zooms out and he is seen in the last part in a long shot.
7. CU. 2s
Detail of Jacoby from a low angle gripping a bar.
8. MS. 2s
Jacoby running on a track. The camera zooms out.

9. CU. 2"
Jacoby's head in profile. The shot fades out to white and changes to the interview.
10. MS. 10"
A medium shot of Jacoby talking in front of the camera.
11. LS. 3"
Jacoby training for the NFL rebirth.
12. ECU. 1"
Heart rate monitor.

We are now in the final part of the news item. Shot 9 shows another close-up of Jacoby during a warm-down session, with Jacoby facing the left-hand side of the screen. The camera zooms out slightly and fades to white. We then see Jacoby talking to the camera, providing some statements from the Tennessee camp (10). In the final part, we see more training images showing Jacoby running (11) and a close-up of a heart rate monitor (12).

This example shows a conventionally edited news piece. Note the presence of an editing "template" for this type of news item: an opening shot of the presenter by way of introduction and then the facts. The use of special effects (panoramic shots and others) helps to identify each section and to distinguish the "live" section from the "recorded/edited" section. The editing structure predominates quite a bit more than the news content itself, both for the sportsman's dynamic routine and his recovery plan. The piece reports on a national sports idol recovering from an injury. It is important therefore to show the details of this process. The information provided by the presenter at the beginning establishes the context and is especially encouraging for Jacoby's fans. General information is also supplied: where and who the news in question involves. His possible new contract with the league is also discussed. Having introduced the background details, we start to see the details of his rehabilitation, accompanied by the voice of the newsreader. The setting is a gymnasium and therefore the most important thing from a news point of view is Jacoby working out. The presence of other individuals and elements is reduced to a minimum to contextualize the viewer. Everything centers on Jacoby: how he runs, sweats, exercises, moves. Note how the shots vary in size and angle and how many of them maximize the internal movement and the camera movement as a factor of action and change of perspective, since the news piece takes place in a specific space and in a limited amount of time. The physical dynamic needs to be maximized to show the sportsman on various machines. Shots show his feet while he is sprinting and of him pushing weights and working out on pulleys. Note that, although the action is intense and centers on only one individual, there are no editing mistakes in terms of continuity. The changes from the feet to head or the heart rate monitor at the end are smooth. Even though there are zoom-outs, a cut to Jacoby himself does not create any problems, as the position or angle of Jacoby always changes. He is always looking at or working out in different places and facing either side of the screen. This avoids any impression of a 180° violation or visual jump. The editor prudently uses a fade to introduce the interview and to avoid any possible disturbance in perceived time (past, present, past) for the viewer. The amount of time we see Jacoby talking in front of the camera is brief, but enough to see his name in the subtitles. We then see more details of his training regime.

What to Remember in Creating News Pieces

1. A clear, detailed explanation of events.
2. Chronological and achronological evolution.
3. Temporal balance and contrasting opinions.
4. The use of archive material.
5. The use of background sound effects to increase the impression of reality.
6. Use of on-location reporters as a presential reference.

Self-study Exercises: Perfecting the Editing of News Items

Obtain some original news archive material of various events. Carry out the following exercises:

1. Analyze the entire news material.
2. Construct different versions of the commentary, highlighting various aspects related to the events shown.

ADVERTISING

Situation	Aim	Scene construction
1. Dramatization 2. Storyline 3. Gag or unexpected event	1. To persuade 2. To convince	1. Continuous editing 2. Flashback 3. Relation by similarity/contrast 4. Close-up of product/brand

Case Study No. 1

Seat (2007)	Agency: Atlético
Seat León	Duration: 46"
Male voices, music, effects.	
Commentary	

BACKGROUND NOISE/VO: "At eight o'clock this morning I saw a shadow and then heard a roar" /ROAR EFFECT/ "I saw it at eight this morning leaving the city" /ROAR EFFECT/ "I saw it at eight too. I blinked and it disappeared, hahaha" /ROAR EFFECT/ "I saw it to the southeast of the lake at eight" /ROAR EFFECT/ "It disappeared into the mist" /ROAR EFFECT/ "It looks like there's more than one out there" /ROAR EFFECT/ "The new Seat Leon, for those who believe in driving"/ /"Auto emoción."

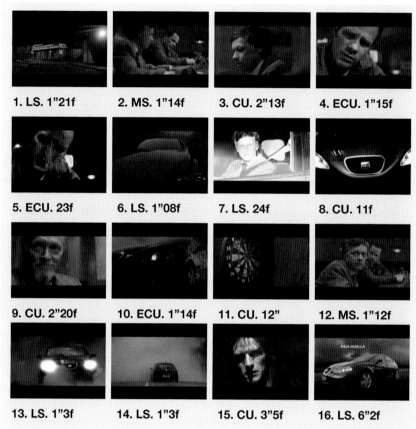

1. LS. 1"21f 2. MS. 1"14f 3. CU. 2"13f 4. ECU. 1"15f

5. ECU. 23f 6. LS. 1"08f 7. LS. 24f 8. CU. 11f

9. CU. 2"20f 10. ECU. 1"14f 11. CU. 12" 12. MS. 1"12f

13. LS. 1"3f 14. LS. 1"3f 15. CU. 3"5f 16. LS. 6"2f

The Seat León car advert takes the form of a mysterious story, using the overall expression of its photographic treatment, the characterization and especially the dialogue and the way the actors express themselves. The narrative schema is quite evocative: "the image that was seen, the moment it was seen." The commercial begins with a shot of the outside of a factory (1). Next, from inside it, we see a group of men talking in an office (2 and 3). A conversation takes place between several of them in which they refer to "something" that was seen earlier. The experience seems to have had an effect: "At eight o'clock this morning I saw a shadow and then heard a roar." The sentence is accompanied by the sound effect of a roar in a close-up shot, followed immediately by a flashback in which one of the character's faces changes (4 and 5). This serves to link the previous sequence with a clear image of a car (6) along with other shots of fast-growing computer-generated branches. We then return to the office, where the men continue talking. We hear: "I saw it at eight this morning leaving the city." A ROAR EFFECT and a second flashback. This time the three shots are more explicit and show the driver of a well-lit car (7) and a fleeting glimpse of the Seat logo (8). The situation takes us back to the office, with a general shot showing the place. More talking, this time

an older man: "I saw it at eight too. I blinked and it disappeared, hahaha" (9). The roaring effect cuts in for the third time and a third flashback is seen in shots 10 and 11. In the office again (12): "I saw it to the southeast of the lake at eight" /ROAR EFFECT/ "It disappeared into the mist" (13–14) /ROAR EFFECT/ Interior: "It looks like there's more than one out there" (15). A close-up shows the enigmatic face of the actor. Another ROAR EFFECT and, finally, the brand legend: "The New Seat León, for those who believe in driving" /"Auto emoción." A long shot shows the car crossing the screen (16). Note how the composition of this commercial helps create suspense through the subject of conversation. Its duration (20") does not allow this suspense to be drawn out, but the photography—the darkness and shadows—along with the particular way the characters express themselves through their dialogues, helps strengthen this perception. The product gradually appears in the following shots and the last part, in which we hear "It looks like there's more than one out there," is a key moment in that more detailed information of the product is shown, which is heard and shown in the slogan and titles. Another fundamental element of the advert's functioning lies in the systematic use of the "roar" effect, which we hear repeatedly throughout and is associated in this case with the model—the Seat León. Technically, it serves as an effective transition to fix the various flashbacks and to emphasize the animation effects seen at various moments. In summary, this advert is a good example of maximum exploitation of the brief amount of time available in which to transmit a great deal of information. The narrative form and the use of all the audiovisual resources makes it possible to show a product briefly in a way that satisfies specific commercial and persuasive objectives.

Case Study No. 2

Johnson & Johnson (2015)	Agency: McCann Erickson
Baby shampoo	Duration: 20"
Male voice, music, effects.	
Commentary	

"The eyes of a child are beautiful in any color, big and red. Johnson shampoo for babies: it keeps them beautiful. So gentle that it passed our 'no more tears test.' It looks after their blue, green and brown eyes. With Johnson shampoo for babies: no more tears."

1. ECU. 1"8f **2. ECU. 15f** **3. ECU. 18f** **4. ECU. 1"2f**

5. MS. 11f **6. ECU. 1"14f** **7. ECU. 1"3f** **8. CU. 2"13f**

This example shows an editing schema based on two communicative components: the maximum use of extreme close-ups and audiovisual matching. If we analyze the connection between the commentary and the images, we notice that it is used to build the story and helps highlight the product's specific qualities: *protecting babies' eyes.* The visual construction exploits this feature to show a sequence based on various shots of babies' eyes, which we see shot by shot while we hear the first part of the commentary: "The eyes of a child are beautiful in any color." The commentary mixes firstly with the sound effect of drops of water and then with tinkling music. Shots 1–4 then show a series of extreme close-ups of eyes of different colors, corresponding perfectly with the commentary: "big and red." Then, when the music reaches its climax, we see a smiling baby playing in the water (5). Here, the video shows the product and brand for the first time: "Johnson shampoo for babies". The commentary continues after a brief pause: "keeps them beautiful. So gentle that it passed our 'no more tears test.'" Here we see images of another baby enjoying a bath (6–7). The commentary continues: "It looks after their blue, green and brown eyes." The series now includes shots that are inserted exactly to match the commentary of children with blue, green and brown eyes. Finally, the slogan: "With Johnson shampoo for babies: no more tears." The clip finishes with the product logo (8) and a last shot of a happy baby's face.

Case Study No. 3

Nescafé (2014)	Agency: JW Thompson
Dolce Gusto	Duration: 30"
Commentary	
"Change the way you see coffee. Coffee can be 'fun.' It can be 'art.' Coffee can be 'classic' or 'cheeky,' even 'a discovery.' Nescafé 'Dolce Gusto': espresso, cappuccino, hmmm, chocolate. Coffee is not just black."	
Male voice, singing.	

1. 2"6f **2. 2"15f** **3. 1"** **4. 20f**

| 5. 2"10f | 6. 1"15f | 7. 2"15f | 8. 2"10f |
| 9. 1"20f | 10. 2"5f | 11. 6"9f | 12. 2"6f |

This advert is extremely interesting, as it includes several new trends in advertising creativity. Note the way in which current animation technologies make the use of cuts as a way of connecting shots and constructing reality completely unnecessary. The idea behind this commercial is to show different situations associated with drinking coffee. In this context, a series of colored images are combined with conventional coffee-drinking situations that are emphasized by the commentary. Only one cut is used at the end, when we see the credits for "Nescafé Dolce Gusto." In all of the shots throughout the sequence, the focus of attention is always the Nescafé Dolce Gusto logo, which is always either center frame or in a prime spot. It only varies in color and its size changes according to shapes it adapts in the situations in which it appears: classic, cappuccino, chocolate, etc. The sequence starts with a violent zoom in towards an apartment door. The logo can be seen in the door's peephole (1). The camera goes through the door and the circular object transforms and enters at the same speed into an overhead shot of a disc jockey in full flow (2). The circular shape of the Nescafé logo this time replaces the DJ's record. And when the word "fun" is said, it changes into a (different-colored) pinball that is thrown towards the right (3). Still using this shape, it turns and shoots off in different directions through the screen: to the right in a computer game (4), bounced up and down by a basketball player (5), in the middle of a game show set (6), grouped together in a light display in an art gallery (7), a scooter's headlight (8), the pin on the biker's jacket (9) and finally a hot-air balloon (10). After contextualizing the situations, we see a series of shots showing only the coffee machine and cups containing various hot beverages. Note how only the cup changes, while the coffee machine, after an initial animated turn, is maintained in the same position in a close-up (11). Notice how the connecting element is always the Nescafé logo, which spins but stays the same color during the transition and only changes when it fades with the next image, where it gains a different meaning. The last shot shows the product along with Nestlé's website address (12).

What to Remember in Creating TV Advertisements

1. Clearly develop the advert's central motivating theme: the story.
2. Plan the most suitable way to present the product or brand.
3. Show the brand in a visually implicit and explicit way at different moments throughout the commercial.
4. Remember the importance of the soundtrack and resources to recreate situations.
5. Take advantage of synchronicity, color, movement and other resources to highlight phrases, contents and ideas.
6. Use expressive postproduction resources such as visual effects and slow and fast motion to create a narrative and dramatic rhythm.

Self-study Exercises: Perfecting the Editing of Commercials

Obtain original archive material showing various advertisements. Carry out the following exercises:

1. Manipulate screen time by using strict durations of 20 seconds, 30 seconds and 1 minute.
2. Modify the order of the shots and check whether these changes affect the construction of the meaning. *Which order works best?*
3. Try different creative options by manipulating various sound elements: voice, music and original effects.
4. Exploit the visual and sound elements. Try putting yourself in the shoes of the viewer and advertiser: *What can I see? What do I want the viewer to see?*

VIDEO CLIPS

Situation	Aim	Scene construction
1. Story 2. Unexpected	1. To entertain 2. To thrill	1. Parallel editing 2. Audiovisual rhythm and synchrony 3. Sudden changes 4. Close-ups of reactions

Case Study No. 1

Michael Jackson	Director: John Landis
Thriller (1983)	Editors: Malcolm Campbell and George Folsey Jr.
Sony Records	Duration: 13'39"

"*Thriller* represents a contemporary milestone in video clip production in the West, although much of its success can be put down to its enormous budget—close to $800,000—which was more than 10 times greater than most other music videos made at the time. *Thriller* is more than that, though. This video has become a reference, as it was the first time that such an original video had been shown on television. The story starts out as a very ordinary situation between two people that takes a dramatic turn when one of them suddenly transforms into a werecat, at which point the story then takes on the form of a musical. We witness Michael Jackson's character's strange behavior, his girlfriend's reaction and zombies. Michael Jackson's character goes through a series of transmutations that define the clip's meaning and the subsequent behavior of his co-star, who is horrified by his unnatural transformation. As a result of playing the part of this particular character, Michael Jackson was surrounded by a mysterious and enigmatic aura that would stay with him until his last days.

The plot contains various features typical of a horror film. An isolated location at night time with the sound of crickets in the background serves to create a perfect atmosphere for monsters and living cemeteries.

Let's take a look at the first section. It is nighttime and Michael Jackson and his girlfriend, played by Ola Ray, arrive at an isolated spot in their car (1–3). They start walking together and he suddenly, in a show of affection, gives her an engagement ring. He is a little nervous and some soft wind music heightens the sensation. Suddenly, after 2'13s (4), we see the moon coming out from behind the clouds and hear sinister music along with it.

1. LS. 23"7f 2. MS. 2"10f 3. CU. 5" 4. CU. 2"8f

The first turn in the clip occurs at this point: Michael Jackson's transformation, which livens up the music. Shots 5–7 are extremely powerful and show how the full moon affects Michael Jackson, transforming him into a werecat. His girlfriend's reaction of horror is also forceful (8). This part is a classic schema of shot/reverse shot showing Michael Jackson's transformation and the changes in his girlfriend's expressions.

5. MS. 4"10f **6. MS. 1"18f** **7. ECU. 1"16f** **8. MS. 1"08f**

In the next set of shots, we see Michael's slow transformation: the eyes, teeth, moustache hair and even the face itself undergo an intense, horrifying change (9–11). We then see the girlfriend running terrified from the scene, unable to take in what she has seen and unable to believe her boyfriend has turned into a werecat. Here, the animation is outstanding, as it makes the facial and bodily transformation seem totally natural and lifelike. Note that there is only one background sound effect, accompanied by Michael's guttural noises, which reflect the internal changes he is suffering due to the transformation. Finally, after the shot of his transfigured face, a new shot shows Michael in the final stages of his alteration in which he howls. At 2'25", his girlfriend screams in horror at the scene before her. The detail of the transformation is painstaking: this final part includes complementary close-ups of faces, hands, claws and ears and his body in general undergoing a complete metamorphosis. The girlfriend flees, terrified (12). The feeling of terror is created here both through Michael's change and his girlfriend's screams of terror. She runs away and Michael chases after her, aggressively hurling sticks and objects at the ground. Intense "chase" music follows them as they race through wood. Then, at 3'38", he suddenly takes her by surprise. As she falls to the ground, Michael pounces on her, showing his claws, howls in the background accompanying the action.

9. CU. 2"4f **10. ECU. 4"8f** **11. CU. 2"6f** **12. LS. 2"10f**

At 3'42", the scene then cuts to a new location. We find ourselves inside a cinema. The two characters are sitting together (12–13) surrounded by a frightened audience watching a film called *Thriller* We now realize that what we were watching before was a film. Michael smiles at his girlfriend (also played by Ola Ray), who is terrified and tells him she wants to go. Here, she shows exactly the same expression as the character in the film. Michael moves closer to her, calm, smiling, and says, "It's only a film!" (14). Ola takes no notice of him and leaves. Michael goes after her, giving his bag of popcorn to a lady sat next to him in the audience. We now find ourselves in a third space—outside the cinema. This is when the song itself starts. A pan shot, made using an overhead crane, heightens

the scene's spectacular imagery and splendor of the cinema's illuminated billboard, which is also the story's starting point. A cut takes us to another location where Michael starts singing (15), while both run through the streets. In the dance routine, Michael imitates some of the movements of the zombies.

13. CU. 2"10f 14. CU. 2"13f 15. ¾ S. 12"15f 16. LS. 11"4f

At 5'45", both run through an old cemetery, where the coffins begin to move and the dead begin to rise out of the ground. Note the electrifying effect of the white smoke and the crisp shadows, which give it an extremely gloomy realism. All the zombies begin to walk as a group in synchrony towards the left of the screen and come together in a wide, open area (17). Suddenly, Michael and Ola are surrounded by zombies, with no way of escaping (18). There is a brief moment of silence, after which we see the zombies' grisly, emotionless faces oozing with blood. Michael and his girlfriend are scared and do not know what to do or how to escape. Suddenly, Michael transforms once again, this time into a zombie. His eyes protrude, his hair is longer and his face is larger. Immediately he joins the zombies in their dance (19). In this part, the girlfriend does not appear in the scene. The cuts here strictly mark the continuity and the movements of the dancers, who move closer to and further away from the camera systematically while turning their faces to the left or right. It is a fairly long section, as it comprises the central part of the video. Suddenly the girlfriend is seen fleeing and running into an old house (20).

17. LS. 5"4f 18. LS. 20"26f 19. LS. 4"11f 20. LS. 4"4f

As she is running, the zombies pursue her, walking slowly and rigidly to the old house, where they, along with Michael, enter by any means (21–22): through the door, windows, walls and even up through the floor (23–24).

21. LS. 3"18f 22. LS. 1"12f 23. LS. 2"11f 24. LS. 2"12f

25. ECU. 1"12f 26. MS. 11"18f

Just before being trapped by the group of zombies, led by Michael, she wakes up and realizes that it was only a dream (25). Another dream. Michael asks her "What's the matter?" and offers to take her home. The video ends with Michael hugging her and, as he turns to the camera, he laughs and we see his evil eyes (26), while we hear Vincent Price laughing in the background.

As we have seen, the video to "Thriller" was in fact inspired by horror films. The narrative approach is highly original as it allows the creation of a series of dramatic elements closely tied to the music itself: a story that appears to be real but then turns out to be fiction (when we see the cinema scene) and then breaks away from reality once again to show the character's physical transformation. In this example, this element guides us throughout the clip's storyline and in doing so strengthens it, as the previous sections served to heighten suspense. Then, when Ola is attacked, we realize once again that what we have been watching was a film, until the moment we see again that Jackson really does transform. Briefly, it is a contest between reality and fiction that constantly changes and alternates. From the perspective of innovations, the video includes animation, sudden cuts to close-ups to fully exploit the reactions, hideous expressions and precisely choreographed dance routines. Other outstanding elements include the soundtrack and editing. The soundtrack itself is not just a direct transcription of the song but carefully incorporates background noises such as the car, nocturnal wildlife, etc., making us forget for much of the time that we are watching a music video. The editing is appreciably natural and attempts to create a true sensation of terror. However, it is the characters' vivid expressions, the use of close-ups, deliberate ellipses and accurate cuts to mark the syncopation of the changes of location, unity and temporal coherence that really make this video exceptional.

Case Study No. 2

Shakira: Loca (2010)	Director: Jaume de Laiguana
EMI Records	Duration: 2'42"

"Loca" is a version of an urban merengue song performed by Shakira, titled *Loca con su Tigre* by the Dominican Edward Bello, otherwise known as El Cata. The song was written by Cata in 2009 for his album *El Patrón*. The new version is based on the original version's lyrics and beat, though it was slightly modified by Shakira, who also took part in the production process. The videos for both versions were recorded in Barcelona (Spain) and were directed by Jaume de Laiguana.

The version analyzed here is the Spanish version, featuring El Cata himself. The video was shot in mid-August in 2010 at various locations in Barcelona, including Barceloneta beach, the maritime promenade, the terrace at Hotel Vela and the Joan de Borbó boulevard.

1. LS. 22f **2. LS. 8f** **3. ¾ S. 2"20f** **4. MS. 2"4f**

The aim of the video is to show the main character in various scenes, using the beaches and surrounding areas in Barcelona as a setting. The first part shows the mayhem that ensues following Shakira's arrival at the restaurant Ciudad Condal. We hear a brief soundclip of Shakira's fans shouting. The images are unsteady, as if taken by hand-held cameras, which seems to be a deliberate decision by the director to create the impression of spontaneity. They are shaky (1) and include out-takes. One shot shows the maritime walkway, another shows people and a sideshot of girls relaxing. Similar shots follow showing the crowd going crazy and action going in opposite directions, all of which is to convey an idea of the difficulty of shooting among the chaos of fans and rollerbladers in such a space (2). The song itself starts in the 14th second (3). At this point, the camera becomes notably more stable and shows the first of the video's three main shots: Shakira dancing, moving her hips characteristically, in a three-quarter shot without leaving the frame. We see how this shot merges with the following, which shows Shakira rollerblading along Barcelona's beachfront in a separate outfit and even wearing headphones (4). Note how continuity is maintained between both shots despite the fact Shakira is in two different locations. However, the moment the camera loses her from sight is used as an opportunity to cut to another shot. Here, intercuts between both sequences start. While the three-quarter shot is used throughout as the main sequence—of Shakira singing—the other is complementary, showing only action shots of her interacting with others appearing in the video. We also see that in various passages new cuts are made over the same general sequence that, while not changing significantly in size, do show important changes in the action, highlighting her facial expressions and rapid movements of her hands and body. One of these intercuts, this time showing just the ground, is used to introduce a transition once again (5).

 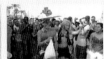

5. MS. 2"12f **6. MS. 1"18f** **7. ¾ S. 2"20f** **8. CU. 2"4f**

Note how this is used as a tool throughout to justify the spatial variation. Also, notice how the three-quarter shot becomes a medium shot (6–8) and serves to cut to the shot of a circle of young people, one of whom has a tray full of what appear to be sweets (7). These alternating shots continue until we arrive at a new shot of Shakira dancing in front of a group of passers-by (9), who freely surround her, cameras in hand filming her, all of which lends an air of spontaneity and naturalness to the situation. The next segment of the video shows her stopping a motorbike, climbing on and touring some of the city's more typical locations. She changes clothes in the middle of the street, showing off her beautiful body, gets on the motorbike and starts her tour of the city, a caravan of Harley Davidson motorbikes in tow (10–11). The intercuts with the main sequence (3–6) continue to be stable in this section. Shakira is then seen dashing across a road and jumping into a fountain. She is seen jumping around, splashing water, while once again a crowd watch her antics. Next, a short sequence shows her dancing with El Cata until 2'25" (12). The last part takes place at sunset. Shakira arrives at the beach, accompanied by a crowd of people, where she dives into the sea and continues dancing until the last beats of the song fade away.

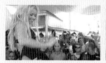

9. MS. 1"23f **10. MS. 1"8f** **11. ¾ S. 1"6f** **12. MS. 18f**

The song lyrics are repetitive and the video's storyline constantly repeats the word *loca* to reflect the artist's bold, non-conformist spirit. This simple, straightforward concept has been transformed into images to create the clip, which exploits Shakira's physical attributes and well-known dance routines. Then, to set the situation outside, with Shakira wearing very little clothing and surrounded by people, shows off her beauty for filming purposes while maintaining the video's spirit. The interaction with the crowd acts as a stable element throughout, generating a Mediterranean spontaneity and freshness. The handheld camera and the chaos give it a boldness that facilitates breaking continuity and allows shots of the singer in various situations and locations to be alternated without causing too many problems for raccord. In this regard, the video mostly tolerates these breaks, as they are interpreted as variations and parts of the natural evolution of the story. The crowd is waiting expectantly; she arrives, mingles with the people, dances, gets changed, climbs onto a motorbike and tours the city. Finally, she arrives at the beach and swims in the sea. In other words, it follows a complete, fairly linear, spatio-temporal journey that is easily understood by the viewer. Therefore, editing acts as a mechanism to give shape to this structure and makes it flow through the various situations in which she takes the central part. The rest is complementary and serves only to tie up any loose ends or simply to give rhythmic variety to the situations shown.

What to Remember in Creating Video Clips

1. They usually take the form of a story inspired by a message/concept in which different situations play out and relationships between the subjects behind the story are constructed. The various aims and approaches range from the simplest to the most complex. A well-developed concept is a good starting point, but needs to be correctly executed during filming and editing. Each phase needs to be tightly controlled.

2. There should always be one or more main sequences of the artist singing in various situations or locations. This allows their presence in various parts of the video to be used, employing esthetic, temporal or simply mechanical reasons to improve the narrative flow.

3. The support shots are also resources that, while they should be included at decisive scripted moments, can also be included in other parts of the video. There is no rule stating that out-takes or non-context shots should be inserted at a precise moment. Their use can be flexible and adapted to editing decisions and last-minute assembly.

4. Continuity in its classic sense is completely broken in music videos, as we have seen. Cuts to the artist in the same location are allowed, as if it was a continuous shoot, but if the space is new, various resources are used to make the cut less obvious, including out-of-focus shots, reframing and close-ups.

Self-study Exercises: Perfecting the Editing of Video Clips

Obtain archive videos of various artists and out-take material. Carry out the following exercises:

1. Alter the continuity, changing the order of the sequences. Include out-takes to cover for missing material. Analyze the results.
2. Create shorter versions of longer clips. Try to condense the main concept in order to practice evaluating the images and extracting the message's main ideas.
3. Try different ways of linking similar shots, but changing the action, size, angle, location, lighting, wardrobe, etc. Experiment with alternative cuts of the same shot and different shots in order to determine the tolerated limits of change.

SMALL-SCREEN FORMATS

Situation	Aim	Scene construction
1. Comedy 2. Speech 3. Surprise	1. To entertain 2. To amuse	1. Parallel (intercalating) 2. Maintaining continuity 3. Action shot from multiple angles 4. Inclusion of reactions 5. Zoom-in shots

Case Study No. 1

Enjuto Mojamuto (2010)	Creator: Ángeles Bermejo Mezquita
RTVE	
Episode: The worst day of my life	Duration: 2'12"

Enjuto Mojamuto is a cartoon character from the television series Muchachada Nui, creation of the Spanish cartoonist, actor and comedian Joaquín Reyes. The character appears in a section of the series itself, lasting no more than a minute and a half, and is always seated in front of his computer.

1. GS. 12" **2. LS. 15"12f** **3. MS. 13"10f** **4. CU. 1"21f**

5. MS. 2"11f **6. LS. 1"20f**

Although new formats may appear to be riskier in terms of language or editing resources, it is not always the case. In this example, the limited budget is reflected in the simple design, which is based on an online cartoon. In fact, the strength of this type of message lies in the situation's condensed format and audiovisual development.

The production's format does not allow for complex plots. Nevertheless, mainly due to its brevity, it ends up offering us a simple but effective approach to storytelling that reflects an aim and structural schema typical of this type of story, which is aimed at a young audience.

Note how the storyline is essentially marked by the narrator, who introduces and relates most of the story, while the character himself—Enjuto Mojamuto—complements the plot's development with short comments. The use of special

effects is key to constructing the scene. He is an animated character and the inclusion of "cybernetic" sound effects, such as the Windows start-up music or the stereotypical voice of the technical assistant, helps build a setting suitable for the story's development. Note how the camera angle is the same in all shots. It only closes in slightly when it frames Enjuto, but it is always shot from the same location (2, 3, 5 and 6). The only insert that varies the clip's visual continuity is the shot of the back of the router (4). Despite the production's simplicity, its logical pattern makes it easy for the audience to follow the plot. The use of close-ups is the result of a clear dramatic decision that follows a continuous natural flow. Note how, within a few seconds, Enjuto becomes desperate at not being able to cancel his Internet connection and how his nervousness is appropriately expressed through the use of close-ups (5) of his worried expression. Thus, we can discern a clear plot structure. The last section ties in with the distinctive closing music (6). The short format of these serialized mini-cartoons means that the plots are basic, with no spatial variation or appearance of other characters. This format means that the few observed elements are more easily controlled and the producer and editor only have to control very specific components in terms of the story's smooth, coherent development.

Case Study No. 2

Angus & Cheryl (2007)	Creator: BRB International
TV3	Editor: QT Lever
Episode: 45 – "Phone"	Duration: 2'15"

Angus and Cheryl is a BRB International cartoon production. The 104 episodes last approximately 2 minutes each.

Angus and Cheryl, who evidently have problems with the opposite sex, live together in a shared house. Angus is of a happy disposition and a bit of a joker, whereas Cheryl is intelligent and capable of standing up for herself, resulting in frequent rivalry. Despite their differences, however, they end up falling in love.

1. GS. 17"14f **2A. LS.** **2B. LS.** **2C. LS. 20"2f**

3A. GS. **3B. LS. 12"8f** **4. MS. 5"4f** **5. LS. 1"7f**

6. GS. 9"1f **7. LS. 2"7f** **8. LS. 22"18f** **9. LS. 21"**

"Angus and Cheryl" is a more elaborate and colored production compared to Enjuto "Mojamuto". The production is better and includes detailed scenes and animation with greater movement and internal expressive strength. The characters do not speak. Rather, they babble. However, their burbling clearly shows their emotional state and mutual reactions. The sound effects play an important role here in creating the ambience and in fitting in with the distinctive music. Turning to the story itself, the first section takes place in the sitting room. A general shot shows a telephone that is ringing. Angus gets up to answer the phone several times, but just as he is about to lift the receiver, the caller hangs up (2–5). Note that it is a continuous shot in which only the internal action varies. Also, notice how the background effect of the telephone serves to increase Angus's annoyance, which is matched by another rhythmic sound effect. A fast zoom towards the phone is the first marked change in the camera position and results in a spatial change. Cheryl is seen behind the wall spying on events (4). Note that the partial durations are fairly regular, at more or less 5 seconds. With this image, we realize that it is Cheryl who is calling, playing a joke on Angus. A rapid transition in time then occurs (5). The clouds darken and nighttime rapidly falls, which is noted in the following shots (6–8). Angus, unaware that Cheryl is outside, closes the terrace door, leaving her trapped outside. She becomes frantic, starts to feel the cold and, scared, glances at the looming storm, which is made more frightening through the use of sound effects. She knocks on the glass in the hope that he will hear her, but Angus is listening to music through earphones, making out that he cannot hear her but knowing perfectly well that Cheryl was the one playing a prank on him earlier. Finally, shot 9 shows the closing credits.

This episode shows a simple situation in a short format, but over a longer time period in order to make it clear that the plot requires its own dramatic evolution. The decision to follow two characters who live together is to show that this modern coexistence has its ups and downs. The action is always of the two characters, while the decorative elements supplement the main story. Shots that need to be emphasized—the phone ringing, Angus with his earphones on—are

shown in close-ups at precise moments, while the transitions serve to extend and complement the second part, thus complicating the conflict and making the ending stronger and clearer. Similarly, two spaces interplay with each other: inside and outside. Both are enough to relate the entire story.

What to Remember for Small-screen Formats

1. Short, unique situations. Little time to set out and develop the storyline.
2. Always center the audience's attention on what the characters are doing and the key objects.
3. Continuity is relative, provided that it allows the narrative thread to be followed. Moderate jumps are tolerated.
4. Sound effects and music should be used to reinforce the action and, in some cases, the strength of the characters, especially when there is not much dialogue.

Self-study Exercises: Perfecting the Editing of Small-screen Formats

Obtain original archive material of various programs. Carry out the following exercises:

1. Combine images from different stories and try to create a new storyline by connecting sentences, voice-overs and images that could appear to be connected in a new context.
2. Create a 5-minute trailer by connecting the best situations of a short series. Try working with the original sound or a track, inserting only images.
3. Analyze the results of both creations.

SPECIAL FORMATS

Situation	Aim	Scene construction
1. Opening credits 2. Promotion	1. To persuade	1. Multiscreen editing 2. Combination of elements 3. Variety of shots 4. Sound matching 5. Complementary effects

Case Study No. 1

Informe Semanal (1987–2002)	RTVE
Opening credits	Duration: 40"

1. 9"10f	2. 7"20f	3. 6"10f	4. 12"5f

In this classic example from RTVE, we can see how the construction of an opening title completely dispenses with intershot cuts as a linking component. Right from the beginning, the communicative power of the music serves to take us into the world of journalism and emphasize the program's sobriety. A visual effect—a brown screen with horizontal moving lines—is used as the backdrop from the start (1), superimposed upon which are a series of shots of static images of various news events representative of the time (the 1990s). Note, in terms of editing, how effective this is at bringing together various representative images in such a short clip. The uniformity lies in the fact that entirely different events, whether political, social, humanitarian, medical, etc., which, in other contexts, would be difficult to connect, are brought together under one genre, in this case the news. They are only related by the fact that they occur in more or less the same time period. The system of editing over the shot and multiscreen effects helps considerably to build an image of unity and stability (seriousness and objectivity typical of news programs) despite the extreme diversity of the situations. The impression of the resulting volume and movement is especially powerful in this section. In shot 2, we can see an image of more than 10 different static screens showing various events that move across the screen, giving the impression of movement, volume and three-dimensionality. The movement of the horizontal lines towards the center of the screen serves to subtly bring the viewer's attention to the name of the program, in this case, "Informe Semanal" (3). Note the change in the opening title's rhythm, which indicates a slight turn. This gives the impression that the events shown on the screen are effectively part of the program and immediately leads us directly into it. There is no narrator or voice-over to explain the message, as it is not needed. The brevity and repetition help to transmit simple and recognizable ideas typical of emblematic programs such as this. The combination of visual material and the program's logo (4) are enough to transmit the clip's simple idea.

Case Study No. 2

Catalonian parliamentary elections (2012)	TV3
The Big Debate	Duration: 25"
Commentary	

VO: "Catalonia's parliamentary elections 2012. Sunday … The Big Debate … The most diverse. The only thing that is certain. Also on Radio Catalonia. Moderated by Ramon Pellicer. We debate Catalonia's future with heads of the main political forces. On the twenty-fifth we decide our future. Here, on TV3's News Service. Here, you win."

1. 2"20f 2. 6"4f 3. 8"8f 4. 7"1f

This example is similar to the previous, but this time more modern. The quality of the image is much better and the technology used allows a more sensationalist editing for the audience. This example of the promotion of the "Big Debate" includes a voice-over, which acts as the guiding thread. The information is more complex and possibly may not be understood without the voice-over. However, if we were to only view the images, we would be able to deduce without any problems what the message is about. The sound track, consisting of music and the voice-over, is key to acting as a guide during the various stages (read the transcript above carefully). We can see the use of a more sophisticated multiscreen approach. Note, in addition to the artificial movement of the images showing the faces of the main parliamentary candidates, the use of complementary titles throughout the clip. The first shot (1) shows the debate's main orange logo, which, after composing itself from various fragments, almost aggressively moves to the center of the screen. The VO sentences are short and paused, the tone assured and somber. Everything appears to be well controlled, producing a perfect synchrony with the images. We then see a series of cropped shots. The speed is a little fast, but allows the viewer to easily recognize the invited participants (2), who are shown in medium close-ups. Whilst a range of colors can be seen, in reality it is the political parties' own colors that are mainly highlighted. Shot 3 introduces the image of the moderator, sitting dressed in a dark suit against a dark background. The voice-over announces that the debate will also be broadcast on Radio Catalonia, with a complementary title showing the date and time. Here is an example of triple editing, with the presenter in the foreground with images of the candidates passing behind him along with the election logo. Once this segment finishes, all the candidates are seen again but in reverse order. The favorite, Artur Mas, appears twice in the last shot of the series. Finally, the closing comment

by the voice-over—"On the twenty-fifth we decide our future. Here, on TV3's News Service. Here, you win"—is accompanied by a new visual composition that brings together the debate's logo and the symbol for voting, with the flag of Catalonia in the background. The clip then finishes with the TV3 logo (4).

As technology progresses, it is becoming increasingly evident that the complexity of many video clips is increasing in terms of performance, as they include new elements that add potential and exploit to the maximum current audiovisual elements. The possibility of working with various visual elements simultaneously over one or more backgrounds with superimposed titles helps to optimize the few screen seconds available to efficiently transmit complex messages containing a lot of information. The producers and editors now have to make great efforts to summarize information in order to vividly integrate a lot of information whilst ensuring semantic coherence. However, the result is not always ideal, as not all the variables are taken into consideration. It seems that sensationalism is still taking precedence over content quality and it is our opinion that this needs to still be worked on. For example, the multiscreen composition not only groups images and objects, but combines them harmonically, applying a balance of perspectives, colors and aspects of symmetry, which are not always noticeable or exploited during editing. In this last example, the first general shot of the presenter is too dark and the contrast with the background is weak, as he is wearing exactly the same colors, meaning that the editors have failed to take advantage of the contrasting effect of the other objects in the shot, which would lend him a more expressive effect rather than just showing him on a dark background. On the other hand, however, the use of concatenated images running in the opposite direction and the regulated speed, which are used well in this clip, is extremely useful for condensing complex or abundant information. If this same clip had been made using cuts, it would have ended up being twice as long. Similarly, the moving titles and logos continually complement and emphasize what the viewer sees and hears.

What to Remember for Special Formats

1. The harmony between the background with the overlaid images in terms of color, symmetry and contrast.
2. Music, voice-overs and effects equally help convey information, but it is not always necessary to saturate the viewer with all the broadcasting information if only a few elements are chosen and assembled.
3. The titles are key to adding and emphasizing the information conveyed by the soundtrack, but need to be carefully positioned.
4. To avoid a jarring effect, the size and speed of the transition should be synchronous with the images' rhythm and syncopation.

Self-study Exercises: Perfecting the Editing of Special Formats

Obtain background shots and images from a variety of programs. Carry out the following exercises:

1. Combine various audiovisual components: backgrounds, static and moving images, title credits, off-screen voice, music and visual effects. Create a sound track and then overlay the visual part.
2. Evaluate the result in terms of the composition of the objects: the lines and direction of the background, the color and harmony with the superimposed shots.
3. Combine different-sized images, track speeds and viewing time. Make sure the message is clearly understandable.
4. Check the same effect with the location, timing, size and letter format of the titles.

PSYCHOLOGICAL AND PERCEPTUAL BASES OF EDITING

PERCEPTION AS AN INTELLECTUAL PROCESS

The act of perceiving a filmic product consists of not only the presence of images that have been edited, projected or broadcast; there needs to be a "receiver" who gathers the stream of information and watches it, pays attention to it, processes it and evaluates it. This model, which considers the cinema screen as a space where identification and recognition between the emitter and receiver converge, represents the cornerstone of the Institutional Mode of Representation (IMR) proposed by the film theorist Noël Burch (Burch 1998). In essence, this film theory concerns the modeling of the meaning of North American cinematography from the early years following its inception. As we have seen, this concept of image perception in terms of the receiver has been systematized through editing by Vsévolod Pudovkin with the aim of building a unifying model of editing that strives for the smooth organization of the visual discourse. In other words, narrative continuity based on the following of stories. Two questions arise from this problem and have been discussed in greater depth elsewhere by other authors.

EDITING AS A UNIFYING MECHANISM OF PROJECTION AND IDENTIFICATION

> The most important thing ... is to understand that the image—as the complete visual scene observed during a certain period—is seen not only in time but at the cost of seldom innocent exploration and that the integration of this multiplicity of successive individual fixations is what produces what we call our vision of the image.
>
> (Aumont et al. 1996, 64)

Firstly, the receiver of the image *watches* in a way that, through his/her own volition, he/she sets in motion a deliberate process of information gathering. Next, once his/her attention is fixed on the screen, he/she surveys the screen, carrying out a succession of eye movements over the image or the various fragments making up the sequence in order to distinguish each of their constituent elements. This means that firstly a recognition event, in which the recognizable elements are identified, takes place in which the receiver distinguishes features and characteristics similar to those seen in reality. The viewer thus carries out an automatic, constant process of comparing and relating *what he/she sees* with *what he/she has seen before*, setting in motion a series of intellectual operations similar to those used to interact with his/her surroundings in reality. Editing, thus, exploits two aspects involved in the act of human perception: firstly, the audience's awareness and knowledge of things they have experienced previously and whose *recognition* acts as the first activating mechanism, which makes paying attention to or the noting of representative elements possible; and secondly, the understanding and retrieval of seen or heard information. In this regard, Gombrich points out that the process of recognition is based on memory, which carries a database of objects and spatial abilities that are activated when the viewer watches new images of similar content. The viewer then begins to automatically relate them the moment he/she sees and remembers them. In this way, although the objects may vary considerably in terms of size and meaning—depending on the size of the image, the perceptual system or the conditions themselves in which the images are assimilated—the viewer's cognitive capacity discriminates and tolerates possible *visual assaults* or *distortions* and compensates for them through an active processing in which the differences end up generating meaningful relationships during viewing.

> When a man walks towards us in a street to greet us, he gets bigger. We don't register the degree of the changes; the image of him remains relatively constant, like the colour of his hair, despite the changes in light and reflections.

> (Gombrich 1982, 90–91)

Furthermore, recent studies of computer vision confirm the possible existence of a *visual buffer*, located in the fovea (Rensink 2002), which is responsible for capturing visual stimuli and "buffering" the perceptual disturbances produced by strong, spatially complex stimuli. In this way, the visual system is able to internally reconfigure the information coherently and stably to enable its decoding without necessarily resorting to the short- or medium-term memory, as claimed by Paul Fraisse (Fraisse 1967, 74).

Editing and its technical mechanisms are able thus to reproduce the constant process of *projection-identification* according to certain

conventions and knowledge of the creator, who assumes the viewer possesses this same knowledge. This "shared knowledge" converges in the message. For his/her part, the viewer has the capacity to *recognize and associate the different pieces* within an ordered and logical set. He/she is, therefore, "prepared" to understand it, because on identifying the relations expressed and connecting them with his/her previous experiences, the viewer establishes an *audiovisual contract* with the message. Despite knowing that the film is not real, the viewer participates in it while watching, assuming for a while that it is true and real. This idea is perfectly summarized by Edgar Morin: "As we identify screen images with real life, our own projection-identifications of real life are put into motion" (Morin 2001, 86).

However, this reference to reality is not a recent phenomenon but has been used since the birth of cinematography. George Sadoul makes reference to the testimony of Lumière himself in a conference of the Society of Photographers in 1895, on the showing of *The Train Arriving at the Station*: "Lumière recorded the resulting effect and saw its commercial possibilities, as it allowed its operators to film precisely those scenes in which the public could recognise themselves" (Sadoul 1973, 284).

Thus, one of the pillars of audiovisual practice is regulated by this fundamental principle of coherence: that narrative intention is sustained by normal human perceptual mechanisms in the search for constant identifications. We have made reference to this previously when we discussed the model proposed by Martin. It is the dynamic that builds the story from a creative routine—a way of seeing—based on the principle of coherence of action, in which the viewer actively participates, linking him/herself so that the information is assimilated. Therefore, what the receiver *sees, deciphers and understands* occurs through a triangular perceptual relationship that editing develops in two parts: in the representation of the actions and characters shown on the screen and between the viewer and this representation. In other words, that the viewer believes him/herself to be one of the characters but located outside of the frame.

EDITING AND THE CONSTRUCTION OF A REALISTIC IMPRESSION

"The realistic effect designates, in effect, the effect produced in the viewer by a representative image (shot, photo or film, the source does not matter) through a set of analogous indicators" (Aumont et al. 1996, 117). Editing is, therefore, the creation of a believable product and acts as the first step towards the understanding of meanings and ideas. For Irwin Rock, constructivism establishes a *neoformalism* in which the spectator, upon

seeing an image, sets in motion two activities, one rational and the other, cognitive:

> Inference making is a central notion in Constructivist psychology. In some cases, the reference proceeds principally "from the bottom up", in which conclusions are drawn on the basis of perceptual input ... Both bottom up and top down processing are inferential in that perceptual "conclusions" about the stimulus are drawn, often inductively on the basis of "premises" furnished by the data, by internalized rules, or by prior knowledge.

> (Rock 1983, 17–20)

This, in our opinion, confirms the various approaches we have discussed regarding filmmaking's step-by-step process. We believe, therefore, that the spatial coherence evoked—preserving the rules of continuity and *raccord*, the variations in meaning between fragments, direction of gaze and movement—constitutes the first level of editing intervention through the structuring of a spatial configuration in which the characters and objects relate to each other logically. This first level of coherence stimulates the viewer's relational need to perceive the realistic universe upon which other organizations of meanings can be built through the story. These organizations aim to awaken the perceptual and associative capacities of the receiver, who should be capable of deciphering the message's codes and conventions.

THE COMPETENT VIEWER

The spectator needs to be *competent* in order to decode the message's content and to assimilate the information supplied audiovisually. He/she has to have the minimum capacity necessary to be able to understand what is passing before his/her eyes. No technical skill is required to decipher the message. The viewer only needs to be competent as a normal receiver, a habitual consumer of audiovisual messages, able to decipher, relate and understand the various components of a visual narrative. As Trevor Ponech states: "By 'competent', I mean the kind of agent who goes into the viewing situation with some accurate, if nontechnical, beliefs about the nature of movie technology and imagery and who can mobilize these beliefs when necessary" (Ponech 1997, 4).

Evidently, any effort to assimilate the message would have no real meaning if the receiver did not have the minimum capacity to understand it, "to know what it is saying," in order to see relationships between these meanings. It is no use discussing an image and how it is projected or broadcast if we do not pay attention to the final destination—the viewer.

The idea of *competence* does not arise of its own accord, but effectively has a direct relationship with other elements of the film piece, allowing *recognition*, but based on coherence and the processes of relating and differentiating perceived elements. From these two elements, which interact through editing, the minimum identification that links the message with the viewer is produced. This necessary adherence of the audiovisual narrative to the principle of realistic representation, which is based on similarity, difference and relationships between the fiction's elements and their real-life analogues, is called *perceptual coherence*.

THE PHI PHENOMENON, PERSISTENCE OF VISION AND FLICKERING

The phi phenomenon is an optical illusion defined by Max Wertheimer in 1912 as part of his Gestalt psychology that, together with the persistence of vision, formed part of the foundation of Hugo Münsterberg's theory of film in 1916.

This optical illusion is based on the fact that the human eye is capable of perceiving movement from fragmented information such as a series of images. That is, from the reproduction of a series of still images at a determined frequency (the speed of reproduction of images in units of time), we perceive the impression of continuous movement. In other words, it is as if we invent the information we do not have to hand (i.e. the information between one image and the next) to create a visual impression of movement. The Phi Phenomenon, which could be considered the basis of cinema, is only an imitation of the human visual system and is based on the concept of persistence of vision.

Persistence of vision causes an image to be retained briefly on our retina, allowing us to relate it to the following image. The persistence of vision only allows the phi phenomenon to occur above 12 images per second. Similarly, although we perceive movement, at this frequency we observe another phenomenon—flickering. To overcome this, sequences need to be shown at 40 images per second, which allows movement to be perceived but, under normal conditions, does not allow the viewer to distinguish the flicker produced by cuts. The cinema is an example *par excellence* of this phenomenon, but there were a series of precursors before its arrival, the oldest of which is the phenakistoscope, a device formed from a spinning cardboard disk with a series of equally spaced slits and a series of drawings of an object in various positions adopted during a particular movement. Another example, the zoetrope, is a circular drum with a series of vertical slits equally spaced around it and a band of images showing a cyclical sequence of movements glued around the inside of the drum just below the slits. By turning the drum and looking through the slits, the images are seen to be apparently moving.

PERCEPTUAL APPROACHES TO EDITING

Based on the psychology of perception and cognition, the first analysis of the processing of editing was developed by Julian Hochberg in 1978, although studies carried out previously by Münsterberg (1916) and Michotte (1946) were still considered relevant. Hochberg's findings have served as a starting point for the development of nearly all subsequent research carried out by investigators interested in this subject, including d'Ydewalle, Lang, Tommasi and Actis, and Smith, among others. Hochberg proposed a model based on the two parts of the perceptual process, from which emerged the three rules of editing:

1. *The law of spatial configuration*: This involves avoiding discontinuities in the edited image that create the impression of a perceptual *jump*, in order to relate similar contents. According to Hochberg, cuts should be made using the variation in camera angle in relation to the axis of action and evenly modifying the size of the shots. The camera should shoot the action perpendicular to the subjects and actions and should preserve during editing a minimum variation of 30° between both images. A smaller angle, according to Hochberg, creates an evident *jump* between shots.

2. *Spatial cognitive schema*: This second level includes the rules that allow the film space to be built. Editing should primarily conserve the *axis* of the action, in which the characters always look in the same direction from where they will be seen by their interlocutor. By respecting this axis, the impression is created of a constant viewing point during the entire sequence. According to Hochberg, this *spatial coherence* is achieved through a constant *directionality* of the entries and exits of the characters into and out of the frame. This means that if a character leaves the frame through the left-hand side, then in the next frame they enter on the right-hand side, as to enter from the same side as they exited results in an awkward visual impression.

3. *Narrative cognition*: This concerns the rules that allow the fine-tuning of the film's narrative structure. It is the highest level and requires a greater effort by the viewer to understand the associations and meanings created by the filmmaker. The rules at this level involve what we have previously termed the "expressive cut" in order to assure maximum dramatic strength, setting in motion a peripheral perceptual process related to the processes and mechanisms of attention of the saccadic eye movements and blinking.

In his book *The Reality of Illusion*, Anderson (1996), following Hochberg's precepts, groups the breaking of the continuity rules into three categories:

1. *Shot-to-shot transitions*: This concerns the coupling of one shot and the next. The editor's task is to choose a shot that connects with the shot immediately before it and to then find the exact place to finish the first shot and the exact frame with which to start the second shot (physical continuity). A cut in the action should follow certain rules. Apart from the 180° rule and the 30° rule, a cut should be made in the middle of the action and, when it is made, the action needs to be repeated in the two frames immediately after in order to give the impression of continuity.
2. *Relationships of comprehension*: This consists of establishing an orientation relationship between the shots that allows the viewer to understand that he/she is seeing homogeneous elements. In this category, the filmmaker specifies the physical orientation of the characters and their physical-mechanical adjustment (directional continuity).
3. *Hierarchical-spatial comprehension*: This final category concerns the macro-relationships between the places and events in the global world of the film (spatial and narrative continuity).

In 1998, Géry d'Ydewalle et al. attempted to evaluate the effect of disruptions created by these common types of editing errors. He proposed a hierarchical model of the cognitive processing of editing, consisting of three levels that correspond to the three basic editing rules. These are broken when:

1. Perceptual variations or dislocations are perceived as a result of minimal changes in camera location or the size of the image in two consecutive shots.
2. The space and the relationship between the characters of a scene or between the characters and the background scenery is violated (180° violation).
3. The logical sequence of the visual narrative is altered.

A few years later, in 2004, Tim Smith proposed another model with certain variations and additions (see Figure 9.1). The first basic level concerns what he terms *graphical perception*, consisting of the rules that allow a smooth continuity of the visual narrative. Based on Anderson's and Gibson's models, this theoretical concept is demonstrated through the location and tracking of various objects in the scene by eye movements, according to the patterns of viewer's interest. The following intermediate level in the process is *cognitive load*, which includes the narrative comprehension of the story and finally, what he terms *compatible cognition*, which is the fruition between what the viewer sees and the viewer's previous experience and the reproduction of the *habitual forms of observation*.

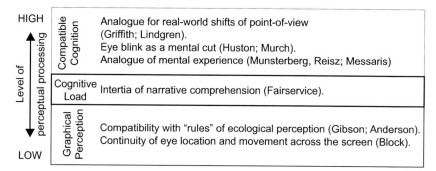

Figure 9.1 Tim Smith's model of film processing

(Source: Smith 2004a)

This model is in line with the approach taken by Hollingworth and Henderson, which states that the visual system integrates partial contents and builds from it a whole, stable picture (Hollingworth and Henderson 2000). This assumes that part of the explanation of smooth, continuous perception lies in the integration of pre- and post-saccadic eye movements, which allow stroboscopic merging and which are a reliable indicator of perceptual stability (as we shall see in detail in the next section).

Along the same lines, Henderson and Hollingworth (1999) propose a connection between perceptual activity and long-term memory (LTM), which contains additional information. Once the eyes start to move (or the scene leaves the screen), the sensory representations established during the previous fixation rapidly decay, leaving only the representations retrieved from the short-term memory (STM) and information retrieved from the LTM. Thus, when the eyes make a new fixation, the information from the STM will be compared with the current fixation. If the information is similar, it will be assimilated. If not, an error signal is generated and the change is detected. The process occurs in four phases:

1. Initial attention and coding of the information from an area of the scene.
2. Retention of this information in an active state in the STM and/or an inactive state in the LTM.
3. Generation of a new representation to compare with the stored representation.
4. Retrieving of the LTM's previous representation in the STM if the latter is not in an active state.

Annie Lang is one of the current academics to have worked most with the psychological processes of narrative perception. In 2000, she proposed the *Limited Capacity Model of Message Processing* (see Figure 9.2). Starting

from the information processing models of Eysenck (1993) and Lachman, Lachman and Butterfield (1979), she proposed two assumptions. The first is that human beings process information in the form of perceived stimuli that, in turn, are transformed into mental representations reproduced exactly or in an altered form to the original information. The second is that the capacity of a viewer to process information is limited. The processing of audiovisual messages requires mental resources and viewers possess limited storage to execute this efficiently. In this model, the treatment of information takes place in three basic processes: (a) coding, (b) storage and (c) retrieval.

Coding

The model proposes the existence of three sub-processes involved in converting a message into a mental representation. First, the message has to make contact with the sensory receptors—the eyes, ears, nose, mouth and skin (Eysenck 1993). The information gathered by the sensory receptors is stored in a sense-specific "warehouse," which may be limited. However, the information is stored here only briefly: 300 milliseconds (ms) for visual storage (Coltheart 1975) and between 4 and 5 seconds for audio storage (Crowder 1976). If a part of the information is not selected for subsequent transformation, it is overwritten by new information and lost. Coding is a two-step process in which some pieces of the message's information is selected and stored in the sensory warehouse and then transformed into mental representations in the working memory or STM.

Storage

Storage is carried out through a networked memory schema thought of as a system of various individual memories connected in turn with others through processes of association and coupling. When a memory is in use, it is activated and can travel, creating a process of related memories that are more active or available in comparison with memories lacking any connection. When a person links a new piece of the information into this network, it is stored better.

Retrieval

This process involves reactivating stored information through network searches. This way, a specific piece of the information is retrieved and transferred to the working memory. Generally, the more associations there are between the pieces of information, the deeper this information is stored and the easier it is retrieved. This parallel retrieval process also plays a role in the storage process, as it integrates old and new information into just one new stream.

Information processing and limited capacity

According to Lang, there are two main reasons why messages cannot be processed in depth. The first occurs when the viewer allocates few resources during watching. The second is that the message may require more resources than those available. Whichever the case, an insufficient number of resources are allocated to message processing and the information is, therefore, not processed deeply.

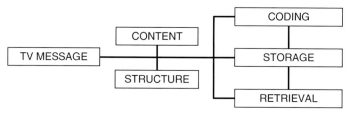

Figure 9.2 The Limited Capacity Model devised by Annie Lang
(Source: author's adaption)

MEASURING INFORMATION PROCESSING RESPONSES

There are various useful indicators and analytical instruments for studying the neurophysiological activity during the viewing of audiovisual messages. Over the next few sections, we briefly review those most used in experimental studies on reception.

Physiological Indicators

Saccadic Eye Movements

The fovea possesses a limited capacity to capture information in only one fixation, as its ability to focus weakens towards the periphery. It therefore requires a series of fixations to be able to assimilate a complex scene. The saccadic movements of the eyes (*saccades*) are extremely fast movements and their trajectory, once started, cannot be altered. They are responsible for the fixation of an object. Each saccade represents the perceptual action of detecting and focusing on a screen element and their trajectory changes according to where the individual centers his/her interest on each of the various objects in the scene. Saccades last between 150 and 200ms. Between each movement, the eyes fix an object in 300ms (Palmer 1999), though this can vary according to the size of the eyes. The range and velocity of saccades are used therefore as indicators of attention, the trajectory made by the eyes and visual memory. These responses are used to

study the possible "attentional distractions" that occur when visual continuity is broken through cuts and abrupt editing junctions (d'Ydewalle et al. 1998; d'Ydewalle and Vanderbecken 1990; Tommasi and Actis 1999, 1998; Seddon 2003; Smith 2006). By contrast, a smooth continuous perception of the narrative results in fewer responses. In this regard, David Irwin, for example, (Irwin et al. 1983), has confirmed the activity that occurs in the fixation of complex variable stimuli during continuous exposure.

Functional Magnetic Resonance Imaging (fMRI)

Functional magnetic resonance imaging (fMRI) is a procedure used in both medicine and research to produce images of the regions of the brain responsible for particular tasks. This procedure has been used recently to study how brain activity is produced and how it appears during the process of audiovisual consumption. Results from research carried out by Anderson, Fite, Petrovich and Hirsch (2006) revealed the presence of a cortical network that is especially active during the visualization of video sequences showing logical actions, but not by sequences of highly complex shots.

Heart Beat

Heart rate variability (HRV) is a measurement calculated by analyzing the time between beats. The alterations in HRV are associated with different pathological states such as the increase in blood pressure associated with an increase in blood activity brought about by emotional activity. One form of measurement is the calculation of the standard deviation of the inter-beat interval.

Blood Pressure

This is the force used to move the blood through the arteries. Its lowest point is called the diastolic blood pressure, while its highest is termed the systolic blood pressure. It is measured using tensiometers.

Conductance

This phenomenon is known by various terms, including galvanic skin response (GSR), skin conductance response (SRC) or electrodermal activation (EDA). The increase in the skin's conductivity represents the activation of an organism's "fight or flight" response. Skin conductance is an excellent measurement of activation or stimulation, but does not provide information about the direction, or valence (whether it is positive or negative), of an emotion. GSR is therefore normally used to determine whether there has been an emotional activation, but other complementary

procedures are necessary to determine whether this activity is due to desire, fear, anger, etc.

Pupil Dilation

The dilation of the pupil of the human eye is an indicator of memory load, state of alert and emotion. Hess (1972) confirmed that 2 to 7 seconds after strong emotional stimuli have been observed, rapid dilations occur. There are two ways to measure pupillary activity: the first is to monitor the dilation of the pupil, while the second is to measure the duration of this dilation. The most commonly used instrument for measuring pupil dilation is the eye tracker. Research led by Tim Smith on moving scenes revealed that, in the moments before a cut, the pupils contract. This can be interpreted as an indication that the segments represent clear units of the initiation of visual cognitive activity and memory coding.

Figure 9.3 summarizes the use of various physiological response indicators, perceptual activity and the results obtained.

Indicator	Instrument/ Codes	Research	Communicative process	Psychological activity	Editing procedures
Saccades	Eye Tracker	Hochberg, Smith, d'Ydewalle	Pleasantness	O.R. Attention Perception	
Facial expression	Facial Action Coding System (FACS)	Paul Eckman	Effectiveness Understanding Memory Emotion	Arousal Coding Recovery Valency	Related cut Jump cuts Ordering Redundance Spatial raccord Rhythmic sequence
Brain activity	Alpha fMRI	Anderson et al.	Effectiveness Memory Understanding Emotion	Attention Perception Coding Recovery	
Heart beat	HRV AG-AGCL	Lang, Zhou, Geiger	Effectiveness Memory Understanding		
Blood pressure	Tensiometer	–	Effectiveness Memory	Arousal Valency	
Conductance	GSR/SCR	Lang	Understanding Emotion		
Pupil diameter	Eye Tracker	Hess, Smith			

Figure 9.3 Physiological response indicators

Rational Response Indicators

Physiological indicators are not, however, the only way to measure the behavior of subjects. Various tests, of different scales, and post-experiment

Instrument/Code	Research	Psychological activity	Communicative process	Editing procedures
Multi-scale test	Lang, Geiger, Strickwerda and Sumner	Comprehension	Coding Retrieval	Order of cuts
Post-analysis questionnaire	d'Ydewalle, Lang	Memory		

Figure 9.4 Rational response indicators

questionnaires can also be used to study rational or conscious responses to audiovisual stimuli. Figure 9.4 shows some of the most representative examples.

A CRITICAL APPRAISAL OF THE COGNITIVE MODELS OF EDITING

We believe that cognitivists have made the greatest contributions to clarifying the issue of the perception of editing and, in general, the filmic experience, through their various lines of research, both theoretical and experimental. Nevertheless, as the only theories to have been formulated and coming from the field of psychology, they have not been compared to other models and could, therefore, be strengthened, yielding potential improvements to their processes and results. We believe that the subject of editing is much broader and complex to be summarized in just a few reductive perspectives. Moreover, modern formats, screens, changes in the way an audiovisual product can be watched, and changes in young people's viewing habits are evidence that research needs to adjust its procedures and conceptual vision of media products in order to adapt to new trends. Nevertheless, we believe that in light of the traditional approaches to grammar, editing and audiovisual rhetoric, we have access to new lines of investigation that, in our opinion, need to be developed from the field of applied communication research. Thus, to study film processing levels, we believe it would be extremely useful, in terms of providing research frameworks for content creation, to accept the capacities and limitations of our perceptual systems and processing. With the use of these measurement instruments and protocols, we could obtain better results regarding a message's effectiveness. An important question, yet to be addressed, is the close connection between existing models (Hochberg, d'Ydewalle and Smith) and the editing methods developed by great theorists such as Arnheim, Mitry and Aumont, and the practical theorists such as Eisenstein and Pudovkin, just to mention a few. This would allow the unique point of convergence, fundamental for further development in this area, to be determined.

10

RESEARCH ON EDITING AND ITS EFFECTS

In this last chapter we review research being carried out on editing and its effects. As outlined in our theoretical framework, the interest of cognitive perception psychologists in these issues gained momentum at the end of the 1970s as a result of the publication of the first works by Julian Hochberg (Hochberg and Brooks 1978). Although this area is very limited, it has yielded significant results in terms of determining the relationship between the so-called *rules of continuity* and the levels of cognitive processing in the receiver (Tommasi and Actis 1998, 1999; d'Ydewalle et al. 1998; d'Ydewalle and Vanderbecken 1990). More recently, studies by Tim Smith and Mark Seddon have focused on linking the perception of continuity with the perception of time and other phenomena (Smith 2004a, 2006; Seddon 2003). Similarly, the fruitful work of the *MediaLab* at Indiana University, headed by Annie Lang, in addition to other researchers including Julia Fox and Shuhua Zhou, among others, has resulted in the development of other experimental procedures that use various methods of measuring physiological responses in the viewer. Over the next few sections, we look at some of the main lines of research, their methods, experimental design and relevant results.

PERCEPTION OF THE CUT

This line of research was developed by Géry d'Ydewalle, Roger Penn and Robert Kraft and concerns measuring the effect of editing cuts by manipulating messages' various structural patterns. Their aim was to empirically confirm that the classic rules of filmic construction are obeyed. The first of these works (Hochberg and Brooks 1978) concerned the length of cuts and whether the use of shorter or longer cuts has an effect on the stable perception of messages. Another line of research attempted to confirm the validity of the 180° rule as the principle to tracking and localizing characters in a scene. As can be seen in Figure 10.1, the experimental designs only manipulate one or two independent variables (the duration of the

cut and the change of axis, which in these examples act as the stimuli) of an equal number of sequences watched by controlled groups of subjects. The dependent variable (the effect) is measured in all cases by monitoring eye movements. As discussed in the previous chapter, saccadic eye movements are indicators of attention activity. If, during viewing, ocular activity is greater than 200 movements per second (mps), it can be concluded that the relationships created through editing are ambiguous and do not help to maintain a smooth perception of the sequence, which consequently affects attention, comprehension and storage of the information. This would allow the hypotheses proposed by researchers to be validated or not. Research by Heft and Blondal (1987) examined the hypothesis that the affective content of a film scene is determined by the relationship between scene content and cutting speed. Two narrative films were made in which only the expressions of the characters were highlighted, either happy or angry. Two versions of each film were edited, one with fast cuts and the other with slow cuts. Subjects assessed the narrative aims of both versions in addition to their own feelings while watching them. The results supported their interaction hypothesis: faster cuts yielded positive scores for the happy film, and enhanced negative scores when the character was seen to be angry. However, they concluded that angry scenes were more complex to define and may possess various layers of meaning and emotional content, although their hypothesis still held.

By measuring attention load, Mark Seddon (2003) carried out several experiments to determine the effect of discontinuous cuts. Four versions of a sequence of 20 clips taken from archive material were edited, varying the continuity before (in two sequences), during and after the main action. The response rate was measured through an examination of secondary responses, with audio stimuli inserted at the moment of the discontinuous cuts, while memory was evaluated through the showing of images two frames long taken from just before the cuts. In the recognition test, the

	Independent variables	Dependent variables	Subjects	Design	Results
Seddon (2003)	Cut in action	Attention/Memory + RT[1]	42	4x20	No significant differences
Heft and Blondal (1987)	2 cuts 2 emotions	Taste	127	4x2	Significant differences
Hochberg and Brooks (1978)	Cuts of 0.5s, 3s	Perception	10	2x24	No significant differences

Figure 10.1 Experiments on the perception of the cut

sequence revealed that only one of the four options was valid. The results indicated that discontinuity is perceived only when at its maximum, but not in the other instances. Reaction times were faster when discontinuity was greater. This indicates that discontinuity does not involve an excess of attention resources that affects the reaction response. Rather, the subjects improved their coding by quickly executing the secondary task.

VISUAL CONTINUITY

Luca Tommasi and Rossana Actis (1998) carried out research using computerized animations of simple kinetic events to assess how shots taken from various distances are perceived as continuous or discontinuous. The results revealed that discontinuity was noticeable when the objects' movement was opposite to natural movement and was perceived as a jarring impression. The results were different for animations in which the cut was from a close-up to a long shot. In this case, the cut was perceived as continuous but, if the cut was made from a long shot to a close-up, it was perceived as a jump. The jump was more evident when the difference in size between the shots was greater. The main finding of this study was the strong impression of temporal discontinuity at the moment of the cut due to the sudden change in size of the objects. This effect seems to be triggered by the size of the signals of evident movement and is suppressed or not perceived if the level of the changes fails to reach a certain differential threshold.

Experiments carried out by Tim Smith attempted to measure the effectiveness of the type of cut when a character enters or exits a frame and to determine whether this change between shots is fluid or not. For this, an experiment was designed using animated characters and manipulating different types of entries and exits from the frame. In the first situation, the character enters the frame. In the second, only half of his body enters the frame. In the third, the whole character appears directly (see Figures 10.2 and 10.3). Subjects' attention was measured using the signals of the reaction times superimposed over the moving object. In this way, the distribution of the visual attention was recorded, demonstrating how it varied according to the way the message was edited.

Several attention effects were revealed during this experiment. When exiting is unpredictable, the subjects waited until at least 50 percent of the object exited the frame before making a saccadic eye movement. This is shown by a significant decrease in the correct response rates in the cue position before the cut. If the cut takes place when the object is not hidden (0 percent exit) or half hidden (50 percent exit) by the screen edge, there is no sign of predictive saccading and the subject takes longer to recover after the cut. This lack of movement before the cut indicates that the subjects are aware of the visual disruption caused by the cut.

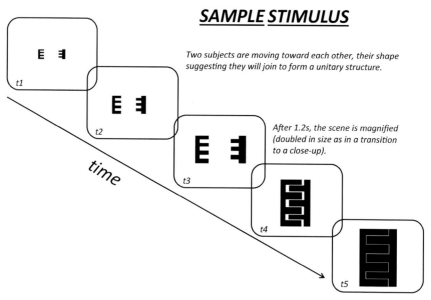

Figure 10.2 Visual continuity experiments conducted by T. Smith
(Source: Tommasi and Actis 1998)

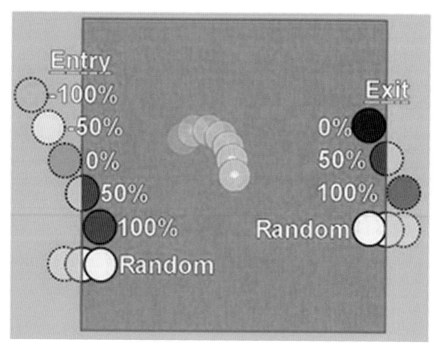

Figure 10.3 Occlusion experiments carried out by T. Smith
(Source: Smith 2006)

D'Ydewalle and Germeys (2005) analyzed the perceptions produced by 180° violations, which result in an inversion of the direction of the action. For this, they designed a test in which 20 subjects observed sequences in which the camera position had been reversed (reverse-angle shot). Five experimental conditions were designed with a larger or smaller number of manipulated shots that affected both the background scenery and the characters. The results revealed an increase in the number of saccades in the sequences with the greatest number of 180° violations in comparison to those with fewer perceptual jumps.

Finally, the study by Magliano and Zacks (2011) aimed to evaluate the impact of continuity editing, specifically the way in which people perceive the structure of narrative films through the activity of brain networks associated with the processing of different types of continuity editing boundaries. Three degrees of continuity were identified that can occur at the editing locations of videos: edits that are continuous in space, time and action; edits that are discontinuous in space and time, but continuous in action; and edits that are discontinuous in action as well as space and time. Cognitive activity was measured using fMRI. Discontinuities in action had a greater impact on behavioral event segmentation, while discontinuities in space and time had minor effects. This indicates that the schema of filmmaking aims to preserve narrative logic in order to facilitate viewers' comprehension of contents even when moderate breaks in the continuity of space and time occur (Figure 10.4).

	Independent variables	Dependent variables	Subjects	Design	Results
Magliano and Zacks (2011)	Spatial and action continuity	Brain activity fMRI	65	211 edits 111 continuity edits 81 spatial	Significant differences
D'Ydewalle and Germeys (2005)	Reverse angle	Spatial continuity Saccades	20	5x22	No significant differences
Smith (2006)	Scene entry/exit	Saccades	28	9x3x3	Significant differences
Tommasi and Actis (1999)	Shot size	Jump –2, +2	7	8	Significant differences

Figure 10.4 Spatial continuity experiments

INFORMATION ORDER

This line of research concerns the effect of manipulating the order of information elements in television messages (Figure 10.5). The starting hypothesis assumes that elements of the audiovisual message must be sequential and consequently coherent in order to produce a clear meaning for the receiver. Studies in this area started with John Isenhour in 1975. In one of his studies (Isenhour 1975), he carried out two experiments in which he varied the sequence of shots. The results indicate that the meaning of the shots varies as a function of two cognitive components: order and context. The degree to which the meanings changed when two shots were juxtaposed depended on the intensity of meaning of each individual shot and the expressive strength existing between them, thus confirming what Kuleshov demonstrated in his edited sequences of the actor Ivan Mosjoukine. Therefore, it can be concluded that juxtapositions themselves constitute a powerful semantic associative concept that influence viewers' affirmations and evaluations.

Kraft (1987) examined the functioning of the memory in visual narratives in which the internal structure was varied. Four different versions of visual narratives were created, each one taking place in just one location and relating the story of two characters. Two experiments were carried out to examine the influence of the establishing shots and the continuity of direction on the short-term memory for events represented in a two-by-two design. The sequence started with or without a general shot, preserving continuity but conserving or violating the meaning of the direction. The results revealed that the subjects were able to correctly recognize the flow of action when it preserved directional continuity, while the cinematic strategy was seen as necessary for remembering the sequence better.

In another study, Annie Lang et al. (1993) examined the differential effects of two different types of cuts (related or unrelated) on attention, capacity and audio and visual memory for information contained in television messages. For this, they used three dependent variables: heart rate, reaction time and memory. Related cuts were similar in content and visual and audio information, while unrelated cuts were created by joining shots from completely different scenes. The results showed that both related and unrelated cuts resulted in cardiac-orienting responses, while the reaction times were slower immediately following unrelated cuts than when following related cuts, indicating that the processing of unrelated cuts required more capacity to process than for similar cuts. Memory was better for information presented after related cuts compared to unrelated cuts. This effect was greater for the visual memory than for the audio memory.

The study by d'Ydewalle et al. (1997) also analyzed the cognitive effects of the narrative structure in films. The authors hypothesized that film in

essence is a predictive account and editing cuts should help following and comprehension, which they term "Third Order" for the high level of processing resources required—the two lower, or less complex, levels are the change of shot and change of camera angle. For this, an experiment was conducted in which an 8-minute film was viewed under two conditions: Condition 1: with the film shown in its correct order; Condition 2: with the film shown in an altered order. In the sound track, pulses of 1,000Hz were inserted and the subjects were asked to press a button as soon as they heard them. These clicks only occurred during discontinuous cuts. The dependent variable was the reaction time. The results revealed significant differences in these reaction times. It was concluded, therefore, that breaking the logical structure of the narrative affected the cognitive load of the viewers, which confirmed studies conducted by Kraft (1986, 1987).

	Independent variables	Dependent variables	Subjects	Design	Results
D'Ydewalle et al. (1997)	Story A/B With/ without continuity	Processing resources	27	13x2	Significant differences
Lang et al. (1993)	Related and unrelated cuts	Processing and memory resources	58^2	2x6x3	Significant differences
Kraft (1986, 1987)	Direction of the characters in a scene	Memory	104	2x2	Significant differences
Isenhour (1975)	Order and context	Cognitive activity	–	2x2	Significant differences

Figure 10.5 Information order experiments

COMPLEXITY OF AUDIOVISUAL INFORMATION

The first studies in this line of research were set out by Julian Hochberg in his 1978 article (Hochberg and Brooks 1978). The complexity of attentional activity in the perception of two sequences having different internal structures, simple and complex, projected onto a screen to various subjects, was measured. Subjects' eye movements were monitored with an Eye View Monitor. The statistical analysis revealed that there were significant differences between groups, validating the hypothesis that a complex visual load involves a greater attentional load, as indicated by greater saccadic eye movement.

In another study, Cowen (1988) edited and tested in four different ways the perception of a short film, manipulating the number of shots, the structure and the presentation of the action. The comprehension indicators of the subjects for the version with greater coherence were better in comparison to the other three in which the order was disrupted or even shown in a chaotic order. The results revealed that the comprehension and recall of the events in a film depend on the interaction between the story grammar and the way editing introduces temporal continuity through the representation of spatial relations and movement. Moreover, the presentation of negative information resulted in negative impressions of the protagonists.

In a later study, Lang et al. (2000) examined the variation in camera position in a visual scene, relating it to the viewers' attention, recognition and memory. The experimental sequences were prepared in four different versions, varying the rate of the cuts (from slow to very fast) and camera position. The results demonstrate that, as the editing rate increased, so did arousal, attention and memory. This implies that modifying audiovisual messages through faster edits can increase the attention and coding of the television message content without significantly increasing the cognitive load of the message.

A more recent investigation studied the effect of inserting texts and animated graphics in television news (Fox et al. 2004). The team prepared their experimental material using diverse news sequences in which various accompanying graphics, either static or animated, were included. The independent stimulus variable was compared with the effect on coding, storage, retrieval and arousal in young and older viewers. The allocation of resources was monitored through measuring heart rate and arousal

	Independent variables	Dependent variables	Design	Conditions	Results
Fox et al. (2004)	3 graphics 2 complexity	Heart rate Conductance	61	7x30s	Significant differences
		Four-scale memory test			
Lang et al. (2000)	Increase in number of cuts	Attention Recognition Memory	39	4x4x5	Significant differences
Cowen (1988)	Ordering	Comprehension Recall	-	4x2	Significant differences
Hochberg and Brooks (1978)	Simple/ complex	Cognitive activity	10	2x24	Significant differences

Figure 10.6 Information complexity experiments[2]

and using electrodes to measure skin conductance. The rational coding response was obtained using four-scale multiple-choice questionnaires, while recall was measured through telephone interviews two and seven days after the subjects watched the messages. The results demonstrated that younger viewers code, store and recall graphics, including redundant information, better than older viewers. The data for recognition and heart rate are especially important in older viewers, as they indicate a more controlled processing of the messages, while the students carry out these processes automatically. A drop in attention occurred when redundant graphics were shown (Figure 10.6).

REDUNDANCY

Research into audiovisual redundancy analyzes the informational correspondence between video and audio tracks—in other words, how the information between both channels is coupled and synchronized (Figure 10.7). It then examines the effects on memory and comprehension when they are varied. The work carried out by Drew and Grimes (1987) and Basil (1992) was the first in this area and opened up a new avenue of research that, over the years, has extended to the study of the influence of titles and supporting graphics on the effectiveness of news messages.

Drew and Grimes (1987) examined the effects of audio and video redundancy on recall and comprehension of television news. A group of students watched a series of voice-over news stories in which the redundancy between the two channels varied over three levels. The participants then answered questions relating to either the visual or audio information or both. The results revealed higher auditory recall and understanding in the high-redundancy condition compared to the lower-redundancy condition. The visual recall, however, showed the opposite. The highest recall scores were obtained in conditions of lower redundancy.

Another line of research into redundancy involved improving the effectiveness of educational material in audiovisual support (Lai 2000). In this study, the functioning of computer-based learning (CBL) was examined. A series of lessons with abstract messages were produced in five versions, varying the way image was related to sound. The participants were divided into three groups based on their score in a reasoning test carried out beforehand. The results showed that both static graphics with no audio narration and animations with complete audio helped the students understand the abstract concepts better in comparison to static graphics with complete audio or pieces that only included animation. Animation with sound had a greater effect on long-term retention. These results suggest that certain basic discursive processes may be more efficient than other, more complex ones, especially if they include content partly explained through audio.

Julia Fox (2004) used a signal detection method to study the discrimination of information from news stories with redundant images and those with dissonant visuals. The expectations regarding visual elements normally associated with television news stories were also evaluated together with the way in which protocols to identify these visual elements were generated. The experiment entailed the creation of two versions of news clips edited expressly to generate redundant and dissonant meaning. Subjects were randomly divided into groups. One group watched the redundant versions of both news items, while another group watched the dissonant version of both stories. While the statistical analyses revealed a better recognition of redundant messages compared to dissonant ones, the results were not significant. However, a significant difference in memory sensitivity, as a measure of memory strength, was observed. It was concluded that signal detection methods need to be used more by communication researchers in order to identify the causes that motivate meaning decisions and memorizing these types of messages.

Zhou (2005) examined the effects of arousing visuals and audiovisual redundancy on the cognitive evaluation of viewers of television news stories. Four thought dimensions were assessed: salience, polarity, originality and emotionality. For each news story, subjects answered some questions and were asked to write down their thoughts about the news stories. These thoughts were then evaluated by the researchers, who graded them for polarity, i.e. whether their answers were favorable, neutral or unfavorable. The news stories were also graded for their salience, emotionality and originality. The results showed that redundancy had an important effect on the four dimensions, while arousing visuals only affected two dimensions—originality and emotionality. The results of this experiment indicate that redundancy had most effect on the capacity to generate thoughts in terms of salience, valence, emotion and reaction to the news stories. This pattern of findings suggests that cognitive evaluation may be a more sensitive measure than previous studies in which only the allocation of resources for recognition and memory were assessed.

Morales Morante (2010) conducted a study to analyze the functioning of perceptive indicators important in the construction of overlaps—the joining of two scenes in which the sound is heard ahead of the image. A sample of 51 original video clips from films, news stories and advertisements were selected. The variation in four important audiovisual indicators present during the overlap—sound intensity, sound attack, overlap time and visual intensity, which formed the independent variables—was measured. Ninety subjects were divided into two equal groups and were asked to individually assess the impression of shock or surprise aroused in them by the clip using a five-scale test similar to the *Differential Emotion Scale* (DES) developed by Carroll Izard (1993). The results revealed that the increases in sound attack, sound intensity and image generated an impression of great surprise in the participants, while overlaps with more

	Independent variables	Dependent variables	Design	Conditions	Results
Morales Morante (2010)	Visual intensity Sound intensity Visual assault Audio overlap	Impression of surprise	51	3x51x90	Significant differences No significant differences
Zhou (2005)	Redundant news Dissonant news	Salience Polarity Originality Emotionality	54	2x2x8	Significant differences
Fox (2004)	Redundant news Dissonant news	Memory	77	2x2	Significant differences
Lai (2000)	1. Still graphics 2. Still graphics with complete audio 3. Animation 4. Animation with key audio clips 5. Animation with complete audio	Memory	316	5x3	Significant differences
Drew and Grimes (1987)	High, medium and low redundancy	Visual memory Audio memory Comprehension	82	2x3	Significant differences

Figure 10.7 Audiovisual redundancy experiments

similar values for these variables were mainly classified as not surprising. The variations in the length of the audio overlap were not significant in terms of the impression of surprise.

EMOTIONAL EFFECTS

Finally, we review another important, well-developed line of research whose findings are useful to advertisers and those working in other areas of communication interested in reaching target audiences, appearing plausible and influencing viewers towards specific behaviors. Specifically, we are referring to emotional effects (Figure 10.8). We could place this line of

research within the context of other studies reviewed in this chapter that analyze the performance of attention and memory together with more qualitative responses such as arousal, excitement or content relevance. As the reader may have noticed, our choice of subdivisions for this chapter is based on the informative need to group the various studies, when in fact they analyze their effects from various perspectives, using various dependent variables that in practice are impossible to classify and study individually, since they go to the heart of important areas of psychology research.

The aim of the study carried out by Emmers-Sommer et al. (2005) was to examine the effect of manipulating editing on the attitudes of men and women towards women. One hundred and seventy-four participants were randomly assigned to one of four groups. Three groups watched a specific manipulation of a film (uncut, mosaic-ed or edited) that showed the true story of a rape. The fourth group served as a control. The study's findings suggest that, in general, men have more traditional attitudes than women and more negative attitudes towards women. Moreover, the immediate reaction to stimuli such as sexual violence based on a true story exacerbates these attitudes. Women, on the other hand, appeared to undergo a more immediate, positive change in attitude towards women following exposure to the same stimuli. It appears that women respond differently than men, with their attitudes based on reality, whilst those of men are based on violent entertainment.

In 2007, Annie Lang et al. conducted an investigation in which they analyzed whether the emotional content of a message alters the effects of information density and how much this type of structure affects the use of available resources. An experiment was designed in which four independent variables were regulated according to the number of cuts and their semantic relation, the level of complexity, positive/negative emotional load and message duration. The first dependent variable was attentional load, which was measured through secondary task reaction times (STRTs). Three audio pulses were randomly inserted into each message, the first shortly after the start. None of the probes coincided with the cuts. Subjects were asked to press a button when they heard the audio pulse. The second dependent variable was recognition, which was measured through a forced-choice test in which the participants had to answer whether they had heard three sentences exactly as they had appeared in the clip. The results confirmed earlier studies that supported the thesis that reaction time is suitable for measuring available resources. Moreover, they demonstrate that this pattern of recognition and measurement of available resources is stable independently of the message's emotional content. Emotion appears to function as a constant, increasing the resources necessary to process information.

Schaefer et al. (2010) carried out a study to test the effectiveness of emotional films. In the initial phase, 50 film experts were asked to propose a list of scenes with distinct emotional intent, including fear, anger, sadness,

disgust, amusement and tenderness, together with emotionally neutral scenes. For each emotion, the 10 most frequently cited scenes were chosen and edited. Three hundred and sixty-four participants then watched the film clips, which included all categories of emotion, in individual laboratory sessions and were asked to rate them on several dimensions. The results showed that the clips were effective in terms of several criteria such as emotional discreteness, arousal, and positive and negative affect. Finally, the classification scores were computed for 24 criteria: subject arousal, positive and negative affect scores derived from the Differential Emotions Scale (DES; Izard 1993), six emotional discreteness scores (for anger, disgust, sadness, fear, amusement and tenderness), and 15 "mixed feelings" scores assessing the effectiveness of each film excerpt to produce specific emotions. The effectiveness of each fragment may be produced through a combination of specific but distinct emotions.

Volkman and Parrott (2012) examined the use of various narrative structures expressing positive or negative emotions in the treatment of osteoporosis. The degree of involvement of the message's narrator was assessed according to three possible levels of narrative and emotional involvement and subsequent behavioral intentions. A design of 12 messages was used that combined the independent variables mentioned. The post-viewing test revealed the existence of positive relationships between the perceived quality of the evidence and the perceptions of message effectiveness in predicting behavioral intentions in the prevention of osteoporosis. Furthermore, arousing emotions such as fear and/or hope may optimize the transmission and sensitivity of health campaigns for osteoporosis or similar diseases.

	Independent variables	Dependent variables	Design	Conditions	Results
Volkman and Parrott (2012)	Narrative structure Narrator	Quality Effectiveness Taste	17	4x3x2	Significant differences
Schaefer et al. (2010)	Eight emotions	Arousal Valence	364	70x10	Significant differences
Lang et al. (2007)	Valence Complexity Emotional load	Attention Recall	94	2x2x2x3x3x2	Significant differences
Emmers-Sommer et al. (2005)	Without cuts With cuts Multiscreen	Likert scale of valence	174 (54 men 120 women)	4x3	Significant differences

Figure 10.8 Experiments on emotional effects

Current communication research is also studying other phenomena and effects of the various messages generated by editing. We believe that the diffusion of these reliable methods of measurement for the control of narratives, procedures and techniques involved in audiovisual production, broadcast and consumption will be of great use in understanding how media reception in all its forms occurs. As we have discussed before, one of the main limitations of the functioning of various editing procedures is that they have emerged from filmmakers' own individual visions. Even until now, their true effectiveness lacks validation. The contribution made by cognitive psychology therefore represents a big step forward in the careful control of the different variables of processing and the rigorous testing of multiple associated effects. In this way, we will be able to understand more scientifically how we see, understand, feel and behave in terms of the narratives we see and hear. The gradual assimilation of this knowledge is important and should be encouraged, not only to incorporate a new line of professional work but also to guarantee the quality and effectiveness of productions. This added value also increases the range of services for clients, broadcasters, advertising agencies, producers, content management enterprises, etc. It is important that communication research also looks towards other horizons and that it not only has access to and develops better technology but also new tools in order to guarantee better content, greater quality, larger audiences and new alternatives to improve investment profitability.

The emergence of connected television, mediated through the Internet (IPTV), HD, 3D and whatever technology the future may hold, is opening up uncertain horizons. Yet at the same time, opportunities are also arising that could be capitalized upon through the intense flow of messages circulating through the media and the need to broadcast them. In light of the technological vision of cinema, video, television and editing, we should not forget their essential and primary function: to create narratives, news, commercials, video clips, credits, etc. This leads us to think first and foremost about contents, narratives, esthetics and how editors' pragmatic ideas and decisions can help to improve them and add value, concepts and new ideas. In short, to ensure a better transmission of information. It is for this reason that the chapters in this book have attempted to bring together the various factors that, in our opinion, a good editor needs to control in order to carry out his/her task. Through a combination of editing theories, methods, narrative criteria and esthetics, together with operative skill, ideal, assured and reliable knowledge is gradually built up. However, two additional issues need to be addressed. Firstly, the need for all editors to be open-minded to changes, to new trends, new products and new approaches and formats, wherever they come from. All of these in one way or another serve to enrich us and to allow us to be at the profession's cutting edge. Constantly seeing what other editors do in other productions will, therefore, be useful and necessary. Finally, we need

to constantly bear in mind the importance of including the conventional viewer in our creative processes and solutions. The work of an editor is usually a solitary and lengthy one and, as such, many of the decisions taken end up being adopted repeatedly and automatically. Editors need to take into consideration different perspectives, various alternatives and outside opinions from experts and non-experts alike. Experimental procedures are always revealing, even when we are not always in a position to conduct them with the specialized equipment needed to measure complex, multiple physiological responses. Nevertheless, questionnaires are extremely useful for measuring the impact, contents and forms of tailored messages and the enjoyment and attitudes of viewers in terms of their experience of them. This is the first step in the search for new horizons that complement this profession's task.

Self-study Exercises: Experimental Editing Design

We now explain some of the basic guidelines in experimental design that you can use to test out your work and measure some of the effects of editing, such as preference, attention, memory, emotions, etc.

In your professional work, you have probably often edited several versions of the same sequence and shown them to others to get their opinions on which they think the best, to which you ask: why? This section aims to provide you with some basic ideas for you to design your own experimental plan, to test your edits on others and finally to choose the best one.

To accurately carry out the experiments, it is important to bear in mind certain basic concepts and steps. The first thing you need to do is edit various versions of your sequence to create, for example, versions A, B and C. Since you have manipulated in some way certain editing variables, they should differ from the others and those who watch them should be able to find differences among them. For example, imagine the following situation. You decide to test which length of shot works better for your sequence. You have the same sequence filmed in different shot sizes. You decide to test the variable "Shot Length" and so create three versions: Version A, with long shots; Version B, with close-ups; and Version C, a combination of long shots and close-ups. The length of each shot is the variable manipulated in each version and we refer to this as the stimulus variable or independent variable, as it contains specifically that editing element we want to test. Other examples of dependent variables include the variation of the order of shots, type of shot, camera movement, color, position, size of titles, etc.

Secondly, you need to define the response you want to measure in the individuals on perceiving the stimulus (independent variable). We will refer to this response as the dependent variable and will measure the effect, i.e. the reactions—attention, emotion, recall, preference, surprise, etc.—of the subjects on watching the sequences.

Finally, to make sure the various responses are due only to the manipulated independent variable, we need to keep the test variables (that is, all the others involved in the experiment) the same; for example, the perceptual capacities of the participants, the setting, the characteristics of the file and system that reproduces it, the screen, distance, etc.

Here are some important recommendations when preparing your experiment:

1. Make sure your versions are noticeably different before testing your product. That way, you will avoid confusion when assessing them.

2. Try to work with as few dependent and independent variables as possible, as this will give you more control of the whole process.

3. Don't create too many versions. It will be easier to obtain and analyze results if you work with just a few versions.

4. We recommend working with small groups of participants in order to control the progress of the experiment. Try and avoid distractions, noise and boredom.

5. Make sure the participants take part in the experiment in adequate conditions, including space, screen, sound and surrounding elements. Try and control the conditions as best as you can, so that they don't affect participants' perception or response.

6. Draw up a short, simple, realistic questionnaire for the participants. Explain it to them before they watch the videos.

7. Give the participants plenty of time to watch all the videos. If necessary, let the participants watch them again.

8. Explain carefully beforehand what the test consists of, so that participants do not fill out the questionnaire incorrectly. You can use multiple-choice or open or closed questions. Remember to explain what their participation consists of and what they should do.

9. Don't reveal your intentions, as this may give the participants clues as to how to respond to the test.

10. You can prepare a paper version of the questionnaire or, better still, use specialized applications to create a digital version of it. You could even distribute this digital questionnaire to groups and social networks to obtain a greater number of answers.

11. Analyze your results carefully and try to improve your methods.

12. Although it will be more complicated, if you can use psycho-physiological measurement instruments you will obtain better results in order to improve your edits. However, you should ideally obtain some specialized training beforehand or get the help of a specialist to use the instruments correctly.

Here are some examples that may help you design your editing experiment.

1. Perceiving the cut.
 (a) Independent variable: Stimulus.

 Length of cuts: short, medium, long.
 Camera angle: normal, low-angle shot, high-angle shot.
 Shot size: long shots, close-ups.
 Movement of camera or action: slow-quick, left to right.
 Combination of shot lengths and sizes.
 Cut before, during or after the action.

 (b) Dependent variable: Response.

 Preference: which version do you prefer: 1, 2 or 3? Choose a number from the scale to score the versions. Explain why you prefer a particular version.
 Recall: After a set period of time, what do the participants remember? What things do they remember?

2. Order and complexity of information.
 (a) Independent variable: Stimulus (possible versions).

 Distribution of the shots in the sequence: linear, reverse, alternating.
 Amount of action shown.

 (b) Dependent variable: Response.

 Which version I prefer most and which least.
 What I understood from the scene: explain the storyline in a few words.
 What I remember from the scene after a few days, weeks.

3. Audiovisual asynchrony.
 (a) Independent variable: Stimulus (possible versions).
 Image and sound contain exactly the same information.
 The image adds complementary information to the information in the sound.
 The sound adds complementary information to the visual information.
 The image and sound contain contradictory information.

 (b) Dependent variable: Response.
 Which version I prefer most and which least: choose a score from the scale.
 What I understood from the scene: explain the storyline in a few words.
 What I remember from the scene after a few days, weeks.

NOTES

1. 'RT' is the reaction time of the secondary task. Reaction time is used to measure the use of attention resources. If a subject allocates a large number of resources (concentration to watch a film), he/she will take longer to detect the signals at the moment of the cut. This response rate should also be higher than the resources allocated to identify sudden changes of shot or camera angle.
2. Twenty-two were monitored for heart rate, 18 for reaction time and 18 for both heart rate and reaction time.

BIBLIOGRAPHY

Amiel, Vincent. 2014. *Esthétique du montage*. Armand Colin, Paris.

Amo, Antonio del. 1972. *Estética del montaje*. Author's edition, Madrid.

Anderson, Daniel R., Fite, Katherine V., Petrovich, Nicole and Hirsch, Joy. 2006. Cortical activation while watching vídeo montage: An fMRI study. *Media Psychology*, Vol. 8, Iss. 1.

Anderson, John. 1996. *The reality of illusion: An ecological approach to cognitive film theory*. Southern Illinois University Press, Carbondale, IL.

Arnheim, Rudolf. 1986. *El cine como arte*. Paidós, Barcelona.

Aumont, Jacques. 1969. Le concept de montage. In *Les Conceptions du montage, Cahiers du Cinéma*, April, pp. 46–51.

Aumont, Jacques, Bergala, Alain, Marie, Michel and Vernet, Marc. 1996. *Estética del cine: espacio fílmico, montaje, narración, lenguaje*. Paidós, Barcelona.

Balázs, Béla. 1978. *Evolución y esencia de un arte nuevo*. Colección Mundo Visual, Gustavo Gili, Barcelona.

Balázs, Béla. 1931. *"Theory of the film": Character and growth of the new art*. Dennis Dobson Ltd, London.

Barroso García, Jaime. 1988. *Introducción a la realización televisiva*. IORTV, Madrid.

Basil, M. D. 1992. Attention to and memory for audio and video information in television scenes. Paper presented at the *Annual Meeting of the International Communication Association*, Miami, FL.

Bergson, Henry. 1920. *Essai sur les donnés immédiates de la conscience*, 19th edition. Alcan, Paris.

Bordwell, David. 2001. *Film art and introduction*. McGraw Hill, Barcelona.

Bordwell, David. 1995. *El significado del filme*. Paidós, Barcelona.

Bordwell, David. 1993. *El cine de Eisenstein*. Paidós, Barcelona.

Browne, Steven E. 2004. *Edición de vídeo*. IORTV, Madrid.

Browne, Steven E. 1989a. *El montaje en la cinta de vídeo: Factor básico en la Post-Producción*. IORTV, Madrid.

Browne, Steven E. 1989b. *Vídeotape editing: A postproduction primer*. Focal Press, New York.

Brownlow, Kevin. 1989. *The parade's gone by*. Columbus Books, London.

Burch, Noël. 1998. *Praxis del cine*. Editorial Fundamentos, Colección Arte, Madrid.

Carlizia, C. and Forchino, M. 1992. *Curso completo de video: Grabación y montaje*. De Vecchi, Barcelona.

Carrol, John. 1984. The film experience as cognitive structure. *Empirical Studies of the Arts*, Vol. 2, No. 1, pp. 1–17

Casetti, Francesco and Di Chio, Federico. 2009. *Analisi del film*. Paidós Ibérica, Barcelona.

Chion, Michel. 2001. *Cómo se escribe un guión*. Cátedra, Signo e Imagen, Madrid.

Chion, Michel. 1994. *Audio-vision: Sound on screen*. Columbia University Press, New York.

Clotas, Salvador, Guarner, José Luis and Jordá, Joaquín. 1969. *Enciclopedia ilustrada del cine*. Labor, Barcelona.

Coltheart, Max. 1975. Iconic memory: A reply to Professor Holding. *Memory & Cognition*, Vol. 3, Iss. 1, pp. 42–48.

Comparato, Doc. 1988. *El guión: arte y técnica de escribir para cine y televisión*. IORTV, Madrid.

Comparato, D., Vázquez, P., and Alonso, P.L.C. 1993. *De la creación al guión*. Instituto Oficial de Radio y Television.

Cowen, Paul S. 1988. Manipulating montage: Effects on film comprehension, recall, person perception, and aesthetic responses. *Empirical Studies of the Arts*, Vol. 6, No. 2, pp. 97–115.

Crowder, Robert. 1976. *Principles of learning and memory*. Erlbaum, Hillsdale, NJ.

Dancyger, Ken. 1999. *Técnicas de edición de cine y vídeo*. Gedisa, Barcelona.

Dancyger, Ken. 1993. *The technique of film and vídeo editing*. Focal Press, New York.

Dellacroix, Henri. 1936. *La conscience du temps*. In G. Dumas, *Nouveau traité de psychologie*, pp. 305–324, Paris, Alcan.

Dmytryk, Edward. 1986. *On filmmaking*. Focal Press, Boston

Drew, Dan and Grimes, Thomas. 1987. Audio-visual redundancy and TV news recall. *Communication Research*, Vol. 14, Iss. 4, pp. 452–461.

D'Ydewalle, Géry and Germeys, Filip. 2005. The psychology of film: perceiving beyond the cut. *Psychological Research*, Vol. 71, Iss. 4, pp. 458–466.

D'Ydewalle, Géry, Desmet, Geert and Van Rensbergen, Johan. 1998. Film perception: The processing of film cuts. In G. Underwood (Ed.), *Eye guidance in reading in scene perception*, pp. 357–367, Elsevier, Oxford.

D'Ydewalle, Géry, Desmet, Geert and Van Rensbergen, Johan. 1997. Film perception: The processing of film cuts. *Psych. Rep.* No. 220, Katholieke Universiteit Leuven, Laboratory of Experimental Psychology, Leuven.

D'Ydewalle, Gery and Vanderbecken, M. 1990. Perceptual and cognitive processing of editing rules in film. In R. Grones, G. D'Ydewalle and

R. Parham (Eds.), *From eye to mind: Information acquisition in perception search and reading*, pp. 129–139, Elsevier, Amsterdam.

Ekman, P., Friesen, W. V., and Ellsworth, P. 2013. *Emotion in the human face: Guidelines for research and an integration of findings*. Elsevier, Oxford.

Eisenstein, Sergei. 2001a. *Hacia una teoría del montaje* (2 volumes). Paidós Comunicación 115 Cine, Barcelona.

Eisenstein, Sergei. 2001b. *Montaje y arquitectura* (1938). In *Hacia una teoría del montaje* (Vol. 1). Paidós Comunicación 115 Cine, Barcelona.

Eisenstein, Sergei. 1999a. *Del teatro al cine* (1934). In *La forma del cine*. Siglo XXI, Madrid.

Eisenstein, Sergei. 1999b. *El principio cinematográfico y el ideograma* (1929). In *La forma del cine*. Siglo XXI, Madrid.

Eisenstein, Sergei. 1999c. *Métodos de montaje* (1929). In *La Forma del cine*. Siglo XXI, Madrid.

Eisenstein, Sergei. 1999d. *Lo inesperado* (1926). In *La Forma del cine*. Siglo XXI, Barcelona.

Eisenstein, Sergei. 1989. *Teoría y técnica cinematográfica*. Rialp, Madrid.

Eisenstein, Sergei. 1974a. *La cuarta dimensión fílmica* (1929). In *El sentido del cine*. Siglo XXI, Barcelona.

Eisenstein, Sergei. 1974b. *El montaje de atracciones* (1923). In *El sentido del cine*. Siglo XXI, Barcelona.

Emmers-Sommer, Tara M., Triplett, Laura, Pauley, Perry, Hanzal, Alesia and Rhea, David. 2005. The impact of film manipulation on men's and women's attitudes toward women and film editing. *Sex Roles*, Vol. 52, Iss. 9, pp. 683–695.

Erisman, Shannon and Roemer, Lizabeth. 2010. A preliminary investigation of the effects of experimentally induced mindfulness on emotional responding to film clips. *Emotion*, Vol. 10, Iss. 1, pp. 72–82.

Eysenck, Michael. 1993. *Principles of Cognitive Psychology*. Psychology Press, Hove, UK.

Fernández, M. C. 1997. *Influencias del montaje en el lenguaje audiovisual*. Ediciones Libertarias/Prodhufi, Madrid

Fernández-Turbau, Valentín. 1994. *El cine en definiciones*. Ixia Livres, Barcelona.

Festinger, L., Sedgwick, H. A. and Holtzman, J. D. 1976. Visual perception during smooth pursuit eye movements. *Vision Research*, Vol. 16, Iss. 12, pp. 1377–1386.

Fox, Julia R. 2004. A signal detection analysis of audio/vídeo redundancy effects on television news video. *Communication Research*, Vol. 31, Iss. 5, pp. 524–536.

Fox, Julia R., Lang, Annie, Chung, Yongkuk, Lee, Seungwhan, Schwartz, Nancy and Potter, Deborah. 2004. Picture this: Effects of graphics on the processing of television news. *Journal of Broadcasting & Electronic Media*, Vol. 48, Iss. 4, pp. 646–674.

Fraisse, Paul. 1978. *Psicología del ritmo*. Morata, Madrid.

Fraisse, Paul. 1967. *Psychologie du temps*. Presses Universitaires de France, Paris.

Fraisse, Paul. 1956. *Les structures rythmiques*. Erasme, Paris.

Frijda, Nico. 1988. The laws of emotion. *American Psychologist*, Vol. 43, Iss. 5, pp. 349–358.

Gibson, James. 1966. *The senses considered as perceptual systems*. Houghton Mifflin, Boston.

Gombrich, Ernest. 1982. *Arte e ilusión*. Gustavo Gili, Barcelona.

Heft, Harry and Blondal, Ragnar. 1987. The influence of cutting rate on the evaluation of affective content of film. *Empirical Studies of the Arts*, Vol. 5, Iss. 1, pp. 1–14.

Henderson, John and Hollingworth, Andrew. 2003. Eye movements and visual memory: Detecting changes to saccade targets in scenes. *Perception & Psychophysics*, Vol. 65, Iss. 1, pp. 58–71.

Henderson, John and Hollingworth, Andrew. 1999. The role of fixation position in detecting scene changes across saccades. *Psychological Science*, Vol. 10, No. 5, pp. 438–443.

Hess, E. H. 1972. Pupillometrics. In N. S. Greenfield and R. A Sternbach (Eds.), *Handbook of Psychophysiology*, pp. 491–531, Holt, Richard & Winston, New York.

Hillstrom, Anne and Yantis, Steven. 1994. Visual motion and attentional capture. *Perception & Psychophysics*, Vol. 55, Iss. 4, pp. 399–411.

Hochberg, Julian. 1986. Representation of motion and space in video and cinematic displays. In K. R. Boff, L. Kaufman and J. P. Thomas (Eds.), *Handbook of perception and human performance*, Vol. 1: Sensory processes and perception, pp. 22.21–22.64, John Wiley and Sons, New York.

Hochberg, Julian and Brooks, Virginia. 1978. Film cutting and visual momentum. In John Senders, *Eye movements and the higher psychological functions*, John Wiley and Sons, New York.

Hollingworth, Andrew and Henderson, John. 2000. Semantic informativeness mediates the detection of changes in natural scenes. *Visual Cognition: Special Issue on Change Detection and Visual Memory*, Vol. 7, Iss. 1–3, pp. 213–235.

Hutchinson, Bruce, D. 2003. An attention model of film viewing. *Journal of Moving Image Studies*, Vol. 2.

Irwin, David E. and Zelinsky, Gregory. 2002. Eye movements and scene perception: Memory for things observed. *Perception & Psychophysics*, Vol. 64, Iss. 6, pp. 882–895.

Irwin, David E., Yantis, Steven, and Jonides, John. 1983. Evidence against visual integration across saccadic eye movements. *Perception & Psychophysics*, Vol. 34, Iss. 1, pp. 49–57.

Isenhour, John P. 1975. The effects of context and order in film editing. *AV Communication Review*, Vol. 23, Iss. 1, pp. 69–80.

Izard, Carroll E. 1993. Four systems for emotion activation: Cognitive and noncognitive processes. *Psychological Review*, Vol. 100, No. 1, pp. 68–90.

Johns, Geoffrey A. and Roof, Judith. 2003. *The psychology of visual stimuli-film theory defined*. ENG 330, Sec. 1.

Jurgenson, Albert and Brunet, Sophie. 1992. *La práctica del montaje*. Gedisa, Barcelona.

Katz, Steven. 1991. *Film directing shot by shot*. Michael Wiese Productions, Studio City, CA.

Kraft, Robert N. 1991. The coherence of visual narratives, *Communication Research*, Vol. 18, Iss. 5, pp. 601–616.

Kraft, Robert. 1987. Rules and strategies of visual narratives. *Perceptual and Motor Skills*, Vol. 64, Iss. 1, pp. 3–14.

Kraft, Robert. 1986. The role of cutting in the evaluation and retention of film. *Journal of Experimental Psychology: Learning, Memory, and Cognition*, Vol. 12, Iss. 1, pp. 155–163.

Kuleshov, Lev. 1987. *Lev Kuleshov: Selected works* (Trans. Dmitri Agrachev and Nina Belenkaya). Raduga, Moscow.

Lachman, Roy, Lachman, Janet L. and Butterfield, Earl C. 1979. *Cognitive, psychology and information processing: An introduction*. Lawrence Earlbaum, Hillsdale, NJ.

Lai, Shu Ling. 2000. Increasing associative learning of abstract concepts through audiovisual redundancy. *Journal of Educational Computing Research*, Vol. 23, Iss. 3, pp. 275–289.

Lang, Annie. 2000. The limited capacity model of mediated message processing. *Journal of Communication*, Vol. 50, Iss. 1, pp. 46–70.

Lang, Annie, Zhou, Shuhua, Schwartz, Nancy, Bolls, Paul D. and Potter, Robert F. 2000. The effects of edits on arousal, attention, and memory for television messages: When an edit is an edit can an edit be too much? *Journal of Broadcasting & Electronic Media*, Vol. 44, Iss. 1, pp. 94–109.

Lang, Annie, Geiger, Seth, Strickwerda, Melody and Sumner, Janine. 1993. The effects of related and unrelated cuts on television viewers' attention, processing capacity, and memory. *Communication Research*, Vol. 20, Iss. 1, pp. 4–29.

Lang, Annie, Park, Byungho, Sanders-Jackson, Ashley N., Wilson, Brian D. and Wang, Zheng. 2007. Cognition and emotion in TV message processing: How valence, arousing content, structural complexity, and information density affect the availability of cognitive resources. *Media Psychology*, Vol. 10, Iss. 3, pp. 317–338.

Larousse Editores. 1993. *Diccionario de cine*. Madrid.

Levin, Iris. 1989. Principles underlying time measurement: the development of children´s construction on counting time. In I. Levin and D. Zakay (Eds.), *Time and human cognition: A life-span perspective*, pp.145–183, Elsevier, Amsterdam.

Lindgren, Ernest. 1954. *El arte del cine: Notas para una valoración crítica del cine*. Artola, Madrid.

Lindgren, Ernest. 1948. *The art of the film: An introduction to film appreciation*. Allen and Unwin, London.

Magliano, Joseph and Zacks, Jeffrey. 2011. The impact of continuity editing in narrative film on event segmentation. *Cognitive Science*, Vol. 35, Iss. 8, pp. 1489–1517.

Mandler, George. 1984. *Mind and Body: Psychology of Emotion and Stress.* Norton, New York.

Mandler, George. 1975. *Mind and Emotion.* John Wiley and Sons, New York.

Martin, Marcel. 2015. *El lenguaje del cine.* Gedisa, Barcelona.

Mascelli, Joseph. 1998. *Los cinco principios de la cinematografía.* BOSCH, Barcelona.

Metz, Christian. 2002. *Ensayos sobre la significación en el cine (1964–1968).* Paidós, Barcelona.

Metz, Christian. 1974. *Film language: A semiotics of the cinema.* University of Chicago Press, Chicago.

Michotte, Albert. 1946. *La perception de la causalité.* Institut Supérieur de Philosophie, Louvain. [English translation by T. Miles and E. Miles, *The perception of causality.* Basic Books, 1963.]

Millerson, Gerald. 2008. *Realización y producción de televisión.* Omega, Madrid.

Millerson, Gerald. 1991a. *Manual de producción en vídeo.* Paraninfo, Madrid.

Millerson, Gerald. 1991b. *Técnicas de producción y realización de televisión.* IORTV, Madrid.

Millerson, Gerald. 1990. *Manual de producción de video.* Thomson-Paraninfo, Madrid.

Mitry, Jean. 2002. *Estética y psicología del cine*, Vol. 2. Siglo XXI, Madrid.

Mitry, Jean. 1970. *Diccionario de cine.* Plaza & Janes, Barcelona.

Morin, Edgar. 2001. *El cine o el hombre imaginario.* Paidós Comunicación 127, Barcelona.

Morales Morante, Fernando. 2010. *Diseño para un estudio del impacto perceptivo del overlapping audiovisual.* Unpublished Doctoral Thesis, Department of Audiovisual Communication and Advertising, Autonomous University of Barcelona.

Morales Morante, Fernando. 2000. *Teoría y práctica de la edición en vídeo.* Universidad de San Martín de Porres, Lima, Peru.

Münsterberg, Hugo. 2013. *Hugo Münsterberg on film. The photoplay: A psychological study and other writings* (1916). Routledge, New York.

Murch, Walter. 2003. *En el momento del parpadeo.* Ocho y medio, Madrid.

Norrisa, Rebecca L., Bailey, Rachel L., Bolls, Paul D. and Wise, Kevin R. 2012. Effects of emotional tone and visual complexity on processing health information in prescription drug advertising. *Health Communication*, Vol. 27, Iss. 1, pp. 42–48.

Palmer, Stephen E. 1999. *Vision science: Photons to phenomenology.* MIT Press, Cambridge, MA.

Páramo, José Antonio. 2002. *Diccionario espasa: cine y TV: terminología técnica.* Espasa Calpe, Madrid.

Pinel, Vincent. 2004. *El montaje: el espacio y el tiempo en el filme.* In *Los pequeños cuadernos de Cahiers du Cinéma.* Paidós, Barcelona.

Ponech, Trevor. 1997. Visual perception and motion picture spectatorship. *Cinema Journal*, Vol. 37, No. 1, pp. 85–100.

Pudovkin, Vsévolod. 1988. *El montaje del film*. In VV.AA, *El cine soviético de todos los tiempos (1924–1986)*. Ediciones Documentos de la Filmoteca Valenciana.

Pudovkin, Vsévolod. 1957. *Lecciones de cinematografía*. Rialp, Madrid.

Quinquer, Luis. 2001. *El drama de escribir un guión dramático*. Nuevas Ediciones de Bolsillo, Barcelona.

Raimondo Souto, H. Mario. 1993. *Manual del realizador profesional de vídeo*. D.O.R.S.L. Ediciones, Madrid.

Reisz, Karel and Millar, Gavin. 2003. *Técnica del montaje cinematográfico*. Plot Ediciones, Madrid.

Rensink, Ronald A. 2002. Change detection. *Annual Review of Psychology*, Vol. 53, Iss. 1, pp. 245–277.

Rey del Val, Pedrodel. 2002. *Montaje, una profesión de cine*. Ariel, Barcelona.

Rock, Irwin. 1983. *The logic of perception*. MIT Press, Cambridge, MA.

Sadoul, Georges. 1973. *Histoire genérale du cinéma*. De Nöel, Paris.

Sánchez, Rafael Carlos. 2003. *Montaje cinematográfico: arte en movimiento*. La Crujia, Buenos Aires.

Schachter, Stanley. 1964. The interaction of cognitive and physiological determinants of emotional state. In L. Berkowitz (Ed.), *Advances in experimental social psychology*, Vol. 1, pp. 49–80, Academic Press, New York.

Schaefer, Alexandre, Nils, Frédéric, Sanchez, Xavier and Philippot, Pierre. 2010. Assessing the effectiveness of a large database of emotion-eliciting films: A new tool for emotion researchers, *Cognition & Emotion*, Vol. 24, Iss. 7, pp. 1153–1172.

Seddon, Mark. 2003. *Investigating the effect on attention of action continuity*. University of Edinburgh.

Simons, Daniel and Levin, Daniel. 1998. Failure to detect changes to people during a real-world interaction. *Psychonomic Bulletin & Review*, Vol. 5, Iss. 4, pp. 644–649.

Simons, Daniel and Levin, Daniel. 1997. Change blindness. *Trends in Cognitive Sciences*, Vol. 1, Iss. 7, pp. 261–267.

Smith, Tim. 2006. *An attentional theory of continuity editing*. Unpublished Doctoral Thesis, University of Edinburgh.

Smith, Tim. 2004a. *Editing attention: The perceptual foundations of continuity editing*. Paper presented to the Cognitive Studies of the Moving Images Conference. Grand Rapids, MI, July 22–24.

Smith, Tim. 2004b. *Perception of temporal continuity in discontinuous moving-images*. Proceedings of the 26th Annual Conference of the Cognitive Science Society. Chicago, August 5–7.

Smith, Tim, Whitwell, Martyn and Lee, John. 2006. Eye movements and pupil dilation during event perception. In *Proceedings of the 2006 symposium on eye tracking research and applications – ETRA '06*, p. 48.

Solarino, Carlos. 1993. *Cómo hacer televisión*. Cátedra Signo e Imagen, Madrid.

Spottiswoode, Raymond. 1976. *Enciclopedia focal de las técnicas de cine y televisión*. Omega, Barcelona.

Tan, Ed. 1994. Film-induced affect as a witness emotion. Poetics, Vol. 23, pp. 7–32.

Thompson, Roy. 2001. *manual de montaje*. Plot, Madrid.

Timoshenko, Stephen. 1956. *Cinematografía y arte cinematográfico*. Futuro, Buenos Aires.

Tommasi, Luca and Actis, Rossana. 1999. Cuts and phenomenal continuity: The role of apparent motion. ECVP (European Conference on Visual Perception), Trieste.

Tommasi, Luca and Actis, Rossana. 1998. Cuts in cinematic displays: the effect on phenomenal continuity. ECVP (European Conference on Visual Perception), Oxford.

Ungerleider, Leslie and Mishkin, Mortimer. 1982. Two cortical visual systems. In D. J. Ingle, M. A. Goodale and R.J.W. Mansfield (Eds.), *Analysis of visual behavior*, MIT Press, Cambridge, MA.

Vale, Eugene. 2009. *Técnicas del guión para cine y televisión*, Gedisa, Barcelona.

Vertov, Dziga. 1988. *Nosotros variante del manifiesto*. In Filmoteca Generalitat Valenciana, *El cine soviético de todos los tiempos 1924–1986*, Ediciones Documentos de la Filmoteca Valenciana.

Vertov, Dziga. 1974a. *Memorias de un cineasta bolchevique*. Colección Maldoror 19, Editorial Labor.

Vertov, Dziga. 1974b. *El cine-ojo*. Fundamentos, Madrid.

Villain, Dominique. 1994. *El montaje*. Cátedra, Madrid

Villanueva, Dario. 1992. *El comentario de textos narratives: la novela*, 2nd edition. Júcar, Gijón.

Volkman, Julie and Parrott, Roxanne. 2012. Expressing emotions as evidence in osteoporosis narratives: Effects on message processing and intentions. *Human Communication Research*, Vol. 38, Iss. 4, pp. 429–458.

Wenger, M.A. 1950. Emotion as a visceral action: An extension of Lange's theory. In M. L. Raymert (Ed.) *Feelings and emotions*, pp. 3–10. McGraw-Hill, New York.

Wolfe, J. M., Klempen, N. and Dahlen, K. 2000. Post-attentive vision. *Journal of Experimental Psychology: Human Perception and Performance*, Vol. 26, Iss. 2, pp. 693–716.

Zhou, Shuhua. 2005. Effects of arousing visuals and redundancy on cognitive assessment of television news, *Journal of Broadcasting & Electronic Media*, Vol. 49, No. 1, pp. 23–42.

INDEX

Note: Page numbers in *italic* refer to figures.